MAPS AND PRINTS

for pleasure and investment

MAPS AND PRINTS

for pleasure
and investment

By D. C. GOHM

ARCO PUBLISHING COMPANY, INC
New York

First published in the United States
by Arco Publishing Company, Inc.
219 Park Avenue South, New York, N.Y. 10003

Printed in Great Britain

CONTENTS

Introduction	1
Suggestions to New Collectors	3
Styles & Methods of Engraving	10
Woodblocks	12
Etchings	12
Line Engravings	12
Mezzotint Engravings	14
Stipple Engravings	16
Aquatint Engravings	16
Lithographs	16
Colour Prints	18
Paper	58
Proofs and States	61
Mounting	66
Fakes and Reproductions	69
Restoration	73
Dictionary of Engravers	89
Maps	170
Colouring for Maps	172
Principal Map-Makers	176
Glossary	187

List of Colour Plates

1. North Midland Railway Bridge by S. Russell. 8

2. A False Alarm on the Road to Gretna by R. Eaves 9

3. Flooded by J. Harris 24

4. The Start for the Great Atlantic Race by T. G. Dutton 25

5. View of Teignmouth from Shaldon by T. Sutherland 40

6. The Wellington Pavilion, Dover by W. Burgess 40

7. Charge of the Heavy Cavalry Brigade by E. Walker 41

8. Enlarged detail of 7 showing texture of lithograph 41

9. Cartouche of Map of Surrey by Jan Jansson 56

10. Cartouche of Map of Cumberland by Joan Blaeu 56

11. Map of Cumberland by Joan Blaeu 57

12. ⎫ A series of four plates showing the various 72

13. ⎮ stages of colouring. See text: 72

14. ⎬ 'A view of the House of Lords' 73

15. ⎭ 73

16. Cartouche of a Map of Huntingdonshire by Joan Blaeu 88

17. Map of Huntingdonshire by Joan Blaeu 88

18. Celestial Chart by J. B. Homanni 89

19. Road Map from London to Holyhead 89

20. The Hon. Phillip Sydney Pierrepont by E. Walker 104

21. Dover Harbour by W. Burgess 105

22. The Royal Dockyard by P. C. Canot 105

23. Map of Surrey by Jan Jansson 120

24. Map of Derbyshire by Saxton 121

List of Black & White Photographs

1. 'The Mutineers turning Captain Bligh and Officers Adrift' 5
 by R. Dodd
2. Her Majesty's Ship 'Howe' by W. Read 7
3. 'The Village Politicians' by A. Raimbach 9
4. An enlarged detail of 'The Village Politicians' 11
5. A View of Charlton by M. A. Rooker 13
6. 'The Politician' by P. K. Sherwin 13
7. Clipper Ship 'True Briton' by T. G. Dutton 15
8. Cynthia with Mosquito and Heroine in Torbay 1849 17
 by Dutton
9. The Essex refitted in Bombay by Jukes and Wells 19
10. The Launch of the Edinborough 1852 by E. Duncan 21
11. Lord Lowther leaving Prince of Wales Island by Duncan 23
12. Taeping in the China Seas with Fiery Cross 1866 by Dutton 25
13. Cottages in Winter by Thomas Williamson 27
14. Book-plate from Finders, The Eagle Tower, 28
 Caernarvon Castle by J. C. Armytage
15. Details of Cottages in Winter 29
16. The distribution of His Majesty's Maundy by J. Basire 31
17. The distribution of His Majesty's Maundy by J. Basire 31
18. Her Most Gracious Majesty Queen Victoria in the 33
 Royal Yacht by L. Hague
19. High Street, Towcester. A lithograph on India Paper 33
20. From an original picture of Marlows by Peake 35
21. The Strand by T. S. Boys 37
22. Water Engine Cold Bath. Fields Prison by J. Bluck 39
23. Prospect of the Choir from the east by W. Holler 41
24. Scraps from the Sketch Book of Henry Alken 43
25. Bowling by H. Alken 45
26. Brewing and Cyder Making. Pub. by Pyre and Nattes 47
27. Sir Charles Thompson by R. Earlom 49
28. Exhibition of a Battle between a Buffalo and a Tiger 51
 by H. Merke
29. The Game Secured by J. Harris 53
30. A Ferncutters Child by Bartoloti 55
31. Quite Fresh by C. N. Smith 57
32. Neopolitan Breed by Nicholson 59
33. The Old-Irish Hunter by Nicholson 62
34. Map showing both Hemispheres by John Senex 64
35. Map of Bermuda by Joan Blaeu 65
36. Henry d'Esterne Darby by R. Earlom 68
37. Puffin Shooting by T. M. Baynes 70

38.	Old Sea Chart by Captain Grenville Collins	72
39.	Old Sea Chart by Johannus Van Keulen	74
40.	Cartouche on Van Keulen sea chart	75
41.	An Offering before Capt. Cook by J. Webber	77
42.	The Baptism of the Eunuch Etching by Rembrandt	77
43.	Using fine glass paper to clean a tear	83
44.	Method of using a spoon to roll down a tear.	83
45.	A cathedral at Huy on the Meuse, Belgium by Ogle	87
46.	Dover by J. T. Willmore	91
47.	St. Winfraw, Abbeville by Ogle	95
48.	Christ at Emmaus. Etching by Rembrandt	101
49.	Lambeth House by Holler	105
50.	Favourites by W. Gilder	109
51.	Blasting Rocks, Linslade, Bucks. by J. C. Bourne	113
52.	View of the Cathedral of Christ Church by James Basire	113
53.	Felis Affinis. Gray. Allied Cat	117
54.	Le Triomphe D'Amphioite by P. E. Moitte	119
55.	A general View of Amsterdam from the Tye by T. Bowles	119
56.	Evening by J. Scott	123
57.	Mid-day by I. H. Wright	123
58.	Marne rue au Soleil Couchant by Schroeder after Vernet, Line engraving	125
59.	England by Robert Morden	135
60.	Gate of Vivarrambla Grenada by T. S. Boys	139
61.	The Escurial by T. S. Cooper	143
62.	Bull Fight, Seville by L. Hague	144
63.	The remarkable Kyloe Ox by T. Berwick	150
64.	Saturday Night by F. Holl	149
65.	Sunday Morning by W. Holl	149
66.	The Ice Islands seen the 9.1.1773 by B. T. Pouncy	149
67.	Meeting of the Royal Bowman by Bennet	153
68.	An interesting French book-plate 'Relieu' by Bernard	153
69.	A Match at the Badger by I. Clark	154
70.	Farriers Shod by J. A. Atkinson	154
71.	The Honourable Samuei Barrington by R. Earlom	154
72.	An Old Shepherd in a Storm by R. M. Meadows	157
73.	George, the Third by W. W. Ryland	157
74.	The 'Enterprise' Steam Omnibus by C. Hunt	158
75.	John Boydell by Valentine Green	158
76.	High Altar, Seville Cathedral by T. Allom	173
77.	A Camp Scene by C. White	175
78.	Veduta generale della Piazzadel Duomi di Pisa by Ranieri Guassi	175

Introduction

Reading is naturally informative, it leads one, very explicitly, yet often unobtrusively, to gain knowledge about a particular interest within the comfort of a favourite armchair, and much can be learnt about antique prints and maps in this way. This book will introduce a branch of collecting that becomes more and more absorbing as one learns to appreciate the skill of old craftsmen, and the romance of the olden times illustrated by artists of the various periods.

The scope for collecting antique prints is virtually limitless, no matter what branch of history or art inspires you a collection can be formed, based on that interest.

Both antique maps and prints, considered with other forms of antiques, have the virtue of being relatively inexpensive, in some instances, they are even grossly underpriced, rarely do they command the high prices associated with other works of art, and this is understandable because there is generally more than a single copy surviving the ravages of time.

Every effort has been made to make this volume as comprehensive as space will allow, and at the same time, maintain a broad aspect so that new collectors can visualise the immense possibility offered by this particular branch of antiques.

Whilst a great number of artists and engravers have been mentioned, it is appreciated that many have not been included, due to lack of space and the impossibility of attempting to include every engraver or artist who produced a print. If your collection is to be based on the works of a particular engraver or artist, then it is recommended that you acquire or refer to a work of reference dedicated to that individual.

Reading and the acquisition of knowledge thus acquired, is complementary to practical experiences, the beauty of an old engraving can only really be appreciated by handling and examining the original, the reproduction of the numerous plates in this volume, excellent as they are, cannot convey the subtle texture of the paper, or the quality of the line, so never let the opportunity pass to handle and examine a genuine old print.

1 Suggestions to New Collectors

The instinct to collect seems to be inborn in most humans, whether it be the young boy with stamps, cigarette cards, or match-box tops; the housewife who religiously saves every sheet of brown paper; or the husband who collects beer mats. Collecting anything is primarily a matter of personal interest, and secondly a matter of finance, if one is sufficiently wealthy, the choice is unlimited, but for those of us who have small, or average incomes, print collecting offers a great deal, and can be very rewarding in both an ascetic and financial sense. But how does one start a print collection! Of course it is a simple matter to walk into a shop that has prints for sale and buy a few that appear desirable, but without some knowledge of the subject, the collector will not be in a very strong position to judge the antiquity, validity or current value of the prints.

First study the various sections of this book, the author, himself a collector and restorer, has endeavoured to pass on to the reader, the 'sense and feel' of antique prints, learn the various processes used to produce them, remembering that the old techniques of engraving were often combined in the production of a single plate, and more important—learn to recognise the type of engraving. This can only really be accomplished by handling and examining a number of prints.

Experience gained by actually handling, and critical, visual examination is the only way to familiarise the beginner with antique prints. Obviously print-sellers will not take kindly to customers who handle every print in the shop and then walk out, but they usually do not mind you *looking*, and if

you do handle the odd print, please do so carefully, and never wear gloves. It is surprising how easy it is to transfer dirt and grime from gloves, that is why some print-sellers cover their smaller prints in a clear plastic cover. Do not overlook the museums, they often have a large collection and the Curators are usually only too pleased to show a specific print, but do not expect them to let you browse.

Now to the purpose of the collection—it is pointless to collect haphazardly, the scope for print collecting is limitless and the new collector is sure to find a subject that is of particular interest and one in which he would like to specialise. Here are a few suggestions to indicate the possibilities:– A particular school or period; a method of engraving; a class of print such as portraiture or fashion; original work only where the print is by and after the same artist or the painter-etcher; or simply take a subject such as topographical views, military, marine, decorative, religious, coaching, racing, games, animals, general sporting and general transport.

Now we come to the matter of buying prints, ultimately experience will guide the collector, and of course, there is really no other way, but a few fundamental checks can be made. Examine the impression for signs of wear on the plate, manifest by the lightening or complete disappearance of the more delicate lines; check that the margins are reasonable to ensure that the picture area is complete. If an old print has a particularly good wide margin, it is possible that this may be false. A false margin is nothing more than a paper frame into which the print has been carefully inlaid. To ensure an immaculate fit, the print and frame aperature were cut simultaneously. Obviously it would be nice to insist that every print added to a collection had the full and original margins, but to do this would exclude many otherwise desirable prints. Check the paper, handle it, feel it, hold it up to the light for signs of a watermark, and endeavour to determine if the paper is as old as it pretends. Even if you are unable to do this, the examination will give you experience, which if continually practised, will eventually lead to you 'knowing old paper'.

Today many fine prints offered for sale have been repaired in some way, patches of paper pasted behind tears, and in some instances the actual print is so badly torn that it is only a backing paper or board that holds the print together. Holes in the paper may well have been repaired by inlaying patches of paper and the lost parts of the engraving added by clever pen work.

Colouring is an important consideration. Ideally prints with original colour are far more desirable than those coloured by modern colourists. However, the majority of coloured prints available will, in fact, have been coloured comparatively recently and providing the work has been competently and sympathetically executed, there is no reason why they should

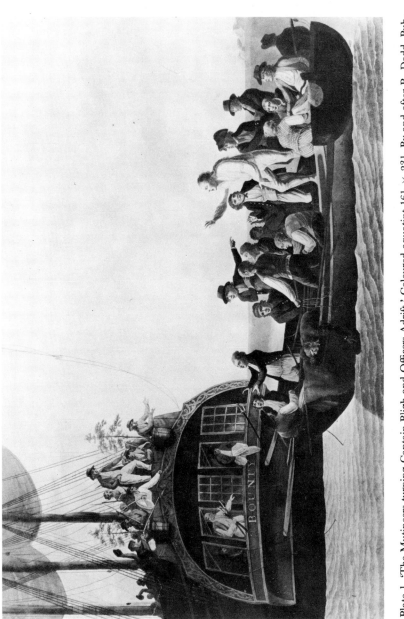

Plate 1. 'The Mutineers turning Captain Bligh and Officers Adrift.' Coloured aquatint $16\frac{1}{4} \times 23\frac{3}{8}$. By and after R. Dodd. Published B. B. Evans 1790. (H.M.S. Bounty, 215 tons. In 1789 the crew mutinied casting Capt. Bligh and 18 officers adrift.) (National Maritime Museum.)

be rejected, but many of the smaller book plates offered in gift shops, book-shops etc., for the popular trade are more often than not, coloured by amateurs for the general public and not for discerning collectors. Whilst examining the print for colour, turn it over and examine the back for traces of colour penetration, if this is evident it means the print was inadequately sized before the colour was applied, and a sure sign of amateurism.

It must not be assumed from the foregoing that only prints in their perfect, original state are worth collecting, if we implemented such a limitation, our collection would be a very small one indeed. Very old prints may well only have a $\frac{1}{8}$ inch margin, the result of earlier trimmings, but providing the picture, title, and any other information is still intact, the beauty of the print is in no way lost. Even minor tears, providing they have been repaired well, need not eliminate an otherwise desirable print, who knows, you may be able to replace such a print with a better copy in the course of time. The standard of any collection must be set by the collector's personal taste and the financial resources at his disposal.

Now how much should be spent on a print? How can a beginner know the value of a print? Sorry, there is no specific rule; current demand, rarity, fashion, and condition all influence the final price. Some prints that commanded a few hundred pounds 50 years ago, can now be bought for a few pounds, and similarly, the reverse applies. For example, the book containing the small book-plates of Shepherds Views of London (2 vols) could be bought for as little as £6 only 10 years ago, today, you will be lucky to buy a copy for £85.

Do not spend a lot of money until you are reasonably sure of yourself, a lot of interest and knowledge can be gained from prints costing only a few shillings, and if you make any mistakes it will not put you in the hands of the Receiver. Prints of low value can also be used for practice should you wish to try your hand at restoration. A final word re: prices. Sale room catalogues are a good indicator of the prices being paid for good quality prints, but remember the trade also visits sale rooms and the retail value could be well in excess of the prices paid at auctions, a better barometer can be obtained from catalogues issued by the various print-sellers and some antiquarian book dealers.

Prints purchased solely for investment will have to be chosen most carefully, and although it is true that selected prints or maps will undoubtedly increase in value, if financial gain is the only motive for collecting, then their real value, in terms of pleasure and appreciation will be lost. There are many other better ways to invest capital for profit, however, there is no reason why one should not collect prudently with an eye to the future.

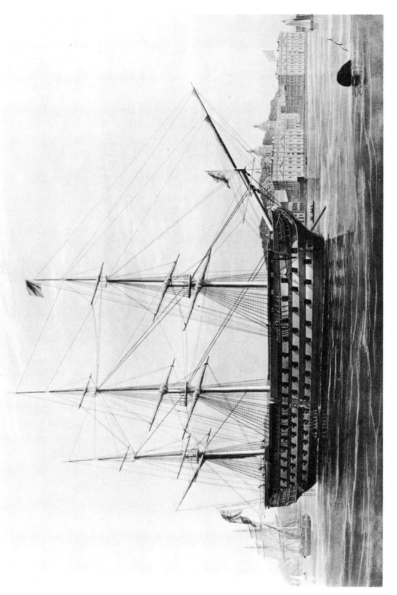

Plate 2. Her Majesty's Ship 'Howe' of 120 guns with a view of Greenwich Hospital and the Observatory. Coloured aquatint 18 × 26½. Dedicated to Captain the Rt. Hon. Lord Clarence Edward Paget. By W. Read after W. J. Huggins. Published *c.* 1840. (National Maritime Museum).

Good quality prints with reasonable margins, a good clear impression, and no repairs will always command a better price than prints of a lower quality. Early state Speed's Maps, are a sound investment and so are the maps of Saxton, Jansson, Ortelius etc. Good quality ship portraits, T. S. Boys London Views, original Goulds Birds, etc., are all sound investments providing they are purchased in the first instance at a reasonable price.

Plate 1. North Midland Railway bridge over the river Derwent and the Matlock Road. By and after S. Russell ($16\frac{1}{4} \times 10\frac{3}{8}$). Lithograph.

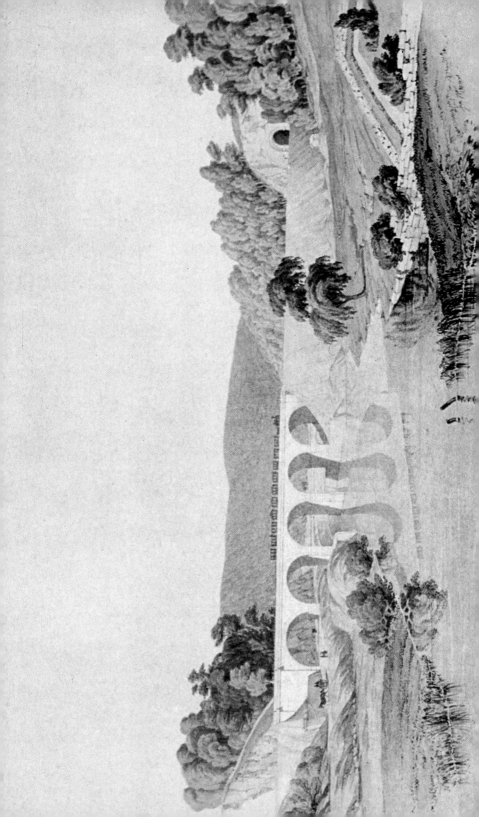

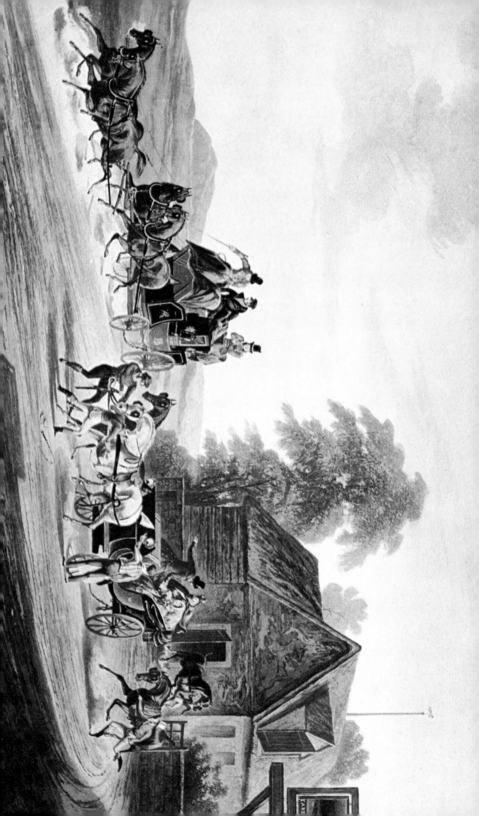

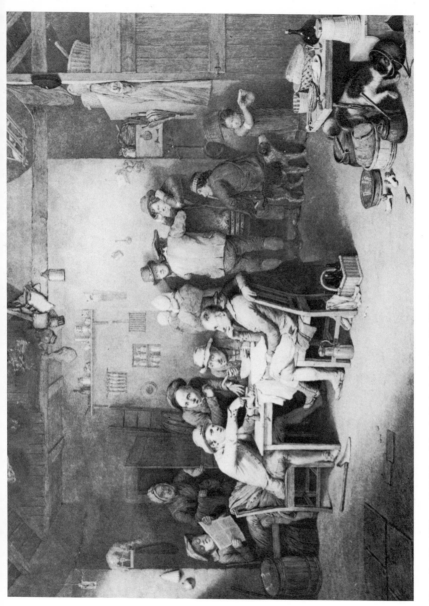

Plate 3. 'The Village Politicians,' by A. Raimbach after D. Wilkie.

9

Plate 2. A False Alarm on the Road to Gretna by R. Reaves after C. B. Newhouse ($15\frac{7}{8} \times 10\frac{7}{8}$) Aquatint.

2 Styles & Methods of Engraving

Prints and maps as stated earlier, provide one of the most rewarding fields for collectors interested in art and craftsmanship, together with a taste for antiquity. Apart from their obvious craftsmanship and artistic merit, prints also provide historical records of a vast and varied range of subjects. Unlike collections of more bulky antiques, they can be stored very satisfactorily in portfolios which require very little space, and a few selected and well loved examples can be framed, and used to enhance the walls of any room, irrespective of the general decor.

Prints, like most of man's achievements, have passed through many stages of development, resulting in a variety of styles and methods of reproduction. Early prints were made from wood blocks, followed by copper, and later steel. The quality of engraving naturally was totally dependent upon the skill of the engraver, and to a lesser extent, the artistic merit of the picture being reproduced. The fact that a print is old makes it interesting, but not necessarily an item worthy of being included in a collection.

More often than not, prints were produced by an engraver from paintings or drawings by well known artists, but this was not an invariable rule. There are many beautiful examples of prints where both the painting and engraving were both executed by the artist.

The majority of prints available to the collector will be those of the seventeenth and eighteenth century, and it will greatly assist and increase

10

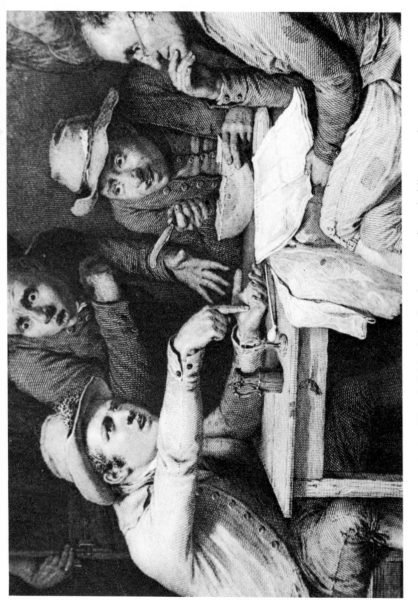

Plate 4. An enlarged detail of 'The Village Politicians', showing the texture of a typical line engraving. (Photo. D. C. Gohm.)

11

our appreciation of prints if first we learn how to recognise the various styles and at the same time learn something about the techniques employed in print making.

Wood Block

The wood engraver first prepared a suitable block of wood of the appropriate size, by smoothing both faces flat. The design was then drawn on the block with ink or brush, and with the aid of a knife or graver, the engraver proceeded to remove all the wood not marked in ink to a depth of about 1/16 inch or more, leaving the drawn design standing in relief.

To produce the print, an ink coated roller was rubbed over the block, so that the raised design only accepted a coat of ink. The paper was then laid on the block and manually rubbed on the back, thus transferring the impression in reverse.

Later woodcuts were made by actually incising the design into the wood with a graver. After inking the block face had to be cleaned to leave the ink in the engraved channels only. This method required greater pressure to transfer a good impression onto paper.

Early wood blocks were made from relatively thin wood, pear, apple, lime, and other soft woods being the most commonly used. Later blocks were made of boxwood, and thicker in section.

Because the wood blocks did not wear particularly well, it was not possible to obtain very many high quality impressions, and as the life of the block was very limited, so were the total number of good impressions limited from any single block.

Line Engraving

The block consisted of a sheet of copper, thick enough to be rigid when taking impressions ($\frac{1}{8}$ inch approximately) and flat. The outline of the subject to be produced was first traced on the copper, then with a burin or graver, which was a triangular tool with a handle that fits snugly into the palm of the hand, the engraver guided this tool with forefinger and thumb along the traced outline, at the same time varying the pressure to cut a groove of varying depths into the metal, to form either a coarse or fine line on the finished impression.

Until about 1820 copper was invariably the metal used for line engravings, although occasionally brass, zinc, iron and even silver were used. From 1820 onwards copper slowly lost its popularity in favour of steel. Steel being a harder metal yielded a greater number of impressions before deterioration of the image.

Etching

The engraver first prepared a copper plate with a thin film of wax ground, then with a needle or similar pointed tool, he proceeded to draw the subject on the wax with sufficient pressure to expose the bare metal

Plate 5. A View of Charlton near Woolwich in Kent. By M. A. Rooker after P. Sandby. Published 1775. (Bookplate 7⅛ × 5.) Line engraving.

Plate 6. 'The Politician' after William Hogarth, etched by P. K. Sherwin, date 1773. (10¾ × 13.) (Photo. D. C. Gohm.)

13

underneath. The next step was to protect the back and edges of the plate with a suitable acid resistant medium, then the plate was completely immersed in acid which bit into the areas exposed in the wax. When the lines requiring light treatment had been 'bitten' to the required depth, the plate was removed, and those areas covered with an acid resistant varnish to prevent any further action by the acid. The plate was then returned to the acid so that lines required to be darker could be etched deeper. Repetitive treatments of 'stopping off' and re-etching resulted in the graduation of lines from the very delicate to the strong and bold.

When the etching stage was completed, the plate was washed, and both varnish and wax removed, leaving a beautifully clean etched plate ready for the first impression to be taken.

Dry Point

Dry point etchings were made simply by scratching the drawing into the copper plate with a needle-like tool. This action produced a thin line in the copper to receive the ink, and at the same time, produced a ragged edge or burr each side of the line, which also retained a large proportion of ink. The resultant impression taken from dry point plates were, therefore, richer and more velvety than impressions from line engraved, or acid etched plates.

It will be obvious that good quality prints in dry point are rare. Due to the delicate nature of the burr, it soon wore down so that the number of prints produced whilst the plate retained its high quality was very limited.

Mezzotint-Engraving

The engraver first polished the copper sheet on the face to be engraved, then with a piece of chalk he marked a series of parallel lines across this face, about $\frac{3}{4}$ inch apart. The first stage of engraving was executed with a chisel-like tool, with a curved edge, one side of which was grooved, shaped, and sharpened to form a series of cutting points, or dots. Placing this tool between the first two chalk lines, he rocked it back and forth, and at the same time moved it slowly across the plate, this formed a band of dotted indentations in the metal. He then proceeded to treat the next chalk marked band in the same way, and so on, down the plate until the whole plate had been covered. The same operation was then repeated vertically over the plate, then diagonally at varying angles until the whole surface of the plate was roughened evenly. This was known as 'laying the ground' and if an impression was taken from it at this stage, the result would be a perfectly black surface. The next operation required the outline of the design to be drawn on the roughened surface, then with a very sharp scraping knife, the engraver proceeded to develop the design by carefully scraping away more or less of the roughened surface to produce the variety of graduated tones from very light to black.

14

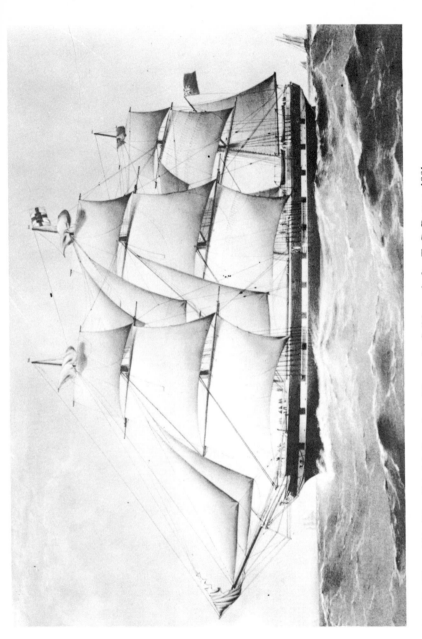

Plate 7. Clipper Ship 'True Britain'. Part view of Sea under Sail by and after T. G. Dutton. 1861. (National Maritime Museum.)

Stipple Engraving

The copper plate was first given a wax ground, and treated in much the same way for etchings, but instead of drawing lines into the wax, the design was first outlined by pricking dots into the wax. The darker passages were then filled in either by larger, or more closely grouped dots. The plate was then immersed in acid to bite the dots into the plate. After this treatment, the wax ground was cleaned off and the engraver proceeded to re-enter most of the dots with a 'stipple graver', to emphasise, and develop the final design. Stipple engravings therefore, are really a combination of the etching, dry point and graver work.

Aquatint Engravings

There were two basic grounds used to produce plates for aquatints; the dust and spirit ground, but whichever ground is used the technique is the same.

The cleaned copper plate was evenly coated with a film of finely powdered resin, the various methods used to scatter the resin were to place the plate in a rotating box, by a revolving fan inside the box, or by blowing with a pair of bellows: the plate was then heated to just melt the resin. Spirit grounds were applied on a carefully cleaned plate by covering the plate with a solution comprising resin and spirits of wine. With the evaporation of the spirit, the resin dried, and in so doing, contracted, leaving the resin adhering to the plate in fine particles, which exposed the raw metal around the particles.

When the etching acid was applied over the resin ground, it bit into the minute exposed areas, but its action was inhibited where covered by the tiny particles of resin. The graduation of tone necessary to express form were obtained by successive applications of acid and by stopping off areas with acid resistant varnish. When a definite or well defined line was required it was added by the etching needle which removed the resin.

Lithographs

Lithographs were not produced by any method associated with engraving, but they rank among the best of some of the antique prints. Lithographic prints were produced from a special kind of limestone to which a granulated surface had been added by rubbing the printing surface with a similar piece of stone. This action naturally flattened the surface also. The design was then drawn on the stone, in reverse, with a greasy pencil and the stone treated with a weak acid. Before applying the ink with a roller the stone was first wetted, and because oil and water do not readily mix, the ink only adhered to the greasy drawn design. It was only necessary to lay a piece of damp paper on the stone and press to obtain the final impression.

An alternative method was sometimes practised by first drawing the

16

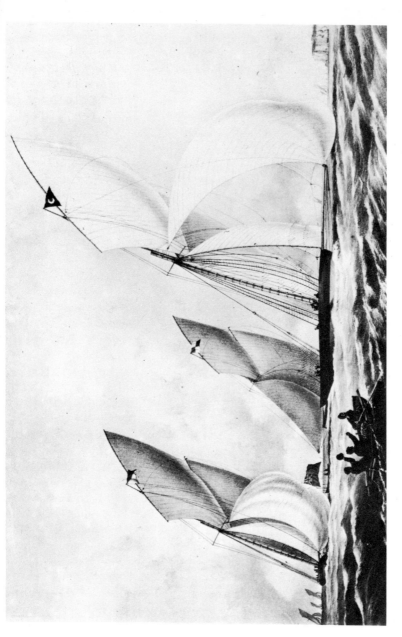

Plate 8. Cynthia with Mosquito and Heroine in Torbay 1849. Coloured lithograph by Dutton after Candy. $12\frac{1}{4} \times 17\frac{5}{8}$. Published 1850.

(National Maritime Museum.)

design with a greasy pencil on a special transfer paper; this was subsequently pressed onto the prepared surface of the stone and the paper removed, leaving the drawn image. Impressions obtained by this method were generally not quite as crisp as those obtained by direct drawing.

Soft Ground Etching

The plates for soft ground etchings were prepared by coating the polished surface of the plate with a tallow or wax, much in the same way as it would be for normal etchings. A sheet of paper was then laid on the waxy surface and the design drawn with a pencil. When the paper was removed, the wax adhered to the underside of the paper wherever a line had been traced, and in so doing exposed the bare metal in the form of the design. The plate was then immersed in acid and the plate bitten on the exposed areas.

The appearance of a print produced by this method shows the lines to be rough and similar to crayon lines, whilst those produced by a normal etching process are fine and clear.

Colour Prints

The majority of old engravings were hand coloured with watercolours, but these must not be confused with engravings 'printed in colour'. Stipple engravings printed in colour were produced from a stipple engraved plate, and the various coloured inks rubbed into the required areas by the printer, excess ink was removed from the plate surface, leaving the tiny pockets of the engraving filled with ink. The subsequent impression resulted in a beautiful coloured print, composed of tiny coloured dots on a white background. Depth of colour tone, or shading, was achieved by the proximity or size of the colour dots.

Colour prints were produced very early in the history of prints by the Chinese, using various wood blocks to produce the individual colours, but the process used by Jacob Christopher Le Blon very early in the 18th century had a similar basis to present day techniques. His process involved making mezzotint plates for each colour, so graduated in texture that they reproduced the required proportions of red, yellow and blue. A fourth plate was used for the addition of black. The plates were inked with their appropriate colour, and printed on the paper, one impression on top of the other, registration of each plate being of considerable importance.

Other colour prints were produced during the eighteenth century from separate colour plates engraved in stipple and aquatint. 1834 saw the beginning of the Baxter oil prints. These were produced from engraved steel plates, the first block engraved became the master, and the subsequent colour plates were prepared by transfers made from this master. The various colours used were mixed by hand to the required tint, plates inked, and print produced by printing one colour impression upon another

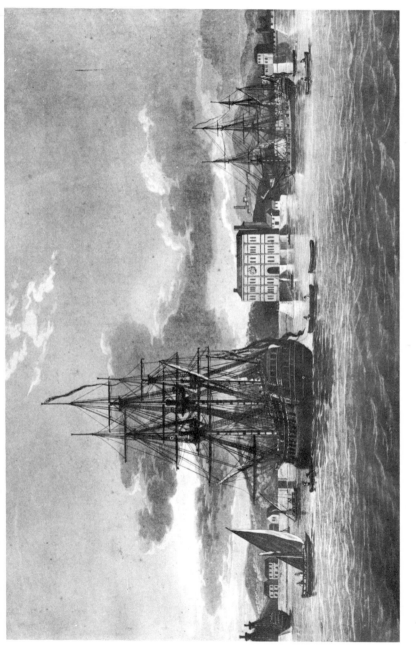

Plate 9. The Essex refitted in Bombay. Aquatint by Jukes and Wells after Luny. $13\frac{3}{8} \times 19\frac{5}{8}$ Published in 1785 by R. Pollard. (National Maritime Museum.)

in accurate register. Later Baxter used a combination of wood blocks and steel plates.

Woodcuts

Although woodcuts do not claim the interest of many collectors today, they cannot be ignored. After all, they were used well before any of the other processes devised for the reproduction of works of art and for conveying pictures of interest to the masses.

The craft of the woodblock engraver is a very old one. The earliest playing cards are thought to have been produced from crude woodblock masters, and the earliest books printed with removable type were often illustrated with a woodblock engraving.

The greatest period of the woodcut was early in the sixteenth century when it flourished mainly in Germany. This was the period when Albrecht Dürer (1471–1528), the celebrated painter and engraver, took the art from its relatively crude state to an elegance rarely exceeded by later designers and engravers. Sometime prior to 1527 he produced his own portrait, and this is now extremely rare.

Such artists as Dürer rarely if ever executed the woodblock in its entirety, they drew the designs on the block and passed the block to craftsman engravers to actually remove the unwanted wood (see Styles). However, they usually supervised this work most diligently to ensure that each line was faithfully reproducible. Hans Holbein (1497–1543) was another early designer of woodcuts, and he produced the remarkable series of fifty-eight blocks known as 'The Dance of Death' the actual wood cutting being executed by Hans Lutzelburger. An original and complete set of these prints are now rare, there were, however, many later issues, including copies by Holler. Holbein's woodcuts were numerous, he was responsible for designing many Biblical subjects, title pages and general illustrations. Between 1515 and 1528 he was working for six different printers, one in Zurich and five others in Basle.

Woodcuts used to produce *chiaroscuro* prints were produced about this period, and the Italian, Ugo da Carpi, claimed to have been the inventor of this process, but there is evidence to support the fact that chiaroscuro prints were produced earlier in Germany by Wechtlin in 1510. Another German engraver, Lucas Cranach produced a chiaroscuro print entitled 'Venus and Cupid' dated 1506 and it is believed that this is the oldest known chiaroscuro print in existence.

Between the years 1630 and about 1770 woodblocks were superseded by metal, consequently the art of wood engraving declined to an extent that it became almost non-existent. Thomas Bewick of Newcastle (1753–1828) revived the art, and his work was in every way equal to that of the old masters. Much of his early work was executed for book illustrations,

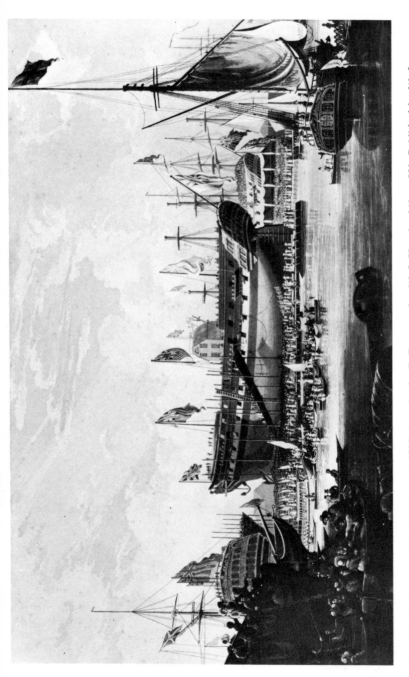

Plate 10. The Launch of the Edinborough 1825. Aquatint by E. Duncan after W. J. Huggins 14⅜ × 22¼. Published by W. J. Huggins.
(National Maritime Museum).

21

but of his earliest separate engravings, the 'Chillingham Wild Bull' a woodcut size $9\frac{3}{4} \times 7\frac{1}{4}$, published in 1789 in Newcastle is a good example. Bewick developed his own particular method of producing the wood block by using a graving tool instead of a knife. He was also skilled in the 'white line' method which is simply cutting the *lines* required into the block so that they 'print' white on the impression taken. (Normal woodcuts cut the wood away between them—see Styles). In his 'Chillingham Bull' both methods have been combined in a single impression.

Bewick was very fond of natural subjects, and obviously a lover of the country, he loved animal subjects and 'The Quadrupeds' published in 1790 and 'British Birds' published 1797–1804 are beautiful examples by this great artist.

During the middle of the nineteenth century the woodblock was no longer the medium of the original designers, but was used mainly by craftsmen engravers for book illustrations much in the same way as modern block-makers provide a service to present day publishers. Much of this work was finely executed by such artists as Frederick Leighton, George Pinwell, Arthur Hughes, J. W. North, W. Small, John Everett, Millais, Frederick Sandys, M. J. Lawless, Hubert Herkomer, John Tenniel, Walter Crane, Edward and Thomas Dalziel, Joseph Swain, W. T. Green, W. J. Palmer, Birket Foster, H. Harral, W. H. Hooper, W. J. Linton, J. W. Whymper, W. Thomas, Charles Keene, E. Burne-Jones and Arthur Boyd Houghton.

Etchings

The process of producing lines by etching with acid is believed to have originated in mediaeval times for the purpose of decorating gold, and for sword ornamentation. It was certainly used early in the sixteenth century for making etched printing plates, but the best period for etching was undoubtedly the seventeenth century. The process has been covered under 'Styles'. Etching was also used extensively for preliminary work on other types of engravings. We are concerned here however, with its more of less pure form.

Although modern collectors prefer the more sophisticated prints produced by line engraving, lithography, aquatint etc., there is still a hard core of art lovers who value etchings for their own sake. The appeal of etchings is in the fact that they often needed no interpreter, or middlemen, the artist was able to work direct on the copper plate and the resulting print was the explicit work of the master.

One cannot mention etching without immediately visualising the greatest and most celebrated etcher of all time—Rembrandt. Born in Leyden in 1606 the son of a miller, Rembrandt's output was prodigious. It is estimated that he etched about 300 plates, and painted something like 650 paintings, of which 60 were self portraits. He also was responsible for

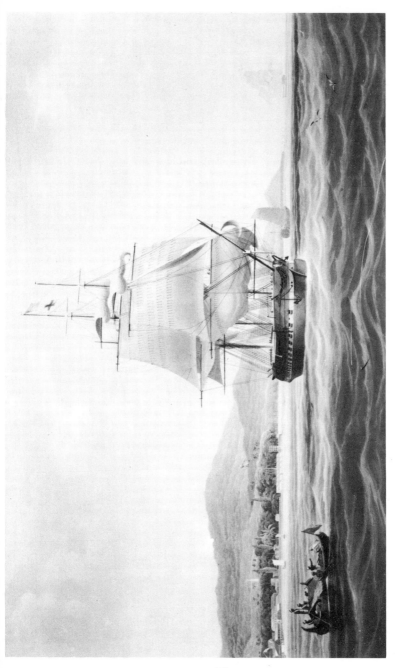

Plate 11. Lord Lowther leaving Prince of Wales Island. Coloured aquatint by Duncan after Huggins. $14\frac{5}{8} \times 22$. Published in 1828 by W. J. Huggins.
(National Maritime Museum.)

23

some 2,000 drawings.

Rembrandt's etchings fall in three broad periods, between 1628 and 1639 he worked mainly in pure etched line; from 1640 to about 1649 he combined etching with dry point; and from 1650 to 1661 he worked mainly in dry point. He died in 1669.

If it is intended to acquire any of Rembrandt's etchings, it is as well to know that many of his plates were copied, and copied so well that it is difficult unless you are an expert, to separate the original from the forgery.

During the seventeenth century, the art was practised in many countries, but it was principally in Holland that it reached its highest form with such masters as Ostade, Everdingen, Zeeman, Du Jardin, Ferdinand, Bol, Van Vliet, Jan Lievens and Seglers.

Wenceslans Hollar (1607–77) was born in Prague, but he worked in England for a period, then left to return again in 1652. After the Restoration, he became 'H.M. Scenographer and Designer of Prospects'. His etchings dealt with numerous subjects primarily intended for book illustration, but they included portraits, maps, and contemporary events. The most interesting of Hollar's etchings were undoubtedly his series of views of London prior to the Fire of London in 1666.

Hollar's prints may not be the most accomplished in artistic merit, but their historical value makes them very desirable; typical etchings are 'Royal Exchange 1644', 'Greenwich', 'Window Views in the North of London'.

For the collector interested in marine subjects there are the two famous seventeenth century Dutch etchers—Reynier Zeeman and Ludolph Bakhuysen. These two artists produced a number of battle scenes and scenes in which ships predominate.

The French Artist—Jacques Callot, produced some plates of rare quality, many of his subjects were on a small scale, but crowded with figures. Callot was born in 1592 and lived only to the age of 43, but during his short lifetime, he produced some 1,500 plates. His early plates included etchings of fairs, festivals, beggars and hunchbacks. Of his later works his 'Grandes Misères de la Guerre', a set of etchings showing the horror and savagery of the Thirty Years War, is probably the best known.

An Italian of some note was Stefano della Bella, a Florentine who produced etched subjects for packs of educational playing cards, and many other interesting plates.

The eighteenth century saw little real development of the art. Many etched plates were produced, of course, and many famous artists were executing work of excellent quality, but little etching of any importance were forthcoming.

The bridging of the eighteenth and nineteenth centuries by the famous

24

Plate 3. Flooded by J. Harris after C. C. Henderson (23⅜ × 12¾) Aquatint.

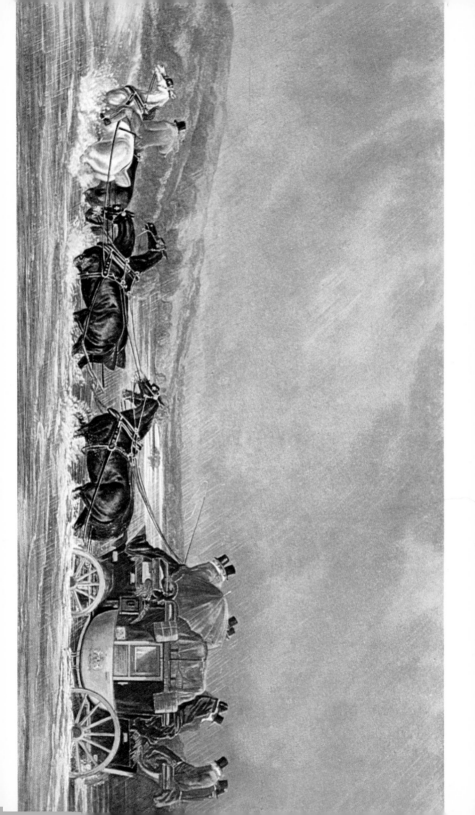

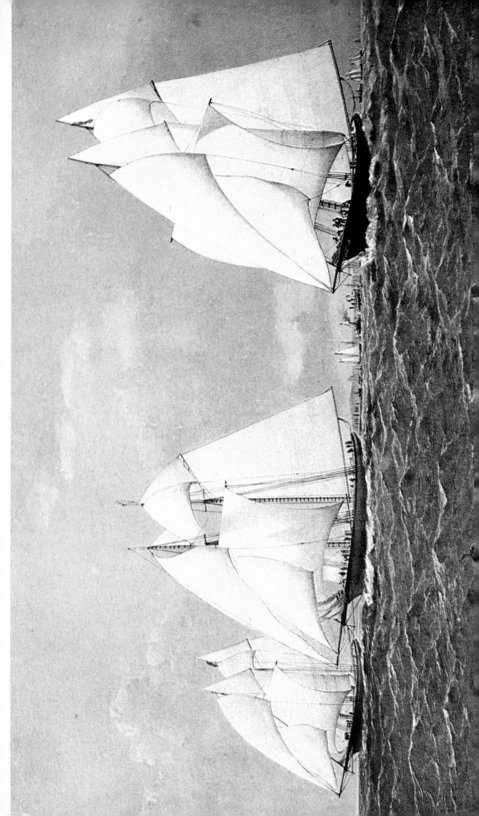

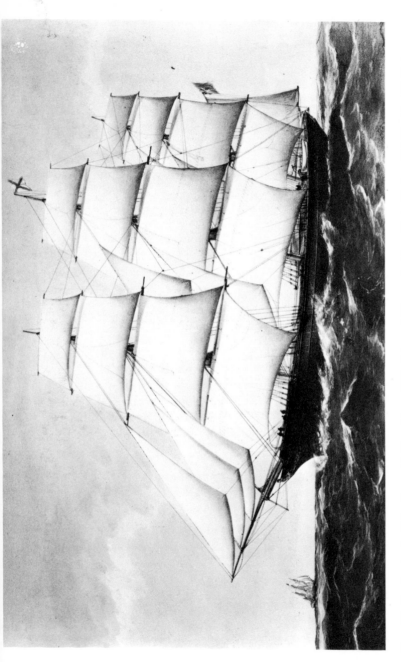

Plate 12. Taeping in the China Seas with Fiery Cross. 1866. Coloured lithograph. 12 × 18, by Dutton. Published by W. Foster in 1866.
(National Maritime Museum.)

25

Plate 4. The Start for the Great Atlantic Race December 11th, 1866 by and after T. G. Dutton (23¼ × 14) Lithograph.

Spanish artist Francisco de G. y. Lucientes Goya, marks a notable step in the progressive history of etching, Goya's beautiful work is well worth the attention of anyone remotely interested in the history of art and specifically etchings. Goya produced Los Caprichos (The Caprices) in 1796–8 'in which fantasy and invention have no limit'. These were satorical studies on manners and customs and on abuses in the Church, and can be seen in the British Museum.

When Napoleon invaded Spain in 1808, the French were guilty of many atrocities and naturally the French troops became a hateful symbol. Goya immortalised this period by a series of etchings entitled 'The Disasters of War' in 1810–13, but they were not published in full until 1863.

From about 1820, Goya became interested in the new process of lithography and produced a few scenes of bullfighting, but he still produced a few etchings and the odd aquatint.

Etching in England was still not a popular mode of expression until well into the nineteenth century although there were signs of a renewed interest during the 1820s. In France however, a revival was well under way, pioneered by such famous names as Paul Huet, Delacroix and Corot, and although the work of these men are not considered to be of the highest quality, they paved the way for the mid-nineteenth century artists including Millet, Méryon, Jacquemart, and Lalanne.

Charles Méryon, an artist who turned to etching because of colour blindness, started by interpreting work of the Dutch painters, but later he turned to original work and in the early 1850's, produced a series of 'Views of Paris' that shows etching in its most perfect state.

Felix Bracquemond, artist and etcher, produced several hundred plates, some after other artists, and some original work, his subjects were varied including landscapes, portraits, and birds.

Collectors should not disregard the early nineteenth century English etchers—as previously stated, etchings were not in great public demand, and it is possible that this affected the supply, after all, artists and engravers had to earn a living; nevertheless, J. M. W. Turner (1775–1851), John Sell Cotman (1782–1842) and Andrew Geddes (1783–1844) together with many others, produced many etchings worthy of the collectors attention. The most famous name to come out of the latter half of the nineteenth century is Whistler—to do justice to the works of this great man would require several volumes, and indeed, many books have already been written so it would be futile to try and condense the history of Whistler in a volume such as this, but neither can he be ignored. Whistler's earliest etchings were published in 1858 by Auguste Delâtre of Paris and these were known as the 'French Set', he later published the famous 'Thames Set' in 1871 a series of 16 etchings and in 1880, the beautiful 'Venice Set'.

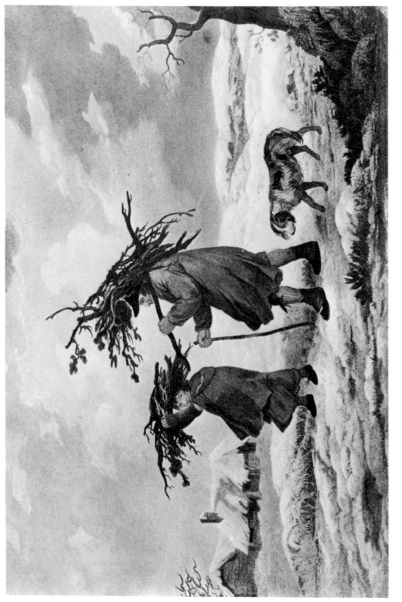

Plate 13. Cottages in Winter, a stipple engraving by Thomas Williamson, after G. Morland. $22\frac{1}{2} \times 17\frac{3}{8}$. Published 1812 by R. Lambe.

(Photo. D. C. Gohm).

Plate 14. Book-plate from Finders. The Eagle Tower, Caernarvon Castle, by J. C. Armytage after W. H. Bartlett. $7\frac{3}{8} \times 5$. (Photo. D. C. Gohm.)

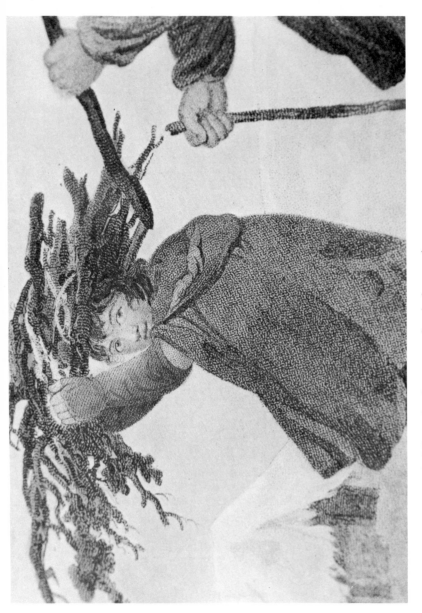

Plate 15. Detail of Cottages in Winter, showing texture of a stipple engraving. (Photo. D. C. Gohm.)

Line Engraving

Many of the early line engravings were produced by artists directly on the plate, and were in effect another medium of expression, but as the art developed it became more of a process for interpreting the works of the artists and painters by craftsman engravers.

Early book printing involved the use of wood blocks that were cut, or engraved with the design, inked and the impression transferred onto paper by rubbing or by the application of pressure. This chapter however is not concerned with wood blocks, but with prints produced from a metal, usually copper, plate.

Early in the seventeenth century, engravers had already become skilled in the use of engraving tools as a means of decorating plate, and it only required a minor transition for the engravers to produce drawings and designs in reverse on a plate for transmitting to paper.

Although many craftsmen and artists worked directly on the plate using only the graver and burin, the great majority of line engraved prints were started by outlining the picture with a foundation of etching, which was subsequently re-entered by the graver.

The metal used for the engraving was, until about 1820, invariably copper, but brass, zinc, iron and silver were used occasionally. From 1820 steel plates were gradually introduced because of their better resistance to wear, and in consequence it was possible to obtain a greater number of impressions.

It is virtually impossible to look at a line engraved print and so determine the material from which the plate was made, but we can assume that any print produced prior to 1820 was *not* from steel, and that the vast majority of these were from copper. Prints after 1820 could, of course, be taken either from steel or copper plates.

The illustration 'Village Politicians' by A. Raimbach after D. Wilkie, is a beautiful example of the technique. Look at the enlarged section and it will be seen that the picture is constructed from individually engraved lines graduated in width, cross-hatched and broken to represent the various forms and texture of the original painting. Because of the somewhat limiting characteristics of producing form and texture by single lines and strokes, a certain conformity of traditional interpretation developed that can be seen to apply to most line engravings from the seventeenth century onwards.

To date, the origin of line engraving for the purpose of producing prints cannot be accurately ascertained, but it is known that the process was practised early in the fifteenth century, and originated either in Italy or Germany. Albrecht Dürer (born 1471, died 1528) was one of the finest early exponents of the art. He was, of course, a painter of some reputation,

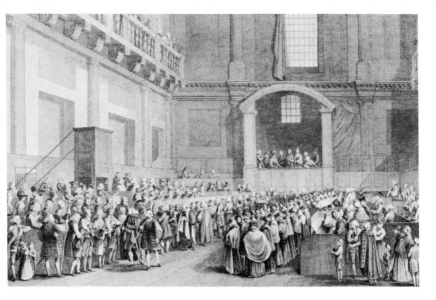

Plate 16. The distribution of His Majesty's Maundy, by the Sub-Almoner, in the Chapel Royal at Whitehall, by James Basire after S. H. Grimm. 24½ × 16½. Published 1789. (Photo D. C. Gohm.)

Plate 17. The distribution of His Majesty's Maundy, by the Sub-Almoner, in the Anti-Chapel, at Whitehall, by James Basire after S. H. Gormm 24½ × 16½. Published 1789. (Photo D. C. Gohm.)

31

and his earliest dated engraving 'Four Naked Women' was inscribed 1497. Some of his best known works include 'The Great Fortune', 'The Shield of Arms with the Skull" 'The Knight of Death' and 'Adam and Eve'. Dürer also worked on wood blocks, and in July 1911, 351 of these were sold at Sotherby's for the exceedingly large sum of £5,400.

The advent of engraving on copper is said to have been first practised in England by Thomas Geminus. He produced some anatomical plates after Vesalius in 1545, he was also responsible for a few portraits of Queen Elizabeth soon after she became Queen.

Probably the earliest English engraver of any note was William Rogers (born c. 1540). Originally a goldsmith, he turned to engraving and worked for booksellers. His prints are mainly portraits and book ornamentations, and most of them are now rare, His portraits included 'Queen Elizabeth', 'Charles, Earl of Nottingham', 'Robert, Earl of Essex' and 'Maximilian of Austria' the latter, full length standing under an archway.

Other artists, mainly portrait, that practised during this period, and are worthy of the collectors interest because of their influence on the development of the art are Simon Van de Passe, George Glover, William Faithorn, John Payne and Pierre Lombart.

1697 saw the birth of William Hogarth, the celebrated artist, and although he only engraved a few of his own works such as the set of 'The Rakes Progress' and 'Southwark Fair', a great number of his paintings have been engraved, and are relatively easy to obtain, because there appears to be little demand for satirical prints at the present time. Some of his better known works include 'The Harlots Progress', 'Marriage a la Mode', Beer Street', and 'Gin Lane'.

Moving along into the eighteenth century and to the more interesting pictorial examples invariably more collectable than portraiture we come to William Woollett, born 1735 of Dutch extraction. He worked with point and graver and was among the greatest masters of the art in the portrayal of landscapes. His 'Battle at La Hague' and 'The Death of General Wolfe' will be of interest to collectors of military and naval subjects, but for collectors with a wider taste his 'Spanish Pointer', 'Views in Switzerland', 'The Fishery', 'The Four Seasons', and 'Views of Pains Hill near Cobham' provide beautiful examples of his work.

Joseph Mallord William Turner was born in 1775 at Covent Garden, and died at Chelsea in 1851. Although Turner was an artist, he greatly influenced the development of line engraving. Not particularly happy with the manner in which his paintings were being interpreted in the conventional way, he continually criticised, supervised, and offered suggestions to a number of engravers until he felt that they had reached a satisfactory standard, the result was a combination of etching and line engraving

Plate 18. Her Most Gracious Majesty Queen Victoria in the Royal Yacht proceeding to Spithead, July 15th 1845, at the departure of the Experimental Squadron. Lithograph by L. Hague after J. M. Gilbert. Published 1846. Size 14 × 10. (Photo D. C. Gohm.)

Plate 19. High Street, Towcester. Published by J. B. Hurfurt. A lithograph on India paper. 11¾ × 8¼. (Photo. D. C. Gohm.)

33

blended to appear as a single uniform process. Line engravers associated with Turner were W. B. and George Cook, J. T. Willmore, W. Radclyffe, John Pye, Robert Brandard, J. B. Allen and E. Goodall.

Some of the best of Turner works were produced in the famous 'Liber Studiorum', a work consisting of a series of 70 plates which was published in fourteen parts between 1812 and 1819. The title of a few of these plates are 'Marine Dabblers', 'The Bridge and Cows', 'Penbury Mill Kent', 'Raglan Castle', 'Coast of Yorkshire', 'London from Greenwich', 'Watercress Gatherers' and 'Calm'.

Abraham Rainbach was another 19th century engraver whose work was much appreciated. We have used his 'Village Politicians' to illustrate his lively interpretation of Wilkie's pictures. He also engraved 'The Cut Finger', 'The Spanish Mother and Child', 'The Errand Boy', 'The Parish Beadle' also after Wilkie.

Collectors interested in topographical line engravings will find excellent examples by engravers and artists not mentioned in this chapter. They are far too numerous to do so, but here are a few suggestions—J. Boydell, R. Havell, W. H. Bartlett, T. Allom, William Westall, Thomas Shepherd.

Mezzotints

Mezzotint plates produced particularly beautiful prints capable of fine tonal graduations, and because of this particular quality, they were ideally suited for portraiture.

The earliest mezzotint was produced in 1642. The inventor of the process was Ludwig von Siegen, an officer in the service of the Landgrave of Hesse-Cassel. No doubt he spent some time perfecting his technique but the first mezzotint known to have been produced was a portrait of Princess Amelia Elizabeth, Landgravine of Hesse. In 1642 Von Siegen sent a copy of this portrait to the Landgrave of Hesse, stating that it had been produced by an entirely different manner.

Von Siegen seems to have retained the secret of his invention for about twelve years. In 1654 he met a kindred spirit in Prince Rupert, also a soldier and lover of the art of engraving, in Brussels. Von Siegen gave Prince Rupert the secrets of his process, who became so enthused with the technique that he enlisted the technical aid of Vallerant Vaillant, a Flemish painter.

Vaillant was one of the first artists to use the process and some of his early portraits are particularly fine.

The introduction of mezzotint engravings to England can be dated about 1660, when Prince Rupert returned after the restoration of the monarchy. He demonstrated this new process to John Evelyn who published his 'Sculpture' in 1662 crediting Prince Rupert as the author of the invention.

34

Plate 20. From an Original Picture of Marlows. Engraved by Peake after Marlow. 13½ × 10½. Published in 1777. (Photo. D. C. Gohm).

The earliest plate engraved in England is believed to be that of Charles II by William Sherwin in 1669, and from its introduction it quickly became an accepted method to be further developed by William Sherwin, Francis Place and others. During this period many experimental techniques were employed to produce the 'ground' including the use of roulettes and other burr raising tools, together with etching and dry point. One early method of burr raising was the use of the steel roller, cross hatched something like the wheel of a modern gas lighter, this tool was rolled across the copper plate in a similar pattern to that when employing a rocker. It is considered that very early mezzotints had their grounds laid in this way. About 1672, the well known Dutch line-engraver Abraham Blooteling came to England and became interested in this relatively new approach to engraving. Eventually he became one of the best exponents of ahe art. In fact Blooteling is credited with being the inventor of the rocker. (See Styles Mezzotint).

The next major step forward was made by George White when he developed the technique of first outlining the subjects by etching, and then laying the ground over the etched subject. Most mezzotint engravers adopted this method soon after its innovation.

Blooteling undoubtedly was the first mezzotinter of any importance in England, but soon comparable results were being obtained by other Dutch mezzotinters domiciled in London. These include Van der Vaart, Paul Van Somer, and Gerard Valck.

Another great name associated with this period is Isaac Beckett. Most of his work was done between 1681 and 1688, his prints which were numerous may not be desirable by modern collectors, but they are of considerable interest historically, representing as they do, the beginning of the art by English engravers. Beckett's masterpiece is said to be 'Lady Williams' after Wissing.

John Smith (1652–1742) a pupil of Beckett takes us into the eighteenth century. He is reputed to have been the greatest mezzotinter of his period, most of his work was portraiture, and included portraits of Arabella Hunt, Godfrey Kneller, Isaac Beckett, Duchess of Grafton, and a great many others. In fact he interpreted 138 portraits from one artist alone, namely Kneller.

Other mezzotinters of this period worthy of mention include John Simon working approximately from 1707 to 1742 producing some 200 portraits; John Faber working from 1712 to 1756 producing some 500 prints; Peter Pelham who took the art to America and Peter Van Bleeck and Alexander Van Haecken who were also painters. James MacArdell, born in Cow Lane, Dublin, somewhere about 1729, engraved mezzotints after such great artists as Sir Joshua Reynolds, who paid him the wonderful

Plate 21. The Strand. By and after T. S. Boys. A coloured lithograph. $12\frac{3}{8} \times 16\frac{7}{8}$. (Parker Galleries, London.)

compliment that he had immortalised him, but MacArdell also executed work after Van Dyck, Rubens, Lely, Ramsey, Rembrandt, and others. He died in London in 1765.

The advancement made over the second half of the eighteenth century was considerable, and it probably represents its most flourishing period, with such famous engravers as John Finlayson, William Pether, Valentine Green, the latter engraving something like 400 subjects. At one time his 'Mary Isabella, Duchess of Rutland' after Reynolds, was sold for over £1,000 but it is unlikely that such a subject would command anywhere near that figure today.

'Flower and Fruit Pieces' after Jan van Huysum engraved by Richard Earlom is a wonderful example of the wide range that mezzotint can offer in the hands of a skilled engraver, and makes a nice change from portraiture. They were produced between 1776 and 1778 and they are very much sought after by serious collectors today.

Two names that took us buoyantly into the nineteenth century were Charles Turner and S. W. Reynolds, their first published works were dated approximately 1794. Charles Turner is reputed to have engraved nearly a thousand prints between 1796 and 1857 when he died. Although much of the early work executed in mezzotint was used to interpret portraiture, the medium was by no means limited to that subject, for example, Charles Turner produced the following titles after numerous artists—'The Ale-House Door', 'The Cottage Girl', 'The Turnpike Gate', 'Beggars', and 'Interior of a Cottage'.

The thread used to illustrate the development of the art of the mezzotint, naturally is a thin one, but it must be remembered that a great many names, no less important than those mentioned, were working to improve the art and contributed numerous prints of high merit for our appreciation today. The Dictionary at the end of this book gives the names of the majority of these, and a list of some of their representational works.

Stipple Engraving

Stipple engraving, fully described under Styles, was practised during the sixteenth century in Europe, and came to England during the mid-eighteenth century. W. W. Ryland is said to have been responsible for introducing the technique into this country, and during his lifetime he produced numerous plates in stipple, many of which were after Angelica Kauffman. Unfortunately Ryland's career ended in 1783 when he was hanged at Tyburn for forging banknotes, although by modern standards of justice the evidence against him was of the flimsiest. Ryland received the appointment of Engraver to the King, and later opened a print shop in partnership with Henry Bryer at the Royal Exchange in Cornhill.

Ryland frequently produced stipple engravings in red ink to simulate

Plate 22. Water Engine Cold Bath. Fields Prison. Coloured aquatint by J. Bluck after Pugin and Rowlandson. $7\frac{3}{8} \times 10$. Published 1808 by Ackermann. (Parker Galleries, London.)

39

crayon drawings. Bartolozzi followed this practice, and the tint became known as 'Bartolozzi red'.

Bartolozzi was born in Florence in 1727 where he studied art with his friend Cipriani the painter. He came to England in 1767, and was elected one of the founder members of the Royal Academy. He became interested in the art of stipple engraving and took the process to its highest form and founded the school.

His earliest works were after his friend Cipriani's designs and the paintings of Angelica Kauffman. So successful was Bartolozzi stipple prints, that eventually approximately 2,000 plates carried his name. This did not mean that he actually engraved all of these plates personally, many were the work of his pupils—Ogbourne, Cheeseman, and Tomkins to mention just three.

Bartolozzi prints cover a wide range of subjects—historical, portraiture, classical, scriptural, fanciful, and allegorical. His stipples in colour are the most prized, but today the desire to collect such subjects is not strong among collectors. Bartolozzi left England in 1802 and went to Lisbon, where he assumed charge of the National Academy and in 1815 died there.

Peltro William Tomkins, one of Bartolozzi's pupils, produced many plates of considerable charm. He also was known for work in connection with book illustrations, examples of which occur in 'The Stafford Gallery'. He died in 1840.

Probably the best known stipple engraving executed by Thomas Cheeseman is the print of Lady Hamilton seated at a spinning wheel, after Romney. It is entitled 'The Spinster' and is dated 1789. Other notable works by Cheeseman include 'The Songstress' by and after Cheeseman, 'General Washington' after Trumbull. 'Death of General Montgomery' after Trumbull. 'The Ladies Last Stake' after Hogarth dated 1825.

Robert S. Marcuard was another of Bartolozzi's pupils who gained a reputation for his mastery of stipple, examples of his work worthy of collecting, if only as a representation of the period, are 'Count Cagliostro, the Alchemist and Sorcerer' after Bartolozzi, published in 1788, 'Nymph with a lamb' after Angelica Kauffman printed in colours, and 'The Shepherdess' published in 1786. He also produced some portraits after Reynolds, etching the shadows rather more deeply than was customary among his contemporaries.

By now stipple engraving had proved its worth as an interpretative medium in the hands of competent engravers and English painters of the period discovered that their works, translated into stipple soon became very popular, consequently they sought craftsmen skilled in the art to popularise their paintings.

Stipple prints were printed in colours other than 'Bartolozzi red'; black,

40

Plate 5. View of Teignmouth from Shaldon by T. Sutherland after T. Fidlow (16 × 10¼) Aquatint.
Plate 6. The Wellington Pavilion, Dover by and after W. Burgess. Published 1839. (17⅝ × 11¾)
Lithograph.

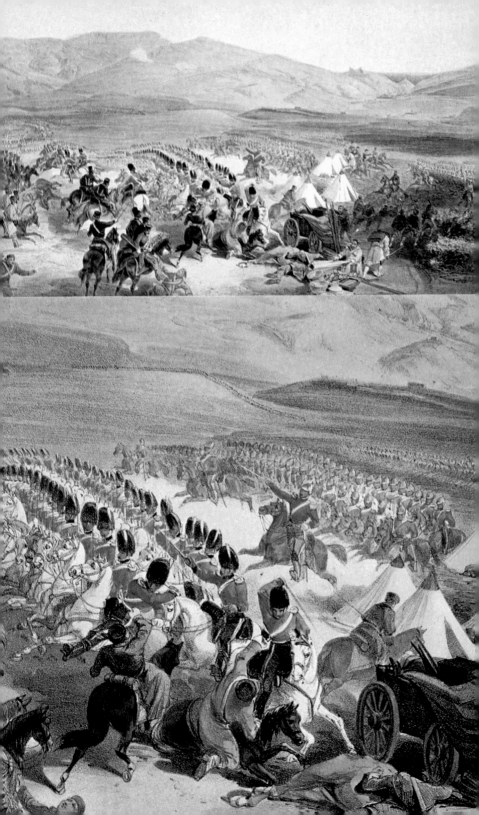

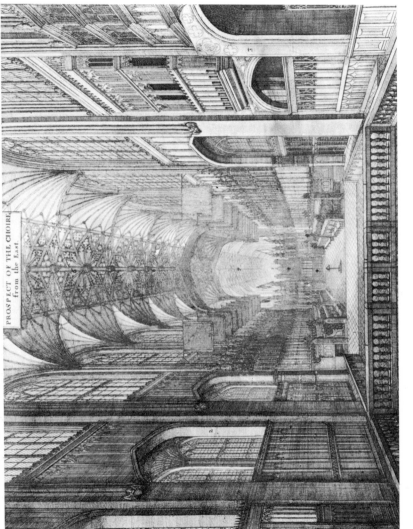

Plate 23. Prospect of the Choir from the east. By and after W. Holler. $12\frac{7}{8} \times 10\frac{1}{8}$ (an etching). (Parker Galleries, London).

PROSPECT OF THE CHOIRE from the East.

41

Plate 7. Charge of the Heavy Cavalry Brigade 25th October, 1854 by E. Walker after W. Simpson. Published 1855. $(16\frac{5}{8} \times 11)$ Lithograph.
Plate 8. Enlarged detail of (3) showing texture of a lithograph.

brown-black, browns and reds, were used also, and by selective colouring of the plate, colour prints were produced.

Stipple engravings are not always executed in dots alone. Many of the engravers were skilled in more than a single style and this led to 'mixed methods' in which stipple, etching, mezzotint and line were all employed in a single plate. Mixed methods of engraving were not restricted to stipple, other plates often combined two or more styles.

Aquatints

The earliest aquatint can be said to date from about 1760, although there is evidence of a few plates produced in part by a similar process some hundred years earlier, they can generally be ignored in the evolution of aquatints.

The process involved in the making of aquatint plates has been covered under Styles. The process originated in France but it is almost impossible to credit a single engraver or artist as the specific inventor, but Jean Baptiste Le Prince is the somewhat disputed inventor, his earliest plates date from 1768. Also about this date Cornelis Ploos van Amstel, a Dutchman, and Per Gustav Floding, a Swede were using the principle of etching through a porous ground.

Paul Sandby, the English watercolour artist, is credited with the invention of the spirit ground, and in 1775 he published a beautiful series of aquatints entitled 'Twelve Views in Aquatinta from Drawings in South Wales'. These were Sandby's first plates, but he also produced 'Chepstow Castle' and 'Encampment in Hyde Park' 'Encampment on Blackheath' 'Encampment in St. James's Park' and 'Encampment at the Museum Garden', these were produced in 1780.

Aquatints can of course be used to reproduce any subject matter but it is a process that is particularly suited to the representation of topographical views, seascapes, architectural subjects, and military and sporting events. Today aquatints of any quality are well sought after by collectors with a liking for beautiful tonal effects so typical of the process.

Francis Jukes, an engraver of considerable ability, executed much of his work in aquatint covering a great variety of subjects, a pair 'Courtship' and 'Matrimoney' produced in 1787, after W. Williams, and published by J. R. Smith, were once very collectable items, but collecting habits change and it is unlikely that they are in any real demand today. Nevertheless, Jukes did not restrict himself to this type of subject and it is likely that the following examples of his work would command a good price—a set of four aquatints 'The Essex' 'East Indiaman' after T. Lury published 1785; 'Baldock Mill, Hertfordshire' after Chapman; a set of four aquatints 'Views of Toulon' after Knight; and of course 'The Pytchley Hunt' after C.

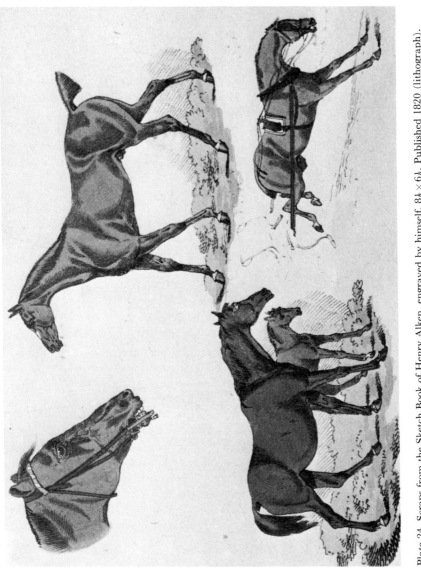

Plate 24. Scraps from the Sketch Book of Henry Alken, engraved by himself. $8\frac{1}{2} \times 6\frac{1}{2}$. Published 1820 (lithograph). (Parker Galleries, London.)

Lorraine Smith, a series of eight beautiful aquatints first published in 1790. 'Vauxhall Gardens' after Rowlandson was aquatinted by Jukes, and engraved by R. Pollard a somewhat unusual combination of three great names joining their artistic abilities to produce a single plate.

Rowlandson was, of course, a celebrated designer and etcher, and much of his work was directed towards books, but his style of artistry lent itself admirably to the treatment by aquatint. Thomas Rowlandson would often etch a plate himself and let some other engraver, Jukes for instance, execute the aquatinting, indicating the various tones by washes. When the process reached the proof stage, he would then colour an impression as a guide for the colourist. The majority of aquatints were hand coloured in watercolours, often tinted to standards set by the colourists, but Rowlandson preferred to dictate much of the colour of his work, that is why his originally coloured prints have a consistency of tone often lacking in other prints.

One cannot talk or think about aquatint engraving without mentioning Rudolph Ackermann, the publisher. He was born in 1764 at Stolberg, but operated from 'The Repository of Arts' in the Strand from 1796 to 1834 when he died. He did much to encourage that art of aquatint and he published a large number of books illustrated by this process, the majority of which were coloured.

These plates were often detached from a book and sold separately. In fact, it is most likely that almost any aquatint published by Ackermann, had its origin in a book. The most prized today is undoubtedly the 105 plates from his 'Microcosm of London' published in 1809, by Pugin and Rowlandson, and aquatinted by J. C. Stadler, Sutherland and Bluck.

It is not possible to mention every notable artist and engraver skilled in aquatint, these have been collected elsewhere in this book, but a few names worthy of examination include Daniel and Robert Havell, working in London between 1800 and 1840; F. C. Lewis; J. C. Stadler, a German engraver of great industry; M. Dubourg who worked in London at the beginning of the nineteenth century, and died in Amsterdam in 1745; collectors of military subjects should seek aquatints by this engraver. James Malton; Thomas Malton; R. G. Reeve; C. Bentley; W. Bennett; J. Hill and G. Hanley are just a few of the great men who provided such beautiful records of their time for our pleasure in our time.

Lithographs

Lithography was first practised in Britain sometime between 1818 and 1820, although it was used as a means of reproduction many years earlier on the continent. The credit for its invention goes to Senefelder of Germany, who discovered the process in 1796, almost by accident. Alois Senefelder was a native of Prague, but at that time he was a resident of Munich. It was the French who first saw the possibilities and exploited the medium, and

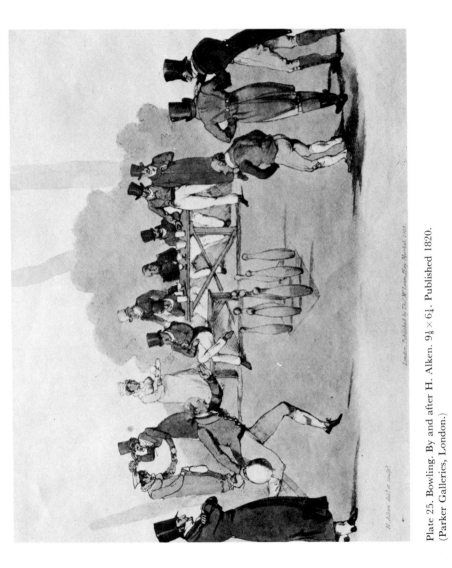

H. Alken del.t et sculpt.

London, Published by Tho.s M.Lean, 26 Haymarket 1820.

Plate 25. Bowling. By and after H. Alken. $9\frac{1}{8} \times 6\frac{1}{4}$. Published 1820.
(Parker Galleries, London.)

during the very early part of the nineteenth century, it had already become an established art there. Examples of this period were produced by Auguste Raffet, Eugène Delacroix, Horace Vernet, and A. G. Decamps, and Théodore Gévicault, whose subjects from English life were printed in London in 1821 by Charles Hullmandel.

Charles Hullmandel, the son of a musician, first practised lithography in 1818. He obtained the process direct from Senefelder of Germany, and became the great lithographic printer of the period. It is claimed for Hullmandel that he was the inventor of the lithotint, a process which involved applying the various coloured inks to a stone by brush. Some of the best, and certainly most prized works are those by J. Shotter Boys, his original views in London are among the best ever executed, just as attractive, but perhaps not quite so sought after in England, are his 'Picturesque Architecture in Paris, Ghent, Antwerp, Rouen' etc. after David Roberts and others in 1839.

James Ward, the well known animal painter, lithographed fourteen famous horses, one of which was 'Copenhagen', the charger used by Wellington at Waterloo, this print is dated May 1824. T. S. Cooper, famous for his studies of cattle produced a beautiful lithographic print titled 'Distant View of Canterbury Cathedral' dated 1833.

Samuel Prout, whose architectural watercolours are highly esteemed by some collectors, executed many exquisite lithographs of building, both in England and on the continent. Prout (1783–1852) was born in Plymouth, and his bold, very controlled style lent itself admirably to the art of lithography, his works include 'Sketches in France, Switzerland, and Italy' and 'Facsimiles of Sketches made in Flanders and Germany'.

Some of the best known artists of this period (the early nineteenth century) who worked on the lithographic stone, and well worth the attention of the collector are J. S. Cotman, David Roberts, David Cox, Thomas Barker, Henry Bright, James Duffield Harding, and Joseph Nash whose 'Old English Mansions' are highly prized.

Although most collectors of prints concentrate on examples that show the way of life that existed between the seventeenth and eighteenth century, including transport, industry, sport and so on, they are primarily concerned with the factual history that is so well illustrated in the print. There are, however, a wealth of wonderful examples that do not specifically represent any event, place or time and these can loosely group as decorative, romantic or classical, for example—Charles H. Shannon's 'A Little Apple', 'Mother and Child', 'The Three Sisters', 'The Infancy of Bacchus', H. Baron's 'Les Pècheuses' etc. A more detailed survey of classical artists will be found under the 'Dictionary of Engravers'.

Undoubtedly the best prints for modern collectors are those of coaching,

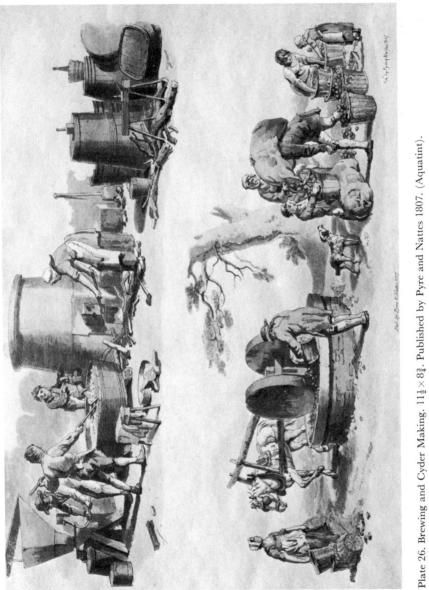

Plate 26. Brewing and Cyder Making. $11\frac{1}{2} \times 8\frac{3}{4}$. Published by Pyre and Nattes 1807. (Aquatint). (Parker Galleries, London.)

shipping, early railways and sports. Coaching prints of any value were usually aquatinted, but not exclusively so, for example 'L'Arrivee a St. Roch' showing coaches arriving outside the church for mid-day Mass, by and after V. Adam, published about 1835. 'Post Chaise' showing the chaise at full gallop, after V. Adam. Published about 1840. 'Diligence' showing a French Royal Mail diligence, by Delpech after Aubry. Published 1823. 'The Dover Day Mail on its way up, passing St. Johns Hole, near Dartford' by J. H. Lynch after W. J. Shayer. Published W. Spooner 1841.

The illustrations 'The Hon. Philip Pierrpont aet 61. A.D. 1847' drawn on stone by E. Walker, is another typical 'sporting' litho.

Prints of sailing ships have always been a favourite subject for collectors, and consequently they are difficult to find, and will invariably be found to be expensive. A sailing ship with billowing sails, cutting through a turbulent sea arouses the spirit of adventure in most men, and the sailing print captures the fascination of the sea with true authenticity.

T. G. Dutton, a famous name in marine lithography, executed many original works, a few examples include 'Port view under sail off Margate, under the command of Captain Close'. Published by W. Foster about 1850; 'Port view at sea. Outward bound. January 1869' showing the tea clipper 'Kaisow'. Published by W. Foster 1869; 'The start off Sandy Hook, depicting the yachts 'Henrietta', 'Vesta' and 'Fleetwing'. Published by W. Foster 1867. (See illustraton.).

Other marine lithographers worthy of attention are L. Haghe; T. Picken; J. Solomon and J. Boydell.

The majority of prints showing warships and naval battles were produced from copper or steel plates and aquatints, but a few can be found lithographed. If these happen to be your interest it will be more profitable to explore prints produced by these techniques.

For sporting enthusiasts lithographs will prove very limiting, the majority of these were either aquatinted, or engraved on copper.

American lithographs date from 1819–20 and to the collector who is fortunate enough to find any in Britain today, will soon discover that American life has been well documented by the process. Even in those days American commercial interests gave impetus to new ideas, and lithography was no exception, exploitation for profit motivated a prodigious output of prints then in popular demand. The most famous printers of this period were undoubtedly Currier and Ives, but there were also many other printers producing excellent work.

American railway prints are highly prized, especially those depicting accurate drawings of engines. Early locomotive prints were, in fact, executed with engineering precision, and were used by the engine manufacturers as advertisements.

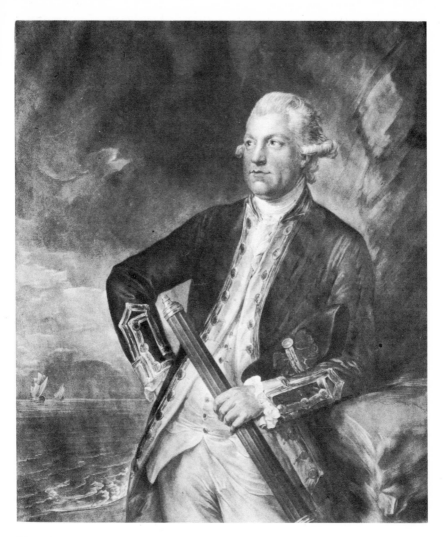

Plate 27. Sir Charles Thompson, Baronet, Vice-Admiral of the Red. By R. Earlom after Gainsborough. 11 × 13. Published 1799. (Coloured mezzotint.) (Parker Galleries, London.)

Closely connected to the actual locomotive print we find a host of viaducts and bridges that combine pictorial views with constructional details that are appealing for their reflections of the robust days of pioneering. 'Portage Bridge' produced from a drawing by J. Stilson in 1865 is such a print.

American naval lithographs and ship portraits appeared from about 1830, and were very popular subjects for artists, engravers, and lithographers. The 'Delaware' a much drawn ship was lithographed entering America's first dry dock at Gosport Yard in 1836, it was the subject of a pair of lithographs after J. G. Bruff, published by Childs and Inman. The publishing house of Currier & Ives, together with many others, printed a wide variety of worthwhile prints, but unfortunately they are scarce, and difficult to find in this country.

Colour Prints

Colour prints are not to be confused with hand coloured prints. Coloured prints are simply engravings to which watercolours have been added to enhance their appearance. Colour prints are those produced by printing with coloured inks direct from the block or plate.

The technique of colour printing is not new, the subject of colour has naturally interested artists for centuries, and it is therefore not surprising to learn that the Chinese produced colour prints of birds and flowers from wood blocks sometime prior to 1670!

Early examples of colour printing can also be found on playing cards. Card playing was a popular pastime in Spain, Germany and Italy during the sixteenth century and the makers of these cards or tarots of seventy-eight cards produced many exciting examples.

Colour prints of the eighteenth century may well interest the print collector as an expression of the period, but it is unlikely that many will be found reflecting the original brilliance of colour, although there is still a reasonably wide field of collectable items.

Early examples of colour prints using coloured inks and copper plates are so rare that the modern collector cannot hope to acquire any impressions of these, but it is interesting to note that line engravings, printed in colours from a single plate, were produced as long ago as 1670–80 by Johannes Teyler of Nymegen, Holland.

The real beginning of eighteenth century colour printing can be attributed to Jacob Christopher Le Blon, a German painter, who was born in Frankfurt in 1667. He studied painting in both Rome and Zurich, and finally settled in Amsterdam in the year 1702.

About this time, 1704 to be precise, Newton published his theory of the composition of light, showing how it could be split into the three primary colours of blue, red and yellow. Using this new found knowledge, Le Blon

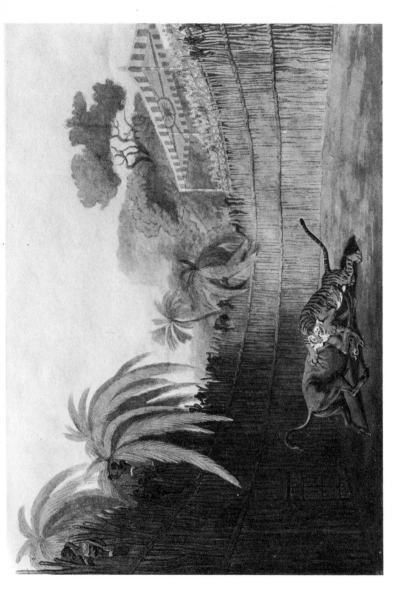

Plate 28. Exhibition of a Battle between a Buffalo and a Tiger. By H. Merke after S. Howett. 16¾ × 11¾. Published 1819. (Aquatint.)
(Parker Galleries, London.)

51

produced a three colour process using three copper-mezzotinted plates, one for each primary colour. Soon afterwards he added a fourth plate for black. The plates were inked with their appropriate colour, and the impressions superimposed, one upon the other in accurate register. In 1719 Le Blon came to London and secured a patent for his process. In 1721 a company was formed with Le Blon as its Managing Director, and prints were issued for sale after paintings by Van Dyke, Guido Reni, Titian, Baroccio and others, but despite this promising start, Le Blon had no head for business, and eventually he had to leave England, eventually to die in Paris in 1741. Prints by Le Blon are now rare.

William Wynne Ryland, born in London during 1732 issued his stipple engravings of 'Domestic Employments' in the year 1775. These were from a single plate, printed in red and blue from his own drawings.

In 1776, Robert Laurie, a mezzotint engraver, developed a process of printing from a single plate, and from about 1775 to about 1815 the majority of English colour prints were produced from a single plate.

Using a watercolour drawing as a guide, the printer would select a colour that occurred most in the drawing, and then cover the surface of this plate with this colour. The colour was then wiped away from the areas where it was not required, and replaced by the addition of various coloured inks in the areas dictated by the master watercolour. Carrying the basic ground colour through the whole design had the effect of uniting the various colours in pleasing harmony. This work must have been somewhat laborious for the printer, because he had to colour the plate in this way for every impression taken, consequently no such two colour prints are ever identical. A final touch here and there with watercolour was often added to the print to 'lift' a passage of colour, or to define a small area such as on the lips and the iris of the eyes. This was the period when the colour print was in high favour and at least a few should be included in any collection to represent one of the most exciting periods in the evolution of colour printing. For example there are many classical and interesting stipples after Angelica Kauffman, engraved by Ryland and Bartolozzi, including 'Psammetichus and Rhodope'; 'Rinaldo and Armida', 'Venus attired by the Graces'; 'Wisdom'; 'Paris and Œnome'; 'Cupid punished by the Graces'; 'Eloisa, and Cyman and Iphigenia'. Bartolozzi's output of colour prints was prodigious, and it is said that their number was in excess of 2,000 covering many subjects. Ryland who was one of the most celebrated engravers was not quite so prolific, but his work was of the highest quality, and may well have equalled Bartolozzi's output if he had not been hanged for forgery in 1783.

Early stipples of 'The Cries of London' after Wheatley are now rare. It is true that this series is continually cropping up in salerooms all over the country, but these are invariably reproductions lacking the finely

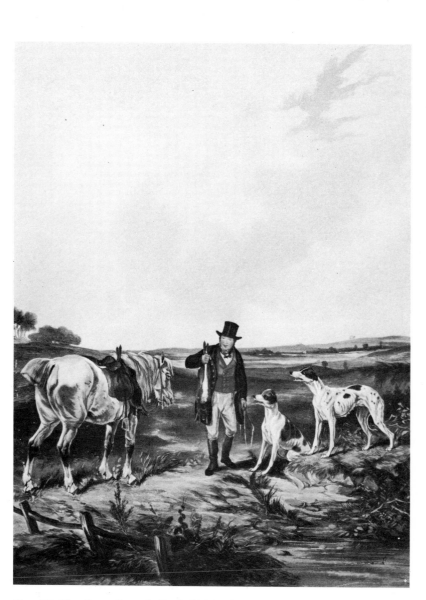

Plate 29. The Game Secured. By J. Harris after W. J. Shayer. Coloured aquatint.
$13\frac{1}{2} \times 18\frac{3}{8}$. Published by Ackermann. 1830.
(Parker Galleries, London.)

53

printed colours of the early issues. This series has probably been reprinted, reproduced, copied and reproduced more than any other series. The rarest of the originals is 'Turnips and Carrots' by Gaugain. Aquatint as a baiss for colour printing was rarely used during this period, and when it was used it was usually restricted to two colours.

Lithographic stones, and later aluminium plates, have also been used to produce colour prints, but as these lack the quality of antiquity they do not usually improve the collection.

Baxter Prints

Baxter prints are not, at the present time, collected so widely as other types of prints. This is rather surprising because they form a compact group, well catalogued, and restricted to a relatively short period.

George Baxter, the second son of John Baxter, a Lewes printer, was born in Lewes Sussex in 1804. His early history is a little obscure, but we know that he illustrated books for his father sometime prior to 1827. At the age of 23 he journeyed to London to become the apprentice of a Mr Williams a wood engraver, and after being with this gentleman for only short time, he left to set himself up as a wood engraver. His address—Blackfriars Road. 1827 was an eventful year for young Baxter, it saw him on the threshold of the beginning of a career that was to make him famous, and it was the year he took himself a wife. She was Mary Harrild, the eldest daughter of a Mr Robert Harrild. Soon after his marriage he removed to 29 Kings Square, from which he issued his first colour prints.

Undoubtedly the prospects of producing prints in colour in quantities and at prices within the reach of most of the population, fired Baxter's imagination. He was a competent wood-block engraver, and from now on he constantly worked at improving his technique eventually evolving the process that was the subject of his patent.

Baxter's few early prints were printed from wood block and the earliest known print is 'Three Butterflies', now extremely rare.

Circa 1835 Baxter again moved his business premises, this time to Charterhouse Square, and some years later he removed once again to 11 & 12 Northampton Square.

Up to 1835, the majority of Baxter's prints were produced as book illustrations, and it was about this time that he introduced the steel plate as the master plate.

It is doubtful if Baxter ever profited financially from his work, there is evidence that he was always in financial trouble, culminating in 1865 in bankruptcy.

Baxter licensed his process to a number of other printers, the best known of these being Abraham Le Blond. Le Blond actually produced prints from Baxter's original plates and blocks which he obtained from Vincent Brooks

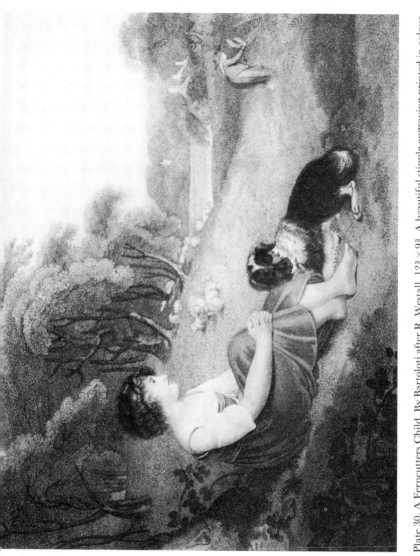

Plate 30. A Ferncutters Child. By Bartoloti after R. Westall. $12\frac{3}{8} \times 9\frac{3}{8}$. A beautiful stipple engraving printed in colour. (Parker Galleries, London.)

sometime after the death of Baxter in 1867.

Liceneses who produced Baxter-type prints were:

Bradshaw and Blocklock

William Dicker

Kronheim & Co.

Abraham Le Blond

George Carhill Leighton

Joseph Mansell

Myers and Co.

After the expiration of Baxter's patent, other printers produced prints by his process, these were:

George Baxter Jnr.

Vincent Brooks

Edmund Evans

Benjamin Fawcett

Gregory, Collins & Reynolds

Leighton Bros.

Moore & Crosby

William Russell.

For the process used by Baxter see under 'Styles'. The majority of his prints are listed in the Dictionary.

Plate 9. Cartouche of map of Surrey by Jan Jansson, 1659.
Plate 10. Cartouche of map of Cumberland by Joan Blaeu, 1648.

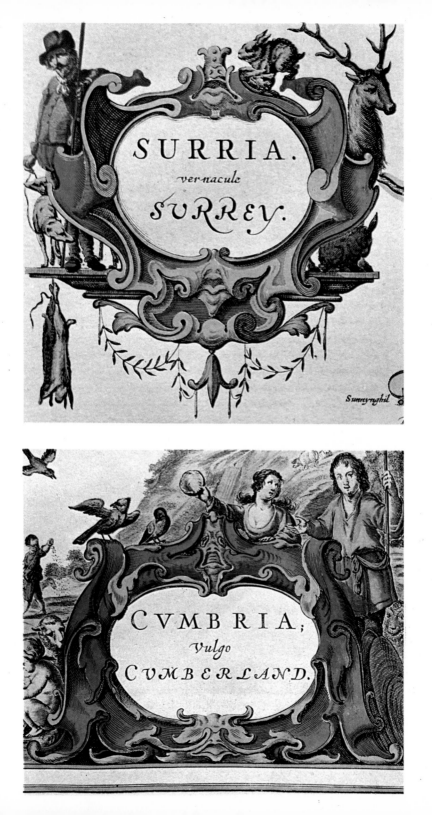

SURRIA.
vernaculè
SURREY.

Surreynghil

CVMBRIA;
vulgo
CVMBERLAND.

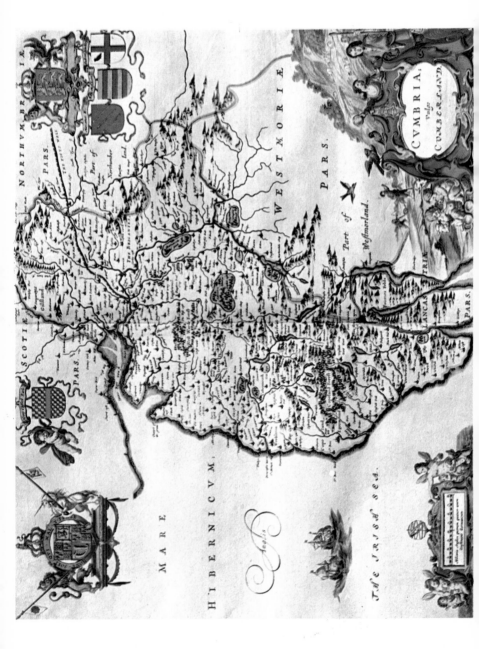

CVMBRIA;
vulgo
CVMBERLAND.

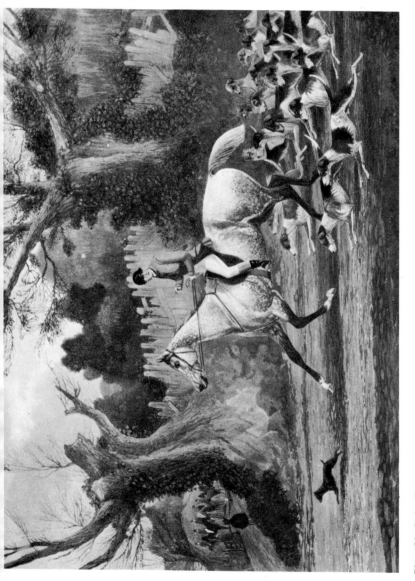

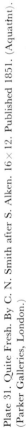

Plate 31. Quite Fresh. By C. N. Smith after S. Alken. 16 × 12. Published 1851. (Aquatint). (Parker Galleries, London.)

Plate 11. Map of Cumberland by Joan Blaeu, 1648 (*Richard A. Nicholson*).

3 Paper

It is necessary to know something about paper, and collectors of prints automatically acquire some knowledge by their frequent handling of the material. The paper mark visible when holding a sheet of paper up to a strong light, was impressed into the paper during manufacture, by wire, or thin brass formed into the required design and attached to the wires of the mould. The paper in close proximity of the design was therefore thinner, and is more translucent.

It is well known that education during the middle-ages and even later, was not for the masses, consequently not many people could either read or write, so signs had to do the intelligence work, hence the shop signs, barber's pole, public house signs and so on, into paper making, where the manufacturer used a device or trade mark impressed in his paper.

The lines seen on some old paper can give a rough indication of period—from about 1480 they were about $2\frac{1}{2}$ inches apart, or narrower, but prior to this date, they were much wider.

The 'Open Hand' paper mark was in use about 1483, 'Post Horn' about 1670, 'Fleur-de-lis' about 1657, and the 'Cardinal's Hat' dates from about 1649.

Most of the old hand made papers were coarse, and often of uneven thickness, but from 1801 the machine made papers made their appearance, being much smoother and of a more even thickness.

With the advent of machine made papers, it did not mean the disappear-

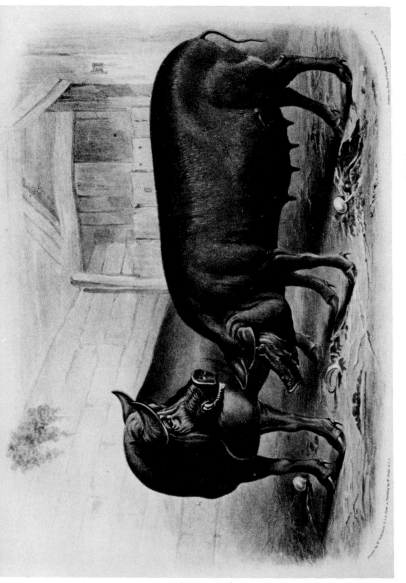

Plate 32. Neapolitan Breed. By Nicholson after Shield. 13 × 10. Lithograph. Published 1842. (Parker Galleries, London.)

ance of the wire mould lines, these were still produced in imitation of the earlier hand made papers, and from about 1815, bleached papers had arrived.

This brief introduction to paper is not exhaustive, indeed, paper, and its history is sufficiently diverse to form a complete study in its own right, and whilst some knowledge is essential for print collecting, experience is going to be your best guide in the end.

4 Proofs and States

It has been mentioned elsewhere in this book that any plate, irrespective of the style of engraving, will wear progressively as impressions are taken of it. It is a statement of the obvious, but it is made to illustrate the fact that early impressions are naturally the sharpest, and have the cleanest and best defined lines. As the plate wears the lines become less distinct and some of the finest details will disappear altogether.

When an engraver is working on a plate, he is invariably working to a mirror image of the final design, working 'in reverse' as it were to provide the negative block. As he proceeds the subject is developed by engraved lines visible in form, but flat and uncontrasting, therefore, to check his work the engraver will take off a single impression on paper, from this impression he can ascertain any necessary corrections. Technically these trial impressions are 'proofs' taken with the object of proving the progression of the engraving and they are an integral part of the process of plate making.

A state defines the condition of a finished plate, or its state at any given time. For example, a first state impression may be printed and issued, sometime later it may be re-issued, but prior to printing the engraver may make some small alteration to the detail, impressions from the modified plate would be referred as 'Second State' and so on. Although there is a somewhat hazy distinction between state and proof, they are in practice almost interchangeable, as they both denote the 'state' in broad terms.

A '*Remarque proof*' is so called because it has a remarque or small sketch

61

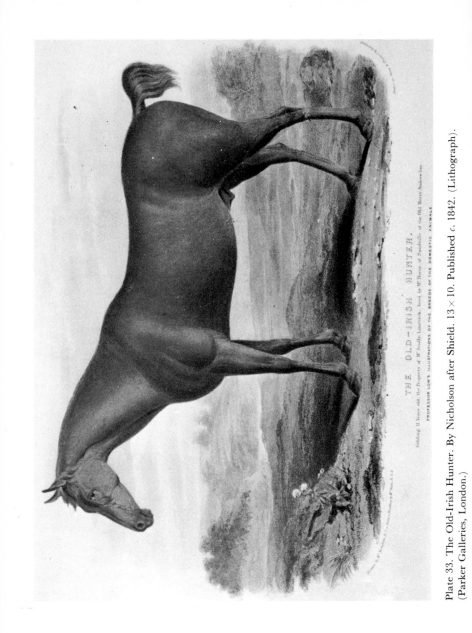

THE OLD-IRISH HUNTER.

Gelding 11 Years old. the Property of Mr Scully Limerick. bred by Mr Burns of Sandville of the Old Mare Andrew line

PROFESSOR LOW'S ILLUSTRATIONS OF THE BREEDS OF THE DOMESTIC ANIMALS

Plate 33. The Old-Irish Hunter. By Nicholson after Shield. 13 × 10. Published *c.* 1842. (Lithograph). (Parker Galleries, London.)

etched or engraved on the lower margin, these sketches were invariably appropriate to the subject matter of the print. Remarque proofs also carried the signature of the artist if he was alive, and the engraver, in pencil, on the left and right of the lower margin. The title of the subject was omitted.

'Artists Proofs on India Paper' often followed the Remarque proof. These were proofs taken on a very thin paper made from the inner fibres of bamboo. This paper had a soft, fine grained texture capable of taking the finest detail. Because of its thinness, it is pasted to a stronger paper for support. Artists proofs may be produced 'before all letters' that is without title, engravers or artists name etc. but they may well be signed in pencil by the artist if living and the engraver. An artists proof 'before letters' will not have its title, but could carry the name and address of the publisher on the lower margin. The next set of impressions may be simply 'Artists Proofs' the only difference being that the impression is taken in plain paper instead of India Paper.

Proofs before letters have a completely blank lower margin except that the names of both the engraver and artist is printed on the left and right of the margin immediately below the picture.

The next stage in the progression is 'Open Letter Proofs', these are proofs to which the title has been added to the lower margin but in outline only, such proofs usually have the artist's and engraver's name, together with the name and address of the publisher.

Finally we have fully lettered impressions, that is the print in its final form, these can be on India paper or any other paper.

The various proof stages outlined represent the possibilities but not all prints go through these individual stages, some are skipped entirely depending on the needs of the engraver and prevailing circumstances, but it will be seen that proofs represent the various progression stages in the production of the plate and the final proof stage indicates that the plate is ready for the press to produce prints in a 'First State' condition.

First State prints made when the plate was new obviously will give the finest detail and when the plate has been worn considerably it is easy even for a collector new to the subject to detect these late pulls by the frailty of some lines or their disappearance entirely, but the various states of the majority of collectable prints can only be ascertained by experience and recourse to works of reference.

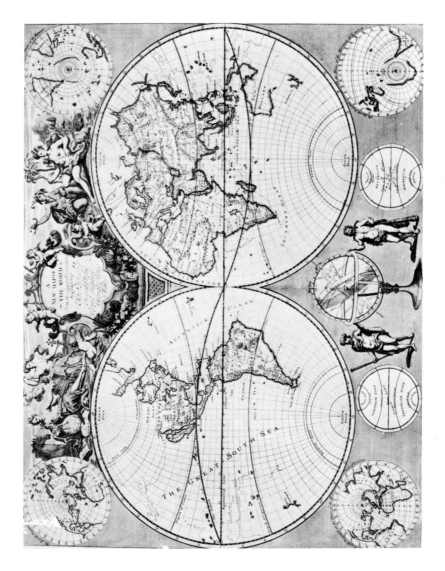

Plate 34. Map Showing both Hemispheres. By John Senex, 1721.

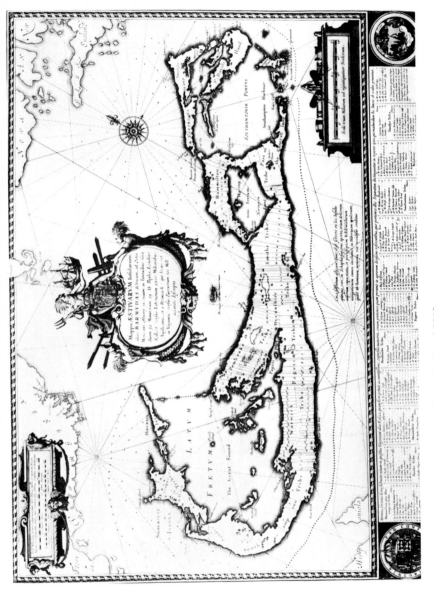

Plate 35. Map of Bermuda. By Joan Blaeu. Published 1646.

65

5 Mounting

Prints are undoubtedly shown to better advantage when they are taste-
fully mounted. Even if there is no intention of framing, the mount will
protect them from one another in the portfolio, and allows them to be
handled by friends without being actually touched.

Prints should never be 'laid down', that is pasted down all over and
attached to a board support.

One of the best methods of mounting is by using an overlay. This
consists of a backboard of strong card, with a hinged front in which a
window is cut to suit the actual picture area and title. The print is attached
to the backboard by means of two small strips of masking tape across the
two top corners, and the front, or overlay, attached to the backboard by
a strip of masking tape along the inside of the top edge. This forms a
hinge, and permits the front to be lifted, and the print to be examined,
both on the front and the reverse.

A final touch can be added by adding a line and wash border to the
mount, but more about this later.

The solid mount consists of a strong backboard of card, to which a
cardboard frame is pasted, forming a box. The print is attached to the
backboard by means of pasted paper hinges in much the same way as
stamp collectors mount their stamps. With this type of mount no part of
the print is covered by the frame.

The window mount is particularly useful for mounting maps that have

text matter on the reverse side of the map. It consists simply of two sheets of similar size mounting boards, with identical size windows. The map can be attached to one board by means of a small strip of masking tape and the second board hinged along the top edge either with masking tape, or by pasting a strip of strong paper in this position. A final protection can be added by making an envelope of cellulose acetate sheet into which the complete mount is slid.

To cut the windows in the mount use a specially sharp mount cutting knife, these are obtainable quite cheaply with interchangeable blades, and a bevelled straight-edge. Mark out the size faintly on the mount with a pencil, then with the blade held at an angle and flat against the bevel of the straight edge, make long firm cuts. The precision of the window cutting will add considerable to the appearance of the mount.

Now if you wish to add a line and wash border, you can mark the lines faintly with a pencil first, or if you are making a number of mounts it will be quicker to make a little jig. The jig is simply a strip of Perspex with holes drilled along the diagonals of the border where the two lines meet. A needle is then used to prick tiny holes in the mount, through the drilled holes, then all you do is to connect two opposed prick-marks with a ruler and draw your line. Make certain that the needle fits the holes, a sloppy fit will only result in incorrect positioning and the lines out of parallel. To draw the line, use watercolour or sepia ink suitably thinned and a ruling pen. After drawing the lines, fill in the centre two lines with a flat wash of colour paint using a flat camel hair brush, and work from one corner, painting down two sides simultaneously so that the edges always remain wet until finally they meet at the corner opposite to the one started. This will prevent a mark showing on the finished border where you commenced.

One final embellishment can be added to large mounts, this is a thin gold line, see illustration. The cheapest and simplest method of doing this is to obtain a sheet of gold, gummed, tissue thin paper from your mount supplier, and with a sharp razor blade and a straight-edge, cut a thin strip to the required length wet the back, and lay in position on the mount. Mitre the corners for the best effect.

Plate 36. Henry d'Esterne Darby, Esq. By R. Earlom after Sir William Beechey, R.A.
Published 1801. (14 × 18.) Mezzotint.

6 Fakes and Reproductions

The awakened interest in old prints and maps is widespread, and is such that the demand exceeds the availability of good quality prints and where there is a demand, there is always some enterprising individual ready to supply a substitute if the original commodity is unobtainable, hence—the reproduction.

To any serious collector, or student of antiquities reproductions will be disregarded as worthless modern copies, but to someone wishing to decorate a home, hotel, office, or public house the effect will be more important than its origin, and the fact that they are considerably cheaper than an original print is another reason for the steady sale of reproductions.

Modern printing techniques, including the lithographic plate, are used to print reproductions in black and white, and colour. An original print is first photographed and the photographic plate used to make the blocks, therefore the details are accurate, but the colour of printing inks are so different from the original hand painted watercolours that authenticity is lost.

Some printers will endeavour to match or simulate old paper, others are not so fussy. The best reproduction are those printed on simulated old paper in black on white paper, and then subsequently finished in water-colour by a skilled colourist. Naturally hand coloured copies are more expensive than those printed in colour.

The decision to include modern reproductions in a collection must be a personal one. It is of course possible that you may wish to have a copy of

Plate 37. Puffin Shooting. By T. M. Baynes, c. 1830. (Lithograph.) $16\frac{1}{2} \times 11\frac{3}{4}$. (Parker Galleries, London.)

a particular print for reference, and find that an original is beyond your pocket, so you buy a 'repro'. Use it for reference, or decoration, by all means, but do not include it in a collection of originals. Unlike originals, it will not increase in value with time. Surely it is better to have a few well chosen little prints produced over 100 years ago by exquisite craftsmen who were contemporary of their period, even if they only cost a few shillings, rather than a modern, massed produced, mechanical copy.

Reproductions are not fakes, they are sold without any pretentions that they are in any way original, forgeries on the other hand, are made specifically to deceive by making a plate as near to the original as possible. Obviously it is usually a rare and valuable print that is selected for such treatment. It is then printed on paper as near as possible to the original paper and then subsequently stained and aged to give it an added aura of authenticity. It is virtually impossible to offer any advice in detecting these forgeries, every detail will be present, plate mark the same size, and margins. will all confirm with any written description. However, as familiarity with prints progresses, so will your sixth-sense, and experience combine to permit you to 'smell-out' a forgery.

Reprints, not to be confused with reproductions, are not in a strict sense forgeries, neither are they authentic. Many of the old plates produced during the eighteenth century are still in existence and can still give a passable impression if used with old paper. I know a printer who has several old hunting plates, and a wardrobe full of Whatman paper, watermarked 1826 and I have seen impressions taken from these, but it is obvious to the experienced eye where passages have been retouched and areas where the impression is almost non-existent indicating a worn plate.

It is not difficult to detect reprints; usually they have been taken from an old plate, but just compare the quality of an early impression with a late one, and you will see a remarkable difference. The fine passages, such as clouds, become very feint, and in extreme instances, will completely disappear, and the strong, bold lines, are proportionally weaker.

Old plates will sometimes have their life extended by being reworked by an engraver, that is the existing lines are virtually re-engraved. If this work is skilfully executed it is sometimes difficult to detect, but it happens quite often that only certain areas are worked and these then become very apparent.

It is doubtful if there are any modern forgers of prints, the work requires considerable skill and time, and there is a shortage of both. Mezzotints and stipple engravings have been produced spuriously for a period, a fact that is well supported by the vast numbers of the 'Cries of London' after Wheatley that are found in almost every auction room, antique dealer and print dealers.

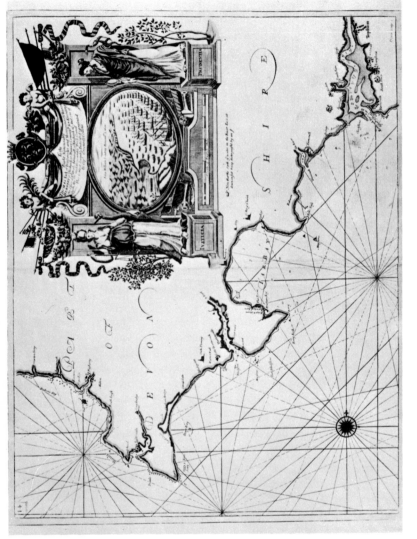

Plate 38. Old Sea Chart. By Captain Grenville Collins. 1693. Torbay, Start Bay and Point and Bigbury Bay. Note large cartouche with scene of King William landing.

Plates 12, 13, 14, 15, A series of 4 showing the various stages of colouring see text "A view of the House of Lords" Published 1822.

7 Restoration

Cleaning, and restoration work in connection with works of art are assumed to be the prerogative of the expert, and generally speaking, this is an accurate assumption. The majority of old manuscripts, and paintings can only be trusted to the skilful and knowledgeable restorer, especially if they are rare and valuable works, but with a little patience and practice the collector can undertake considerable work on his own behalf, and apart from the obvious financial savings this activity will offer, it is also a very self-satisfying pastime that will greatly add to the pleasures of print collecting.

There will, of course, be limits to which any particular print can be improved, depending upon its original condition, and the ability of the collector. In the early, experimental stages, it will be sensible to practice on worthless prints, or those of little value. As proficiency increases the collector will find that prints he refused in the past because of some defect, will become an attractive proposition, more so as they can usually be bought at bargain prices.

Cleaning

A print that has dirt and dust ground into its surface, but is otherwise intact, can be greatly improved by being given a wash in cold water. It is advisable to first remove any loose dust and dirt with a soft camel hair brush, covering the complete surface with short flicking strokes. A rectangular rubber sponge, used dry, will then remove any of the more

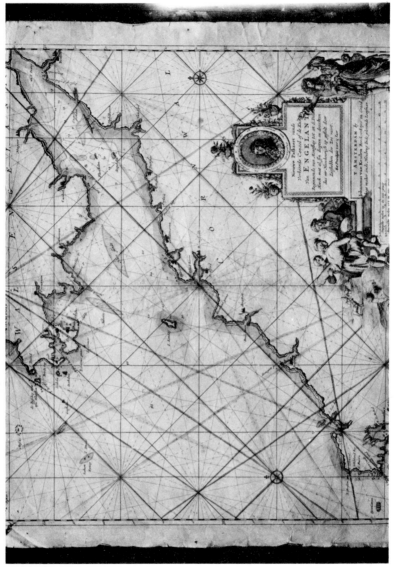

Plate 39. Old Sea Chart. By Johannus Van Keulen, showing the northern coast of Cornwall and the South Coast of Wales.
(Parker Galleries, London.)

74

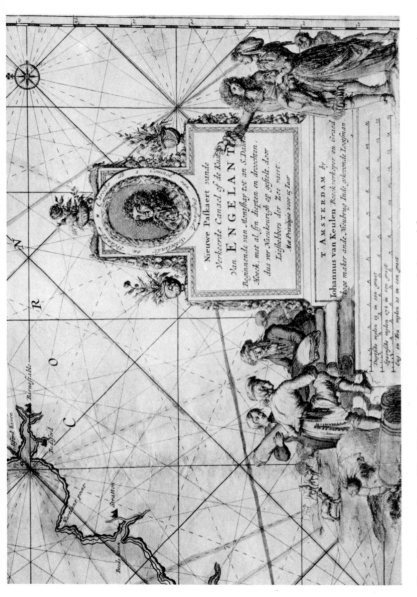

Plate 40. Cartouche on Van Keulen sea chart showing elaborate design and figures. (Parker Galleries, London).

75

persistent particles. Care must be taken not to rub up the surface of the print, use only very light and delicate strokes, *never*, under any circumstances, use an eraser on the inked surface. A very soft eraser, like Art Gum, can be used carefully on the margins and back of the print. An old fashioned, but effective means of lifting out dirt is to use a ball of moist bread. Press the ball onto the print surface and lift, any loose dirt will adhere to the tacky bread, and can be kneaded into the ball to present another clean surface for further applications.

Having dry cleaned as far as it is practical to do so without damaging the print in any way, it may well be that the print is now clean enough. If however, further treatment is required, lay the print on a sheet of glass or plastic covered board, like Formica, and gently flood with tepid water. It is better to pour the water from a cup than to risk the more violent action of a direct stream from a tap. When the paper is really soaked, pour over a cupful of warm water to which has been added about a teaspoonful of liquid soap, and then with the palm of the hand held flat gently work the hand over the print to form a lather. It is important to remember that the paper is very fragile when wet, and the hand should not, under any circumstances, actually rub the paper, the lather should form a film between hand and paper, allowing the hand to pass over the print about $\frac{1}{16}$ inch above the actual surface.

Treat both back and front of the print in the same way, then flood with clean water to remove all traces of soap. Lay the cleaned print flat on blotting paper, or a piece of towelling and allow it to dry naturally.

Remember that a print soaked in water is very much heavier than when it is dry, so be careful not to handle it carelessly or try to lift it by a single corner. Transfer the wet print from the board by laying a piece of material over the board and print, turn the board over, holding the material onto the board by a hand held each end, and then laying it down on a flat surface, remove the board at the same time, gently easing the wet print away from the board.

Removal of Backing Cardboard

Prints are often obtained firmly pasted to a sheet of cardboard, and before any restoration work can proceed this has to be removed. First soak the board in a cold water bath until it has absorbed as much water as possible. Then remove and lay, print down, on a sheet of glass, or a similar flat surface, and carefully lift a corner of the board and peel away from the print.

Never under any circumstances attempt to peel the print off the card, *always remove card from print.*

If soaking in cold water fails to release the adhesive, carefully peel away the board lamination by lamination, until only two laminates are attached

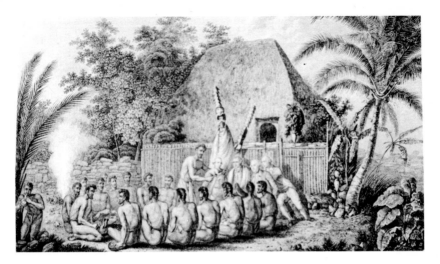

Plate 41. An Offering before Capt. Cook, in the Sandwich Islands. Drawn by J. Webber, figures by Hall, landscape by Middeman. (15 × 8¾.) Line engraving.

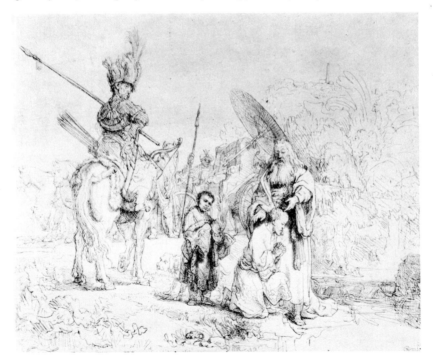

Plate 42. The Baptism of the Eunuch (7⅛ × 8⅝.) Etching by Rembrandt. Signed. 164₁. (Victoria and Albert Museum.)

to the print. Cardboard consists of a number of separate sheets and these can be separated by inserting a knife at the corner. A long flat knife will greatly assist in this operation.

Now return print to the bath and re-soak in very warm water to permit the print and cardboard to expand, then remove, lay card print side down again, on a sheet of glass, and flood the back with near boiling water. The remaining board can now be peeled away carefully. If any areas fail to yield to this treatment, do not force, otherwise you are likely to remove a layer or even tear the print, reflood the area, with boiling water, and peel whilst hot.

If the backing is strawboard, it will not laminate, and can only be removed by prolonged soaking in warm to hot water and carefully rubbing away with the fingers whilst it is still wet. Finally sponge back of print to remove any paste.

Removal of Paper Backing

When prints are pasted onto paper, they will yield if similar treatment is given to them as for removing cardboard, but it may only be necessary to lay the print face down on glass, and to well soak the back with a sponge. Warm water to be used first, followed by further applications at a higher temperature.

Alternatively, lay the print face upwards, in a bath of warm water, and leave until well soaked.

If starch paste has been used and it is particularly difficult to soften, try floating the print face upwards in a bath containing a warm aqueous solution of Parazyme (a starch and protein digestive enzyme mixture). Temperature of water should not exceed 60°C, when using this or any other enzyme.

Removal of Canvas Backing

Prints that have been pasted to canvas fixed to a stretcher, have first to be removed from the stretcher. Insert a sharp knife along the edge and slit all round, then lift off canvas backed print.

The procedure for removing the canvas is much the same as for removing paper backing, but it may not be necessary to actually soak the print in a bath. First try sponging the canvas with warm water, leaving for a while, then gently lift a corner and peel back diagonally across the print, keeping the hand as near to the print as possible, so that the canvas is being pulled back onto itself.

Removal of Varnish

Rarely is it possible to remove oil varnish successfully, even experts fail, but occasionally it is possible to remove spirit varnish, but do not be surprised if your attempts end in failure.

First try turpentine, this should be applied with a pad of cotton wool

that has first been rubbed in the palm of a hand to smooth the surface. This will remove any surface dirt.

There are two solvents we can try, methylated spirits and liquid ammonia (0·88) diluted with water at a proportion of 50 to 1. Try the action of the solvent on a corner of the print before proceeding over the whole print, to ascertain the most suitable strength solvent.

Having chosen the solvent, lay the print, face uppermost on a sheet of glass, preferably in a tray or bath and flood the surface with the solvent. A flat, soft brush, can be used discriminately to help the action. When the solvent becomes stained, pour off, and apply fresh. If the varnish has been removed successfully, the print will be a dirty brown in colour. Wash thoroughly in water and bleach.

Old spirit varnish may not respond to the above treatment, if so, try placing the print on glass, and immersing it in a bath of hot water. Sometimes this will soften the varnish and cause it to come away in flakes.

Bleaching

Prints are bleached to remove large stains, and the overall dirty brown coloration caused by exposure to polluted atmosphere, smoke and stains caused by water. Bleaching should be the final treatment. Always dry clean a print first then remove any stains requiring local attention such as ink, grease, etc. and only when these have been successfully removed and the print thoroughly washed to remove any residual chemicals, should the final bleaching treatment be carried out.

The majority of bleaching agents are more or less harmful to the paper. Therefore, always use the weakest possible solution initially, and only increase the strength enough to give effective results.

It is assumed that the collector is not in the possession of a fume cupboard, therefore, techniques requiring this equipment have been omitted.

Sodium hypochlorite, diluted with water, is probably the easiest and most convenient bleach to use. It is made up in a bath and the print completely submerged. Remember prints should always be laid on a support when they are immersed in a bath so that they can be lifted out without being handled. A sheet of glass or plastic is ideal.

Sodium hypochlorite is commercially available marked '10% w/v available chlorine'. It is always sold in a dark coloured bottle, and it should always be kept in the dark and cool. Generally one volume of bleach to twenty volumes of water will be found effective, but if it is necessary to increase the strength, never use a proportion greater than 5 to 20.

When the print has reached the desired stage of cleanliness, lift out, and wash gently with clean water. Then immerse in a 2% strength solution of sodium thiosulphate (photographic hypo.) to remove any residual chlorine,

finally wash again in clean water and leave to dry.

Chloramine-T is a much safer and gentler bleach. It is obtainable in the form of a white powder, and must always be kept well stoppered. Make up the solution immediately prior to use, 2 gm to every 100 ml of water. It can be used in the same way as sodium hypochlorite, but because the corrosive properties are soon lost, only a minimum amount of washing is necessary, and if necessary, omitted entirely. Solutions of Chloramine-T can be applied to local stains by covering them with a pad of blotting paper, held down with a sheet of glass.

If the stains are not completely removed by the first application after about 30 minutes, repeat the applications of bleach as necessary.

Chloramine-T, because of its gentle action, and the fact that subsequent washing is unnecessary, is ideally suited for treating watercolours, and hand coloured prints.

The retention of colour during any bleaching process is difficult, but it can be minimised if you lay the print face down, on a sheet of glass, gently soak the back with a wet sponge, then apply the bleach. The bleach will permeate the paper from the back to perform a mild action on the front. If sodium hypochlorite is used for this method, a final wetting with 2% hypo should be given whilst the print is still held face down on the support, followed by clean water. During the whole of this process the object is to prevent any bleach touching directly the front of the print, should it do so it is likely to cause unsightly bleach marks. Now reverse the print on the support so that it is face upwards, and gently wash the front for a few moments with clean water, and leave to dry.

Immersion of India-proof prints is likely to result in the India paper becoming loose, or completely free from the backing paper. If this happens it is quite a problem getting it back free of creases. A method often used for such prints is to soak a sheet, or sheets, of blotting paper in a strong solution of sodium hypochlorite, say 4 to 10. When the blotting paper is almost dry, sandwich the print between the sheets, and place between two sheets of glass.

Ink Stains

There are various treatments for the removal of ink stains, but the most effective one to use for a particular stain can only be ascertained by trial. The reason for this necessity is the very great difference in the composition of inks.

First try a 2% aqueous solution of chloramine-T. The stain may require a few applications, but if it does not completely remove it, try a 5% solution of oxalic acid, or alternatively a 10% solution of citric acid. Wash thoroughly after applying these latter two solutions.

If a more drastic method is required try sodium formaldehyde sulph-

oxylate. The stain should be wetted and the powdered chemical sprinkled over the stain. This treatment will also bleach out many other coloured stains. Always wash very thoroughly after using this chemical.

One other treatment can be tried if all else fails, but this method has the big disadvantage of being harmful to the paper, however, it is worth trying if it saves a print that would be ruined otherwise. Make a 0·5 solution of potassium permanganate and paint this over the stain, it will form a brown patch. Leave for about five minutes then cover the brown patch with a 2% aqueous solution of oxalic acid. Wash thoroughly in clean water.

Wax and Candle Grease

First remove any large patches carefully with a sharp penknife, then immerse the print completely in a bath of petrol. Let it soak for a few minutes to soften the wax, then gently rub the stain with a flat camel hair brush whilst the print is still submerged.

Remember that petrol is highly inflammable so please be careful, where and how you use this method.

Fly Stains

These will often disappear during normal washing and bleaching with chloramine-T but you can also stipple the individual spots with hydrogen peroxide mixed with an equal volume of alcohol, or a 2% aqueous solution of chloramine-T.

Black Stains on Red and White Pigments

Prints were invariably coloured with watercolours, and these prints are often marred by black staining on the whites and reds. This is caused by sulphuretted hydrogen gas present in the atmosphere. To oxidise the black and obtain the brilliant original colour, dab the affected parts with hydrogen peroxide. Commercially obtainable hydrogen peroxide may contain some corrosive impurities, therefore, if you wish to be certain that you do not introduce any undesirable chemicals to your prints, use the following method. Prepare a solution of hydrogen peroxide (20 vols) and ether. Mix thoroughly by shaking in a glass or plastic stoppered bottle. Because the two components are immiscible, the ether layer rises to the top leaving any impurities trapped in the aqueous layer below. The ether will have absorbed enough hydrogen peroxide to be effective. Dip cotton wool into the top *ethereal layer only* and dab the areas affected. You must be warned that ether is volatile, and highly inflammable, so use it in a well ventilated room, or in your garage, and do not have any naked flames in the vicinity.

Oil, Fat and Tar Stains

Benzene is a solvent for these stains, but the use of Pyridine, in its purest form is recommended as a much better solvent, this will also remove

stains of an asphaltic nature.

Apply solvent with a pad of cotton wool, and wash finally in clean water. The use of a little soap foam may well facilitate the final cleansing.

Tea and Coffee Stains

First damp the paper and then stipple the stain with a 2% aqueous solution of potassium perborate, and expose to strong sunlight for a few hours, the action of the bleach is slow, so do not become impatient. Should the paper appear to soften, stop the action by flooding with water.

If necessary, a final bleaching can be effected using ethereal hydrogen peroxide, but make sure the paper has been dried before applying the solution.

Tears

When a print has been torn along one of its edges, it is a relatively simple operation to effect an excellent repair. First soak the print in water for a few minutes, then remove and wait until the paper is only just damp. Lay the print, face down on a sheet of plate glass, and gently tap the joint until they are welded together, a spoon is an ideal tool for this operation, also it can be used to smooth the joint by rocking the spherical or curved bowl along the joint. Pressure is obtained by placing the forefinger of the hand holding the spoon in the inside of the bowl, and pressing downwards during the rocking motion. Paste may be applied to the two edges to be joined, but use sparingly.

If the joint requires reinforcing, stick a patch of paper behind it, and when dry, sandpaper the patch to remove the edges and to reduce the overall thickness. Make certain you use similar, old paper, otherwise on drying it is likely to cause wrinkling.

When a print has a piece completely torn away, or a hole, and the collector has the complete piece, adopt exactly the same procedure, but you must position the loose piece accurately, making certain that the feathered edges are lapped correctly. You can check this by turning the support glass, and examining through the glass. When it is necessary to insert a piece of paper, it is important to use paper of approximately the same age, thickness, and appearance. Sometimes it is possible to take a small piece from the margins, when they are very wide, if not, old prints beyond repair or valueless should be retained for this purpose.

The print is laid face down on a sheet of glass and the edges of the hole chamfered. Initially, a very sharp knife or razor blade can be used to remove some of the paper, but it will require the use of fine glass paper to obtain the very fine feather edge necessary for a good repair. Do not hurry this operation and use the glass paper with very gentle pressure otherwise you will tear pieces of paper away.

Now paste the chamfered edges with a fairly dry paste, and stick the

Plate 43. Using fine glass paper to clean a tear before applying paste. (Photo. D. C. Gohm.)

Plate 44. Method of using a spoon to roll down tears. Normally this work is performed on the back of the print, with a sheet of tissue paper interposed but the operation can be performed on the face of the print if care is taken (Photo. D. C. Gohm.)

patch over the hole. The patch should be about $\frac{1}{4}$ inch larger all round, than the hole, gently tap with spoon, and lift away from support to ensure excess paste has not seeped through and stuck your print to the support. Leave to dry.

When dry, carefully tear away the excess paper, holding the patch down onto the glass at the join as you work round it. Finally glass paper the back so that the inserted piece of paper is the same thickness as the rest of the print.

When using machine made paper, the grain of the paper must be maintained in the patch. The grain can be ascertained by wetting two edges at right angles to each other, the paper will swell across the grain and will crinkle a little.

Keep the joints as clean as possible, any dirty paste, or dirt introduced during repair, will only emphasise the join, and after all, we are seeking to make it invisible.

Paste

For the average repair, one of the best pastes can be made from ordinary wheat flour, but not self-raising. It is a simple formula:–

White flour (Wheat)	500 grams
Water	2·5 litres

To make the paste, mix the flour, with a little of the water, into a fine smooth cream, boil the remainder of the water, and add, still boiling, to the cream, stirring continually. Now put the paste into a double pan, or stand the container in a pan of water and boil, stirring all the time until it thickens.

On cooling, a crust will form on the top which is easily removed. This paste will keep for a few days if kept cool, but do not use if it turns sour. If you wish to extend the useful life of the paste, add 10 ml of formalin into the mixture whilst it is still fresh, but as the paste is so cheap to make it is better to make it fresh when required.

As an alternative, the best quality photographic mountants may be used, but do not experiment with any others unless you are confident that they do not contain any staining chemicals or harmful preservatives.

Sizing

After prints have been bleached, especially if they have been totally submerged in sodium hypochlorite, the body of the paper will require strengthening. A simple test is to damp the print with a spot of water and hold it up to the light. If the spot appears light, and the paper is very absorbent, like blotting paper, the print will need sizing to restore the strength and to render it suitable to take the colour of retouching.

One of the best sizes is the old fashioned jelly size. It is not easy to find a supplier, but when you do, you may have to purchase a whole keg. An

average strength size is made by dissolving the jelly with water, 1 vol. of size to $3\frac{1}{2}$ vols. of water. Boil for about three minutes in a porringer, or double pan, and apply to the print whilst still hot with a wide soft paint brush, always in one direction only.

An alternative, and more readily available size can be made from sheets of clear gelatine. Dissolve one sheet of gelatine in a quart of water (strength should not exceed 1·5 grams per litre). Always make this size immediately before use, and apply in the same manner as you would jelly size.

Reduction of Whiteness

After bleaching, and before sizing, it may be desirable to reduce the brilliant whiteness of a print that has been cleaned. This can be subdued by immersing the print in a weak solution of tea or coffee. The strength of which can be ascertained experimentally on a piece of paper similar to that of the print.

Colouring

After cleaning it is often necessary to replace the colour in a print that has been lost due to the bleach action and its immersion in water. Also prints are often found in their original uncoloured state and many collectors will prefer to have colour added to them. Now with regard to the latter the question will arise—'Is an antique print or map that has been coloured recently still a genuine antique, and has the addition of modern colouring detracted from its original value? There is no specific answer to this question, after all, the value of any antique is mainly determined by its rarity and the price collectors are willing to pay. The print is still, of course, antique, and it is obviously more desirable to have one that was coloured contemporary of its period, but it must be admitted that almost any uncoloured print can be made considerably more attractive by the addition of colour, applied skilfully and as near as possible to the colour that would have been applied had it been painted during the period when it was printed originally. The current trend indicates that modern colouring does not detract from the print's value, providing the work is executed by knowledgeable colourists, in fact, the prices are usually considerably higher.

It is interesting to know that during the eighteenth century, and into the nineteenth century many people would buy uncoloured prints and maps for the pleasure of colouring their own, the results of these amateur colourists are somewhat mixed.

It is not suggested that a collector should go to the trouble of making his own paints in the same manner as the early colourists were compelled to do, but he should study the tints and textures of paint applied by old colourists and simulate these as near as possible by colour mixing. Sometimes it is possible to buy old block colours from an antique shop and these

are quite useful for comparative purposes, and the touch of odd colour that is difficult to mix.

One eighteenth century book gives formulae for making watercolours, one of these is printed here for interest.

The formula was recommended for copper green:– Take some French verdigris and beat it into a fine powder with about $\frac{1}{5}$ of cream of tartar. Mix the powders in about five or six times their weight of water, then boil until only half of the liqueur remains. When cold, strain and let stand until the liqueur is clear. There is also a warning of fumes, and a suggestion that the nose should be stuffed, and the mouth covered to prevent poisoning.

Should you wish to pursue the subject of old colour making, there are some eighteenth and nineteenth century books that will provide the necessary information.

Now assuming the collector wishes to try his hand at colouring, he should obtain a selection of good quality sable or camel hair brushes, and an initial supply of the following watercolours, preferably in tubes because these colours are easier to mix in quantity than block colours:– Indigo, Prussian Blue, Burnt Sienna, Raw Sienna, Sepia, Raw Umber, Burnt Umber, Olive green, Light Red, Vermillion, Gamboge, and a tube of opaque white. You may wish to increase your pallet in time, but the suggested list is adequate. We also will need a small sponge, and some saucers to mix the colours or pots specially supplied by art shops, and *plenty* of blotting paper.

We are now ready to start, the following suggestions and colours are general, accuracy of tints to periods and styles of engraving must be learnt from experience gained by looking at, and closely examining old coloured prints. Let us assume we are going to colour 'A View of the House of Lords' it will at least show how you should approach the subject, but the method of applying watercolour can only be gained by practical experience. Practice as much as possible on worthless prints, checking your results continually with genuine old coloured prints.

Dip the sponge in clean water and wet the front and back of the print. At this stage it is wise to check that the size has been evenly absorbed over the total print area by holding the print up to a strong light. It should appear opaque *all over*, any areas or spots that appear light will not have absorbed size, and colour applied over these areas will immediately soak into the surface and discolour the back, a sure sign that the colouring has been recent and executed by an amateur. If the sizing is not satisfactory, do not attempt any colouring, but put the print aside and give it another thin coat of size at your convenience. Assuming the print has been adequately sized lay it on its back and blot it. Mix a touch of raw sienna with a touch of light red, then add white until a soft warm cream is

Plate 45. A Cathedral at Huy on the Meuse, Belgium. By Ogle after L. J. Wood, *c*. 1868 (Chromo litho.)
(Photo. D. C. Gohm.)

obtained—paint the cloud edges and horizon with this colour. Now mix prussian blue with white (make enough to cover the total sky area) until a natural sky blue is obtained and paint the sky leaving the areas already coloured cream. Try and finish the sky whilst the print is still damp so that no hard lines result. Next mix a pale wash of raw umber and paint the stonework of the House, and the brick building light red.

The ground can be washed in with a wash of burnt sienna flattened with a tint of sepia. Do not paint over the figures. When dry paint the roof grey made from Prussian blue and sepia. (Paynes Grey can be used as an alternative).

Now paint the shadow areas with a pale wash of prussian blue.

Finally paint the figures and coach—faces light red, uniforms correct colours, dresses and coats brightly, but not brilliantly, contrasting.

Plate 16. Cartouche of map of Huntingdonshire by Joan Blaeu, 1648.
Plate 17. Map of Huntingdonshire by Joan Blaeu, 1648 (*Richard A. Nicholson*).

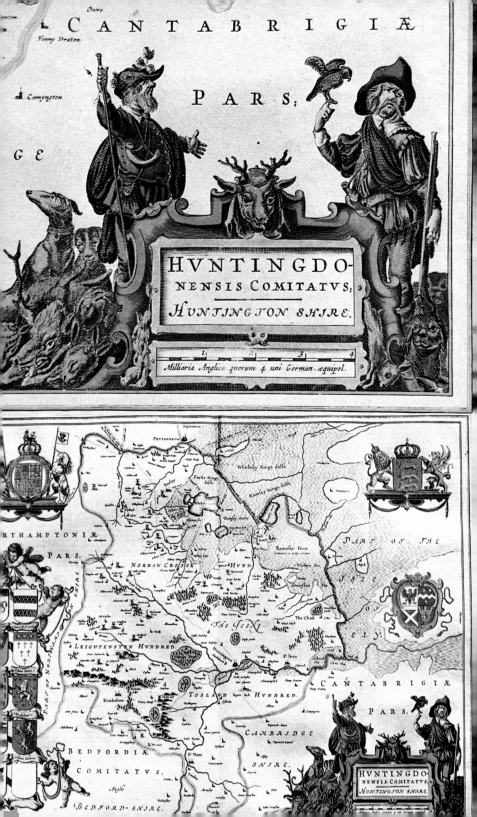

CANTABRIGIÆ

PARS,

HVNTINGDO-
NENSIS COMITATVS,

HVNTINGTON SHIRE.

Milliaria Anglica quorum 4 uni German. æquipol.

Septentrio

Peterborow

Whitlesey Kings delfe

Farley Kings delfe

Ramsey Kings delfe

Ramsey mere

Ramsey Fenn

PART OF THE

ISLE

OF

ELY

NORTHAMPTONIÆ

PARS,

NORMAN CROSSE

HVND.

PART OF NORTHAM

The fenn

LEIGHTENSTON HVNDRED

The Sea

CANTABRIGIÆ

PARS,

Kimbalton

TOSLAND HVNDRED

CAMBRIDGE

BEDFORDIÆ

COMITATVS,

SHIRE.

BEDFORD-SHIRE.

HVNTINGDO-
NENSIS COMITATVS,
HVNTINGTON SHIRE.

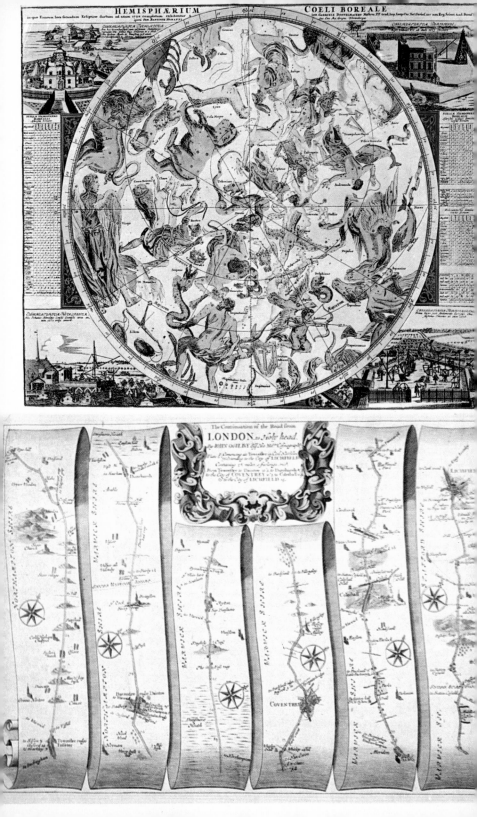

8 Dictionary of Engravers

The following dictionary of engravers, together with references to a few of their principal works, is intended to give the collector an opportunity to get to know their engravers, and the various types of prints associated with them where this is applicable. It has been compiled with every intention of being comprehensive, but it is obviously impossible to *include* *every* engraver who produced an engraved plate, or to list every print produced by a particular engraver.

* Denotes print illustrated in this book.

AGAR (JOHN SAMUEL)

Agar was both an engraver and portrait painter. He was born about 1770 and died in 1840. Most of his engravings were executed in stipple, some of which were after the famous Cosway.

Mrs. Duff after Cosway, published 1807. 17 × 14.

Lady Heathcote after Cosway, published 1809. 17 × 14.

Countess of Chesterfield after Anne Mee, published 1812. 11 × 9½.

Henry VIII's First Meeting with Anne Boleyn after T. Uwins, published 1819. 7 × 10.

ALEXANDER (WILLIAM)

Alexander was an artist and engraver. He was born in Maidstone in 1767 and died in 1816. During an expedition to China in 1792, he accompanied the Earl of Macartney's Embassy and is said to have been responsible for the illustrative drawings recording the expedition, many of which were

Plate 18. Celestial Chart by J. B. Homanni, 1740 (*Richard A. Nicholson*).
Plate 19. Road map from London to Holyhead by Ogilby, 1670 (*Parker Gallery*).

produced in book form. Most of this artist's works will be found as book plates.

Representation of the Dinner given to the Kentish Volunteers in the presence of their Majesties by and after W. Alexander, published 1800. $15\frac{1}{2} \times 34$.

Scenes in China 25 off coloured plates, published 1797.

Dress and Manners of the Chinese, Russians, Turks and Austrians 224 off coloured plates, published 1813–14. 8vo.

ALKEN (HENRY)

Most of Alken's works of any importance were produced between 1816–1831. He is better known for his sporting prints, but also illustrated many books, the earliest productions being published anonymously under the signature 'Ben-Tally Ho'. The following examples of his work are after as well as by Alken.

The Westminster Cockpit 1830. $9\frac{1}{2} \times 10\frac{3}{4}$.

The High Mettled Racer by Alken and Sutherland after Alken. This comprises a set of six plates published in 1821. 11×14.

The Steeplechase by Alken. (A series of six 4to).

Hunting Casualties published in 1850. $8\frac{1}{8} \times 11\frac{1}{4}$. (A series of six).

The Mail Coach in a Storm after Newton. 24×26.

The Royal Mail Coach Blocked by the Snow. This is a coloured aquatint published in 1837.

Aylesbury Grand Steeplechase by J. C. Bentley after H. Alken published 1866.

**Bowling* after H. Alken, published 1820. $9\frac{1}{8} \times 6\frac{1}{4}$.

ALKEN (SAMUEL)

Most of this celebrated engraver's work was accomplished between 1780–96 during which he produced many fine aquatints and other plates after Morland, Wheatley, Rowlandson and others.

View of the City of Waterford after Roberts. 14×18.

The English Lakes $14\frac{3}{4} \times 10$. These comprise a set of four aquatints.

A Trip to Brighton after Rowlandson. These were aquatints tinted in brown comprising a set of eight.

A View near Exeter after P. Pindan, published in 1801. $7 \times 10\frac{1}{2}$.

Partridge, Pheasant, Duck and Snipe Shooting. Etched by Rowlandson and aquatinted by S. Alken after George Morland. These comprise a set of four plates which are now extremely rare.

ALLEN (DAVID)

This Artist was born in Alloa in 1744 and died at Edinburgh in 1796. Although basically a painter of historical subjects and portraiture he etched a number of plates, mostly of a rural character, combining etching with mezzotint.

Scaramouchs Last Pinch after Stothard, published 1828. The size of the plate 14×9.

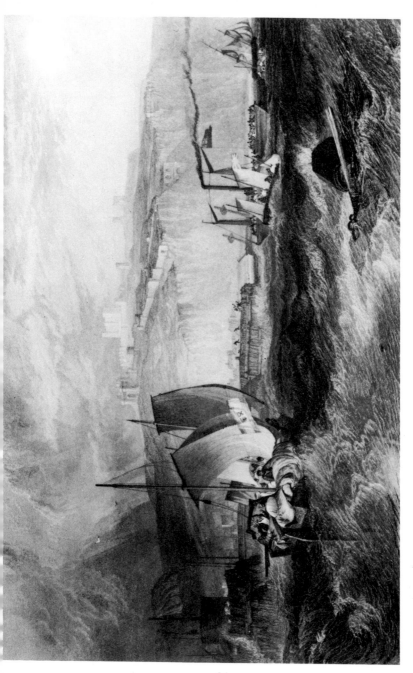

Plate 46. Dover. By J. T. Willmore after J. M. W. Turner. Published 1851. (23¼ × 16.) Line engraving. (Photo D. C. Gohm.)

ANSDELL (RICHARD)

This artist was born in Liverpool during 1815 and died in 1885. Although he etched a few plates they are not considered to have any real merit.

A Stag Standing Listening.

A Group of Three Donkeys.

ANSELL (CHARLES)

This artist was more celebrated as a painter than an engraver. He was living in 1784. There is some doubt if he ever produced any engravings personally.

The Graces of Archery, or Elegant Airs, Attitudes and Lady Traps after Ansell

Death of a Race Horse after Ansell, published in 1784, comprising a set of six plates.

ARMSTRONG (COSMO)

This engraver was born in Birmingham in 1781. It is not known when he died, but he was still living in 1836. Although an engraver of some reputation, very few of his works were ever published as specific prints. Any prints found bearing this engraver's name are almost certain to have been originally intended for book plates. His name is probably better known in connection with his illustrations for Chalmers's edition of Shakespeare published in 9 volumes 8vo. 1805.

ARTLETT (RICHARD AUSTIN)

This engraver was working between the years 1830 and 1843. The majority of his work consists of portraiture.

Lady Darnley after Lawrence 10×7 (Oval shape).

Lord Lyndhurst after Chalon.

ATKINSON (JOHN AUGUSTUS)

This artist was born in London during the last quarter of the eighteenth century and is probably better known as a painter and draughtsman. His colour plates, many of them drawn and etched by himself, appear in Howitts 'Foreign Field Sports', 'Picturesque Representations of the Naval, Military and Miscellaneous Costumes of Great Britain' published in 1807 and 'Manners, Customs and Amusements of the Russians' published in 1803–4. If any of the plates are met with they are almost certain to have been extracted from these books.

The Carriers Wagon. The Mail Coach both drawn and etched by this artist. Published January 1807. $13\frac{1}{2} \times 9$.

Launching a Dover Cutter in colour.

Soldiers Drilling.

Troops Watering Horses.

**Ferriers Shed.* Published 1807. $6\frac{1}{4} \times 8\frac{1}{2}$.

ATKINSON (T. L.)

Basically an engraver in line. He also worked occasionally in mezzotint

and re-produced many of the works of Landseer.

The Foresters Family after Landseer.

The Farm Yard after J. F. Herring, published 1848. 24 × 31

The Shepherds Prayer after Sir E. Landseer, published in 1858. 38 × 40.

Windsor Castle after Sir E. Landseer, published 1851. 29 × 34.

Feeding the Horse after J. F. Herring, published 1848.

BACON (FREDERICK)

Basically a line engraver Bacon was born in London very early in the nineteenth century. He did a great deal of work for the Art Annuals and seems to have been either a pupil or greatly influenced by Finden. He was an excellent engraver who emigrated to America and died there in 1887.

John Bunyon in Bedford Gaol after T. G. Donval, published in 1851.

The Shot after R. Ansdell, 12 × 22.

The Fall of Clarendon after G. M. Ward.

BAILY (JAMES)

Little is known about this engraver but occasionally his prints will be found. He was apparently working in London between 1780 and 1815 mainly in line. He also occasionally worked in aquatint.

The Mail Arriving at Temple Bar after Newhouse. Aquatint. $11\frac{1}{2}$ × 16.

BAIRD (JOHNSTONE)

On the Dee.

Waterloo Bridge.

The Pool, with distant view of the Tower Bridge.

BAKER (B. R.)

Very little is known about this engraver, except that he was living during the first half of the nineteenth century and that he worked in London mainly in lithography, some of which were coloured.

St. Mary's Church, Islington 1821. 12 × 16. (Col. litho).

The Tower of London 1824. 13 × 15. (Col. litho).

BALDREY (JOSHUA KIRBY)

This artist was born in 1754 and was working between 1780 and 1810. The majority of his prints, if not all of them, were executed in stipple or in a style representing a chalk line. Few of them are met in colours. Baldrey was a portrait artist but is better known as an engraver. He died in 1828.

Cecila (Portrait of Mrs Lane) after Hoppner. $8\frac{1}{4}$ × 7.

An Offering to Charity after J. Kendall.

The Flower Girl after Gardner.

Patience in a Punt. A Rat Catcher both after H. Bunbury.

BANNERMAN (ALEXANDER)

This engraver was born at Cambridge about 1730 and was still living in 1770. He worked for Boydell the publisher and was considered to be an engraver of reasonable ability but not necessarily an outstanding engraver.

The Death of St. Joseph after Valasquez.

Joseph Interpreting Pharaoh's Dream after Spagnoletto.

BARLOW (FRANCIS)

Born in Lincolnshire about 1626, died London 1702. This painter and engraver is noted for his natural history subjects.

In 1666, one hundred and twelve plates after his own designs were published in a translation of 'Aesop's Fables'.

His plates are often to be found signed simply 'F. B' sometimes surrounded by a circle.

Set of prints of 'Hunting, Hawking and Fishing'. (11 plates).

The Eagle and the Cat.

St. George Slaying the Dragon.

BARLOW (THOMAS OLDHAM)

Born at Oldham, Lancs, c.1825, died in London in 1889, best known for his work in mezzotint.

The Prison Window after John Phillips, published 1857 and reprinted 1860. 26 × 19.

Huntsmen and Hounds after Ansdell. 36 × 26.

The Vintage at Macon after J. M. W. Turner.

Hawking after Ansdell.

Return from Hawking. Part. Published 1871 and 1872 respectively. 26 × 20 each.

The Wreck of the Minotaur after J. M. W. Turner.

The Jersey Lily (Mrs Langtry) after Millais, published 1881. 18½ × 13½.

The Spanish Gipsy Mother after John Phillips. 16 × 13.

Alfred Lord Tennyson after Millais.

Mother and Child after Sant. 13 × 10.

BARNARD (WILLIAM)

Little is known about this artist except that he was working in London between 1798 and 1819. He is best known for his work in mezzotint.

The Golden Lane Brewery after Wolstenholme.

Girl in a Woody Landscape after Gainsborough.

'Diamond' a Racehorse after Marshall.

Morland's Summer, Morland's Winter, both after Morland.

The Brown Jug or The Waggoners Farewell after Morland. 13 × 17.

The Cottage Fireside after Morland, published 1808. 18½ × 22½.

England: Scotland: Ireland: Wales, four prints after Porter.

Lord Nelson after Abbott.

The Death of Nelson, published 1805. 20 × 24.

Fox Hunting, The Death after Morland.

BARNEY (J. H.)

This artist was living in 1794, but his life span is unknown. He was an

Plate 47. St. Winfraw, Abbeville. By Ogle after L. J. Wood, *c.* 1868. (Chromo litho.) (Photo. D. C. Gohm.)

engraver in stipple, and a precise craftsman, his plates either bear the name Joseph Barney or J. H. Barney.

The Pilgrim after Hamilton. 20 × 15.

Silvia by and after J. Barney.

The Fisherman's Departure: The Fisherman's Return both after Wheatley, published 1793. 18 × 23.

The Cottage Fireside, The Dairy after J. Barney.

The Thatcher by and after J. Barney, published 1802. 16 × 22.

BARNEY (WILLIAM WHISTON)

Little is known about the life history of this engraver, except that he worked mainly in mezzotint, and appears to have been a pupil of S. W. Reynolds.

The Happy Cottagers, after Hamilton, published 1794. 14 × 17½.

Girl with a Pitcher after Hamilton.

Georgiane, Duchess of Devonshire after Gainsborough.

Lady Caroline Spencer after Cosway.

The Two Sons of the Marquis of Blandford after Cosway.

BARRY (JAMES)

Born at Cork in 1741, and died in London in 1806, Barry although a celebrated painter, also engraved a number of his own works.

Philoctetes in the Island of Lemnos, published 1777. 15 × 18¼.

Jupiter and Juno on Mount Ida. 14½ × 12½.

William Pitt, Earl of Chatham.

BASIRE (JAMES)

Born in London in 1730 and died there in 1802. Several members of his family practised engraving but James is the only one of importance.

The Farmer's Return after Hogarth.

**Distribution of Maundy Money.* 1777. 17 × 24.

**Distribution of Maundy Money in the Chapel at Whitehall* after S. H. Grimm, published 1789. 17 × 24.

The Honble. Lady Stanhope after B. Wilson, 1772.

The Embarkation of Henry VIII at Dover.

The Encampment of the English Forces near Portsmouth on July 19th 1545.

The Coronation Procession of Edward VI from the Tower to Westminster after S. H. Grimm. 25 × 50.

BAXTER (GEORGE)

George Baxter was born at Lewes in Sussex and died in 1867. Originally an engraver of wood blocks he became famous for the Baxter oil colour prints, the first of which is thought to be the 'Three Butterflies'.

The following list of Baxter's prints are believed to be comprehensive but it is possible that a few have escaped the catalogues.

For reference purposes an asterisk (*) has been added to indicate that the print was produced for book illustrations and the word 'Mount' to indi-

cate that the print was issued either on a stamped or red seal mount. Naturally some prints were issued for all categories.

1829

Butterflies. $6\frac{1}{2} \times 5\frac{1}{2}$ Unsigned*.

1834

Eagle and Vulture. $3\frac{1}{2} \times 2\frac{1}{2}$ Unsigned*.
Hindoo and Mohammedan Buildings. $8\frac{5}{8} \times 6\frac{1}{4}$ Unsigned*.
Dippers and Nest. $3\frac{1}{4} \times 2\frac{3}{4}$ Unsigned*.
Little Grebes and Nest. $3\frac{1}{4} \times 2\frac{3}{4}$ Unsigned*.

1835

Air Bird $1\frac{1}{2} \times 2\frac{1}{2}$*.
Caroline Mordaunt. $2\frac{5}{8} \times 4\frac{3}{8}$ Unsigned*.
Cattle Drinking. $2\frac{7}{8} \times 4\frac{1}{2}$ Unsigned*.
End of Time. $3\frac{1}{4} \times 2\frac{1}{8}$. Unsigned*.
Evening on the Sea. $3\frac{3}{4} \times 3$ Unsigned*.
Modifications of Clouds. $4 \times 6\frac{3}{4}$ Unsigned*.
Norfolk Bridge. $6\frac{1}{4} \times 4\frac{5}{8}$ Unsigned*.
Polar Sky. 4×3 Unsigned*.
Scene on the Mountain Tops. $3\frac{1}{2} \times 3$ Unsigned*.
The Seasons. $1\frac{3}{4} \times 2$ Unsigned*.
The Shore. $2 \times 1\frac{1}{2}$ Unsigned*.
Temperate. $1\frac{1}{2} \times 2$ Unsigned*.
Tropical Scenery. $4 \times 3\frac{1}{2}$ Unsigned*.
Convolvus Scroll and Wreath. 5×3 Unsigned*.

1836

Bohemian Peasants. $4\frac{1}{4} \times 4$ Unsigned*.
Boy Throwing Stones at Ducks. $4 \times 2\frac{1}{2}$ Unsigned*.
Boy with Bird's Nest. $2\frac{1}{4} \times 2\frac{1}{4}$ Unsigned*.
Boys with a Kite in a Tree. $2\frac{7}{8} \times 4\frac{3}{8}$ Unsigned*.
Children outside the Gates of a Mansion. $4 \times 2\frac{1}{2}$ Unsigned*.
The Conquer of Europe. $7 \times 4\frac{1}{4}$ Unsigned*.
Convolvus Leaves. $3\frac{3}{4} \times 3$ Unsigned*.
Hungarian Peasants. $4\frac{1}{2} \times 4$ Unsigned*.
Lovers Standing under a Tree. $3\frac{1}{2} \times 3$ Unsigned*.
Mosaic Pavement at Pitney. $7\frac{5}{8} \times 3\frac{3}{4}$ Unsigned*.
Cluster of Passion Flowers and Roses. $8 \times 6\frac{1}{2}$ Signed. Mount.
Southdown Sheep. $3\frac{1}{2} \times 5\frac{1}{2}$ Unsigned*.
Virginia Water. $2\frac{7}{8} \times 5$ Unsigned*.
The Welsh Harper. $3 \times 4\frac{7}{8}$ Unsigned*.

1837

Advice on the Care of the Teeth. $4\frac{1}{2} \times 3\frac{1}{2}$. Unsigned*.
Annuals. $3\frac{1}{2} \times 3$ Unsigned*.

Autumnal Artist. 2×2 Unsigned*.
Avalanche at Lewes. 4×2½ Unsigned*.
Bird of Spring. 1⅛×2 Unsigned*.
The Boa Ghaut. 5¼×4 (Also produced with sun rays) Unsigned*.
Cape Wilberforce. 3½×5½ Unsigned*.
The Carrier Pidgeon. 5⅛×4⅛ Unsigned*.
Cleopatra. 5½×4¼ Unsigned*. Mount.
Destruction of Sodom. Unsigned*.
Greenhouse Perennials. 3½×3 Unsigned*.
Greenhouse Shrubs. 3½×3 Unsigned*.
Jeanie Dean's Interview with the Queen. 5¼×4⅛ Unsigned*.
Lady Chapel Warwick. 5¾×4 Unsigned*.
Lugano. 4×5¾ Unsigned*.
Orchidae. 3½×3 Unsigned*.
Summer Fly. 1½×1¾ Unsigned*.
Te Po. 5⅜×3½ Unsigned*.
Turn of the Monsoon. 4¼×3¼ Unsigned*.
Vernona. 5¼×4 Unsigned*.
Vineyard near Mount St. Bernard. 4×3½ Unsigned*.
Rev. John Williams 5⅛×4⅛ Unsigned*.
Winter Bird. 2×2 Unsigned*.
Zenobia. 5⅜×4¼ Unsigned*.
Isola Bella Lago Maggiore. 3½×3¼ Unsigned*.

1838
Departure of the Camden. 5¾×9¾ Unsigned. Mount.
The Dying Gladiator. 2×1½ Unsigned*.
The English Ship by Moonlight. 3×2½ Unsigned*.
Milo of Crotona rending the Oak. 4×3½ Unsigned*.
The Old Water Mill. 4×3½ Unsigned*.
Yes, I am Come of High Degree. 3½×3 Unsigned*.
Mr Medhurst in Conversation with Choo-Tih-Lang. 5×4¾ Unsigned*.
Sunshine and Cloudy Sky. 2×2½ Unsigned*.
Rafaralahy. 5⅜×4¼ Unsigned*.

1839
Greek Monastery 5¾×4⅛ Unsigned*.
Judgment of Brutus. 4½×3½ Unsigned*.
Lo Studio. 4½×3½ Unsigned*.
View from Mission House at Bangalore. 4¼×5⅝ Unsigned*.
Michaelangelo Moses. 2×1½ Unsigned*.
Parsonage at Ovingham. 3×4⅝ Unsigned*.
Socrates. 1¾×1½ Unsigned*.

1840
Child on a Bed. $1\frac{1}{4} \times 2\frac{1}{4}$ Unsigned*.
Domestic Happiness. 4×4 Unsigned*.
The Landing of Columbus. $5\frac{1}{2} \times 4\frac{1}{8}$ Unsigned*.
Prospectus of the Coronation. (Royal Arms).
Prospectus of Opening of Parliament (With arms in colour and with arms in black)
Six Malagazy Christians. $3\frac{3}{8} \times 5\frac{1}{2}$ Unsigned*.
1841
Coronation of Queen Victoria. $21\frac{7}{8} \times 17\frac{3}{8}$. Unsigned. Mount.
Opening of Parliament. $21\frac{7}{8} \times 17\frac{3}{8}$. Signed. Mount.
Reception of Rev. John Williams at Tanna. $8\frac{3}{8} \times 12\frac{3}{4}$ Unsigned. Mount.
Shells. $3\frac{1}{2} \times 3$ Unsigned*.
Massacre of the Rev. J. Williams and Mr Harris at Erromanga. $8\frac{3}{8} \times 12\frac{3}{4}$ Unsigned. Mount.
1842
The Launch of the Trafalgar. $8\frac{1}{2} \times 12\frac{3}{8}$ Unsigned. Mount.
Rev. John Williams. $4\frac{1}{4} \times 3$ Unsigned*.
Queen Victoria in Garter Stall. Unsigned*.
1843
The Rev. Robert Moffat. $10\frac{3}{4} \times 8\frac{3}{4}$ Unsigned. Mount.
Wreck of the Reliance. $11\frac{7}{8} \times 16\frac{1}{4}$ Unsigned. Mount.
Rev. John Williams. $5\frac{3}{4} \times 4$ Unsigned*.
Rev. John Williams. $10\frac{3}{4} \times 8\frac{3}{4}$ Unsigned. Mount.
1844
Charles Chubb. $11 \times 8\frac{7}{8}$ Unsigned. Mount.
Maria Chubb. $11 \times 8\frac{7}{8}$ Unsigned. Mount.
Destruction of the Tanjore. $3\frac{1}{8} \times 5\frac{1}{8}$ Unsigned*.
Gathering Apples. $4 \times 3\frac{1}{2}$ Unsigned*.
Landing of the Missionaries, $11\frac{7}{8} \times 16\frac{1}{4}$ Unsigned. Mount.
Wesley Missionary Ship. $2\frac{3}{4} \times 4\frac{1}{8}$ Unsigned. (Not coloured)*.
1845
Her Majesty's Marine Residence. $3\frac{1}{2} \times 2\frac{3}{4}$*.
Jerusalem. $3\frac{3}{4} \times 3$ Unsigned*.
Pomare, Queen of Tahiti. $10\frac{3}{4} \times 9$ Unsigned. Mount.
George Pritchard. $10\frac{3}{4} \times 9$ Unsigned. Mount.
Richmond Hill (Morning). $3\frac{1}{4} \times 5$ Unsigned*.
Surrey Zoological Garden. $3\frac{1}{2} \times 2\frac{1}{4}$ Unsigned*.
1846
Rev. John Williams. $10\frac{3}{4} \times 8\frac{3}{4}$ Unsigned. Mount.
Wesleyan Mission Station at Waingaroa. 4×6 Unsigned*.
Teeth in Age. $5\frac{1}{2} \times 3\frac{1}{4}$ Unsigned*.

1847

Abbeyville. $2\frac{7}{8} \times 2\frac{1}{8}$ Unsigned. Mount.
Bolton Abbey. $2\frac{1}{8} \times 3\frac{5}{8}$ Unsigned. Mount.
Crossing the Brook. $3\frac{3}{8} \times 2\frac{3}{8}$ Unsigned. Mount.
Dovedale, Derbyshire. $2\frac{1}{4} \times 3\frac{5}{8}$ Unsigned. Mount.
En Cathedral. $2\frac{7}{8} \times 2\frac{1}{8}$ Unsigned. Mount.
Near Folkestone. $2\frac{1}{8} \times 3\frac{5}{8}$ Unsigned. Mount.
La Biondina in Gondoletta. $2\frac{1}{8} \times 3\frac{5}{8}$ Mount.
Hindoo Temple at Gyah, Behar. $4\frac{1}{2} \times 3\frac{1}{2}$ Unsigned*.
View near Ilkley. $2\frac{1}{8} \times 3\frac{5}{8}$ Unsigned. Mount.
Indian Settlement (Small). $3\frac{1}{4} \times 2\frac{1}{4}$ Unsigned. Mount.
The Rev. William Knibb. $10\frac{1}{2} \times 8\frac{3}{4}$ Unsigned. Mount.
Lake Garda. $2\frac{1}{8} \times 3\frac{5}{8}$ Unsigned. Mount.
Lake Luggelaw. $2\frac{1}{4} \times 3\frac{5}{8}$ Unsigned. Mount.
The Little Gardeners. $3\frac{1}{2} \times 2\frac{1}{4}$ Unsigned. Mount.
View in Madeira. $3\frac{3}{8} \times 2\frac{3}{8}$ Unsigned. Mount.
Miss Aldersey's School at Ningpo. $4\frac{3}{8} \times 6\frac{1}{8}$ Unsigned*.
Nuremburg, Bavaria. $3\frac{1}{4} \times 2\frac{1}{4}$ Mount.
The Ordinance of Baptism. $11\frac{1}{4} \times 15\frac{1}{4}$ Unsigned. Mount.
The Ordinance of Baptism. $11\frac{1}{4} \times 15\frac{1}{4}$ (without sail). Mount.
River Scene, Holland. $2\frac{1}{4} \times 3\frac{3}{4}$ Unsigned. Mount.
The Tarantella (Small). $2\frac{1}{8} \times 3\frac{5}{8}$ Unsigned. Mount.
Yggdrasil. $4\frac{1}{2} \times 3\frac{1}{2}$ Unsigned*.

1848

The Andalusians. $3 \times 2\frac{1}{4}$. Unsigned.
Duke of Buccleuch's Residence. $2\frac{1}{4} \times 3\frac{5}{8}$. Unsigned. Mount.
Greenwich Observatory. $3\frac{5}{8} \times 2\frac{3}{8}$. Unsigned*.
Parhelia (Mock Suns). $2\frac{3}{4} \times 4\frac{1}{2}$. Unsigned*.
Paul and Virginia (Small). Unsigned. Mount.
Prince Consort on Balcony. 6×4. Signed. (Also produced with blue breeches for book illustration, and top boots on mount).
Queen (Victoria) on Balcony. 6×4. Signed. Mount*.
Temples of Philae. $2\frac{3}{8} \times 3\frac{3}{8}$. Unsigned. Mount.
Westleyan Chapel. Pophams Broadway. $2\frac{7}{8} \times 5$. Unsigned*.
Claremont. $2\frac{3}{8} \times 3\frac{5}{8}$. Unsigned. Mount.
Bride (Small). $3\frac{1}{8} \times 2\frac{1}{8}$. Unsigned. Mount.
Conchologists. $4\frac{3}{8} \times 2\frac{5}{8}$. Unsigned. Mount.
Chalees Saloon. $2\frac{1}{4} \times 3\frac{5}{8}$. Unsigned. Mount.
Fisherman's Home. $2\frac{3}{4} \times 2\frac{1}{4}$. Unsigned. Mount.

1849

Derwentwater Cumberland. $2\frac{3}{8} \times 3\frac{7}{8}$. Unsigned. Mount.
The Mission Premises at Kuruman Station. $5\frac{1}{2} \times 8\frac{3}{4}$. Unsigned*.

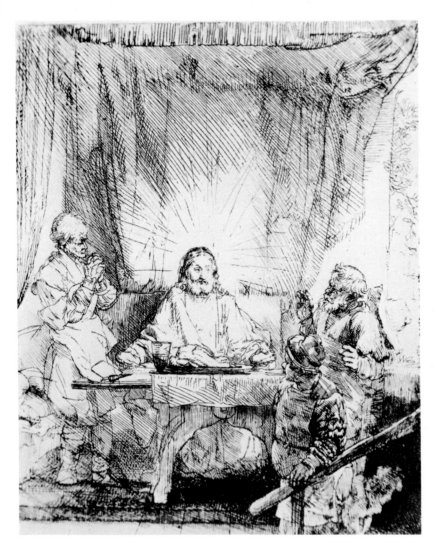

Plate 48. Christ at Emmaus. ($8\frac{1}{4} \times 6\frac{3}{8}$.) Etching by Rembrandt. Signed. 1654.
(Victoria and Albert Museum.)

Summer (Small). $2\frac{3}{8} \times 2\frac{7}{8}$. Unsigned. Mount.

Winter (Small). $2\frac{7}{8} \times 2\frac{1}{4}$. Unsigned. Mount.

Deserted Rock Quarry on the Wye. $2\frac{1}{4} \times 3\frac{1}{2}$. Unsigned. Mount.

1850

The Arctic Expedition. 6×8. Unsigned. Mount.

Balmoral Castle. $2\frac{3}{8} \times 3\frac{3}{4}$. Unsigned. Mount.

Ben Nevis Scotland. $2\frac{3}{4} \times 4$. Signed. Mount*. Also produced unsigned.

Bride (Large). $4\frac{3}{4} \times 3\frac{1}{8}$. Signed. Mount.

The Bridesmaid. $15 \times 10\frac{3}{4}$. Signed. Mount.

Brighton Chain Pier. $2\frac{1}{8} \times 3\frac{5}{8}$. Unsigned. Mount.

Brougham Castle. $2\frac{3}{8} \times 3\frac{5}{8}$. Unsigned. Mount.

Cader Idris. $2\frac{3}{4} \times 4$. Unsigned. Mount.

Chalees Saloon (Large). $3\frac{1}{8} \times 4\frac{5}{8}$. Mount.

Chimborazo. $3\frac{1}{4} \times 5\frac{5}{8}$. Unsigned*.

Circassian Lady at the Bath. $6\frac{1}{8} \times 4\frac{1}{4}$. Signed. Mount.

The Conchologists. $4\frac{3}{8} \times 2\frac{5}{8}$. Signed. Mount.

Crucis Abbey. $2\frac{3}{8} \times 3\frac{7}{8}$. Unsigned. Mount.

De La Rue (Small Queen on Balcony). $3\frac{3}{8} \times 2\frac{3}{4}$. Signed. Mount.

Dripping Well Hastings. $2\frac{3}{4} \times 4$. Unsigned. Mount.

The First Impressions. $3\frac{3}{4} \times 2\frac{3}{4}$. Unsigned. Mount.

View from Harrow-on-the-Hill. $2\frac{3}{4} \times 3\frac{7}{8}$. Unsigned. Mount.

Indian Settlement (Large). $3\frac{3}{4} \times 2\frac{1}{4}$. Signed. Mount.

Her Majesty Leaving Kingston Harbour Ireland. $4\frac{1}{8} \times 6\frac{1}{8}$. Signed. Mount.

Lake Bala. $2\frac{3}{8} \times 3\frac{3}{4}$. Unsigned. Mount.

Lake Como. $2\frac{3}{4} \times 4$. Unsigned. Mount.

Llangollen. $2\frac{3}{4} \times 4$. Unsigned. Mount.

Lovers' Seat, Hastings. $3\frac{3}{4} \times 4$. Unsigned. Mount.

Netley Abbey. $4 \times 2\frac{3}{4}$. Unsigned. Mount.

Prince of Wales Landing from his Boat. $3\frac{1}{2} \times 2\frac{1}{2}$. Signed. Mount.

Queen (Victoria) on Dais. $4\frac{1}{2} \times 3$. Unsigned. Mount.

Richmond Bridge. $2\frac{1}{2} \times 3\frac{3}{4}$. Unsigned. Mount.

River Camel, Cornwall. $3\frac{3}{4} \times 2\frac{5}{8}$. Unsigned. Mount.

River Tiefy, Cardiganshire. $4 \times 2\frac{3}{4}$. Unsigned. Mount.

St. Ruth's Priory. $4 \times 2\frac{3}{4}$. Unsigned. Mount.

Shall I Succeed? $3\frac{1}{2} \times 2\frac{1}{4}$. Unsigned. Mount.

Stolzenfels. $2\frac{1}{4} \times 3\frac{3}{4}$. Unsigned. Mount.

The Tarantella (Large). $3\frac{3}{4} \times 4$. Signed. Mount.

Tintern Abbey. $2\frac{3}{8} \times 3\frac{3}{4}$. Unsigned. Mount.

Warwick Castle. $2\frac{3}{8} \times 4$. Unsigned. Mount.

Water Mill on the Wye. $3\frac{1}{2} \times 2\frac{1}{4}$. Unsigned. Mount.

Welsh Drovers. $2\frac{3}{8} \times 3\frac{3}{4}$. Unsigned. Mount.

Windsor Castle from the Long Walk. $3\frac{1}{2} \times 2\frac{5}{8}$. Unsigned*.

Windsor Castle, returning from the Stag Hunt. $2\frac{1}{2} \times 3\frac{1}{2}$. Signed. Mount.
View from Windsor Forest. 3×4. Unsigned. Mount.
1851
Bethlehem $2\frac{1}{2} \times 3\frac{5}{8}$. Unsigned*.
Grand Entrance to Great Exhibition. $3\frac{1}{8} \times 4$. Unsigned.
Grand Entrance to Great Exhibition. $3\frac{1}{8} \times 4$. (with 8 horses).
Grand Entrance to Great Exhibition. $3\frac{1}{8} \times 4$. (with 2 horses).
Great Exhibition. The Exterior. $6 \times 12\frac{3}{4}$. Unsigned. Mount.
Houses of Parliament. $3\frac{1}{2} \times 4\frac{3}{4}$. Unsigned. Mount.
New Palace, Westminster. $2\frac{3}{4} \times 3\frac{7}{8}$. Mount.
The Royal Exchange. 3×4. Unsigned. Mount.
1852
Flora (Oval). $8 \times 6\frac{3}{8}$. Unsigned. Mount.
So Nice. $6\frac{1}{4} \times 4$. Unsigned. Mount.
1853
Christ Blessing Bread. $8 \times 6\frac{3}{4}$. Unsigned. Mount.
Christ Blessing Bread. $8 \times 6\frac{3}{4}$. Unsigned. Mount (without numbers).
Curcifixion (Large). $14 \times 12\frac{1}{4}$. Signed.
Crucifixion (Small). $5\frac{5}{8} \times 4\frac{7}{8}$. Signed.
Crystal Palace, New York. $5\frac{3}{4} \times 12\frac{3}{4}$. Signed. Mount*.
The Day Before Marriage. $14\frac{7}{8} \times 10\frac{7}{8}$. Signed. Mount. (Also published in 1854 and undated).
The Descent from the Cross. $8\frac{1}{2} \times 6\frac{1}{2}$. Unsigned. Mount.
Duke of Wellington (without arm). $4 \times 2\frac{3}{4}$. Unsigned. Mount.
Duke of Wellington (with arm). $4\frac{3}{8} \times 3\frac{1}{4}$. Unsigned. Mount.
Funeral of the Duke of Wellington. $6\frac{1}{8} \times 4\frac{3}{8}$. Unsigned. Mount.
Me Warm Now. $6\frac{1}{4} \times 4\frac{3}{8}$. Signed. Mount.
Napoleon Bonaparte. $4\frac{1}{4} \times 3\frac{1}{8}$. Unsigned. Mount.
Lord Nelson. $4\frac{3}{8} \times 3\frac{1}{8}$. Signed. Mount.
Sir Robert Peel. $4\frac{3}{8} \times 3\frac{1}{8}$. Signed. (Variety also with extended finger).
So Tired. $6 \times 4\frac{1}{8}$. Unsigned. Mount.
Copper. Your Honour. $6\frac{1}{8} \times 4\frac{3}{4}$. Signed. Mount.
The Holy Family (Large). $14 \times 12\frac{1}{4}$. Unsigned. Mount.
The Morning Call. $6\frac{1}{8} \times 4\frac{1}{8}$. Signed. Mount.
1854
A Mother presenting her Son with the Bible. $4\frac{3}{4} \times 3$. Unsigned. Mount.
The Attack of the Eagle. $4\frac{3}{4} \times 3$. Unsigned. Mount.
Charge of the British Troops. $4\frac{7}{8} \times 9\frac{1}{2}$. Signed. Mount.
Crystal Palace, Sydenham. $5\frac{1}{2} \times 11\frac{3}{4}$. Signed. Mount.
Cupid and Psyche. $4\frac{3}{4} \times 3$. Unsigned. Mount.
Dog and Serpent, The Attack. $4\frac{3}{4} \times 3$. Unsigned. Mount.
Dog and Serpent, The Defence. $4\frac{3}{4} \times 3$. Unsigned. Mount.

Ecce Homo. 6 × 4¼. Unsigned. Mount.
The Faithful Messenger. 4⅜ × 3. Unsigned. Mount.
Girls Fishing. 4¾ × 3. Unsigned. Mount.
The Greek Slave. 4¾ × 3. Unsigned. Mount.
Hagar and Ishmael. 4¾ × 3. Unsigned. Mount.
Infant Samuel Prayer. 6 × 4¼. Unsigned. Mount.
The Lion in Love. 4¾ × 3. Unsigned. Mount.
Mazeppa. 4⅜ × 3. Unsigned. Mount.
News from Australia. 4⅜ × 6. Signed. Mount.
The Ninth Hour. 8¼ × 6½. Unsigned. Mount.
The Pompeian Court. 7½ × 11½. Unsigned. Mount.
Proposed Communist Settlement. 6 × 9. Unsigned*.
Sabrina. 4¾ × 3. Unsigned. Mount.
Siege of Sebastopol 4¼ × 6¼. Unsigned. Mount.
The Slaves. 14½ × 12. Unsigned. Mount.
The Soldier's Farewell. 4⅜ × 6. Signed. Mount.
So Nasty! I Don't Like It. 6⅛ × 4¼. Signed. Mount.
The Third Day He Arose Again. 8¼ × 6⅝. Unsigned. Mount.
The Unhappy Child. 4¼ × 3. Unsigned. Mount.
The Veiled Vestal. 5⅛ × 3⅞. Unsigned. Mount.*
Crystal Palace Gardens. 4½ × 6½. Signed. Mount.
Review of the British Fleet at Portsmouth. 5 × 9⅞. Signed. Mount.
Rinaldi and Armida. 4¾ × 3. Unsigned. Mount.

1855
Ascent of Mont Blanc. 4¼ × 6. Unsigned. (A set of four). Mount.
Dover Coast. 8 × 10⅞. Unsigned. Mount.
It is Finished. 6 × 4¼. Unsigned. Mount.
The First Lesson. 8½ × 6½. Signed. Mount.

1856
Edmund Burke. 3½ × 2½. Unsigned. Mount.
Fruit Piece. 5⅛ × 6½. Unsigned. Mount. (A set of two).
The Gardener's Shed. 15 × 11. Signed. Mount.
Gathering Roses. (Summer Time). 6 × 4½. Signed. Mount.
Harvest Time. The Gleaners. 6 × 4¼. Signed. Mount.
The Hop Garden. 6 × 4⅛. Signed. Mount.
The Lover's Letter Box. 15 × 10⅞. Signed. Mount.
The Mountain Stream. 14¾ × 11. Signed. Mount.
The Daughter of the Regiment. 6⅛ × 4⅛. Signed.
Rev. John Wesley. 4¼ × 3¾. Unsigned. Mount.
Puss Napping. 4⅜ × 6¼. Signed. Mount.
Queen Victoria with Head-dress. 4⅜ × 3. Unsigned. Mount.

Plate 20. The Hon. Philip Sydney Pierrepont acet 61, A.D. 1847 by and after E. Walker (20⅝ × 15¾) Lithograph.

Plate 49. Lambeth House. By and after Holler, dated 1847. $(11\frac{1}{4} \times 5\frac{5}{8}.)$

105

Plate 21. Dover Harbour by and after W. Burgess. Published 1844 $(11 \times 8\frac{3}{8})$ Lithograph.
Plate 22. The Royal Dockyard by P. C. Canot after R. Paton and J. Mortimer. Published 1793 $(25\frac{1}{2} \times 31\frac{3}{4})$ Line engraving.

Little Red Riding Hood. 6¼×4⅜. Unsigned. Mount.
Short Change. 6×4⅜. Unsigned. Mount.
1857
Come Pretty Robin. 6×4¼. Signed. Mount.
The Cornfield. 3¾×6. Signed. Mount.
Great Exhibition. The Interior. 6×12¾. Unsigned. Mount.
Hollyhocks. 15×11. Signed*.
Infantine Jealousy. 6×4⅛. Signed. Mount.
Lake Lucerne. 10½×15. Signed. Mount.
Vah-Ta-Ha. 3⅜×2⅝. Unsigned*.
1858
Queen Victoria in Robes of State. 15¾×11½. Unsigned. Mount.
The Parting Look. 25×18⅝. Signed.
Prince Consort. 4⅜×3. Unsigned. Mount.
Prince Frederick of Prussia. 3⅜×3⅛. Unsigned. Mount.
See Saw Margery Daw. 6×4¼. Signed. Mount.
Princess Royal. 4⅜×3⅛. Unsigned. Mount.
1859
Christmas Time. 6×4½. Unsigned. Mount.
Stolen Pleasures. 6×4⅜. Unsigned. Mount.
Summer (Large). 10¾×15. Unsigned. Mount.
Winter (Large). 11½×15. Unsigned. Mount.
Wreck of the Reliance (Originally 1843). 11¼×15⅝. Unsigned. Mount.
Dogs of St. Bernard. 17½×24. Unsigned. Mount.
Fruit Girl of the Alps. 15×11. Unsigned. Mount.
Italy. 7¾×6. Signed and unsigned variety.
Map of the Franco-Italian Austrian Campaign. 14½×21. Unsigned.
1860
The First Impression. 13⅞×11½. Unsigned.
Queen Victoria with Hand on Table. 4⅜×3. Unsigned. Mount.
Date Uncertain
Descent from the Cross. 8¼×6⅝. Unsigned. Mount.
Lake Lucerne. 10½×15 (without setting sun). Signed.
Morning Lessons. 3½×2½*.
Title Pages for Pocket-Books. 4⅝×3. Unsigned*.
Music Illustrations
Prince of Wales in Military Uniform. 4½×3¼.
Adoration 1853. 6×4¼. Unsigned.
Belle of the Village. 1854. 8¼×6¼. Signed.
Her Majesty landing at Cove Ireland. 1850. 4⅛×6. Signed.
Empress Eugenie of the French. 1854. 4¼×3. Unsigned.
The Small Exterior of the Great Exhibition 1851. 4×6. Unsigned.

The Holy Family 1850. 6×4.
Jenny Lind 1850. $6\frac{1}{4}×4\frac{1}{8}$. Signed.
Jetty Treffz 1850. $6\frac{1}{4}×4\frac{1}{8}$. Signed.
Vive L'Empereur Napoleon III 1854. $4\frac{1}{4}×3$. Unsigned.
News from Home 1853. $4\frac{3}{8}×6$. Unsigned.
Paul and Virginia 1850. $5×2\frac{7}{8}$. Signed.
Princess Royal 1858. $6\frac{1}{4}×4\frac{1}{8}$. Unsigned.
Reconciliation 1852. $8\frac{1}{4}×6\frac{5}{8}$. Unsigned.
Returning from Prayer 1855. $5\frac{3}{4}×4\frac{1}{4}$. Signed.
Verona Evening Scene 1850. 6×4. Signed. (Two varieties exist one signed in the water, the other signed on the boat).
The above were also produced as prints either in a red seal mount or a stamped mount.

Print Series

*Frosts Eleven Astronomical Diagrams**.
Gems of the Great Exhibition. $4\frac{3}{4}×9\frac{1}{2}$. Unsigned. (A series of six prints).
The Queen and Heroes of India. Unsigned 1857. (A series of ten prints on one sheet).
Allied Sovereigns and their Commanders. Unsigned 1851. (A set of 10 prints, oval portraits $1\frac{1}{8}×\frac{7}{8}$).
Figures and Landscapes. Unsigned 1858. (A set of 10 prints on one sheet).
Greek Dance and Harem Set. Unsigned 1850. (A set of 10 prints on one sheet).
The May Queen Set. Unsigned 1857. (A set of 10 prints on one sheet).
Pas de Trois. (A set of 5 prints).
Fairey Scenes and Pas de Trois 1852. (A set of 10 prints on one sheet).
Fairey Scenes. (A set of 5 prints).
Greek Dance. (A set of 5 prints).
Harem Set. (A set of 5 prints).
Queen's Floral Needlebox Top 1850. 6×4.
Queen's Floral Bouquets. Signed. $3\frac{3}{4}×2\frac{1}{2}$. (Three groups).
Queen's Floral Needleprints. (A set of 10 on one sheet).
The Tarantella Set 1850. (A set of 10 on one sheet).
The Regal Set 1850. Unsigned. (A set of 10 prints on one sheet).
Religious Set 1852. Unsigned. (A set of 10 prints on one sheet).
*Young's Two Plates of Diagrams.**
Raphael Cartoons 1855. (A series of 7 prints uncoloured of religious scenes).

Miscellaneous

Rev. John Williams 1846. Unsigned. $2\frac{3}{4}×2\frac{1}{4}$. (Uncoloured woodcut)*.
Sir David Scott Bart. $8\frac{1}{2}×6\frac{7}{8}$. (Mezzotint)*.
Dr. and Mrs. Milne. $3\frac{3}{4}×3\frac{1}{4}$. (Woodcut)*.
Greenwich Hospital. $3×4\frac{1}{2}$. (Woodcut)*.

BEARD (THOMAS)

Born in Ireland about 1680, and still living in 1728, the date of his demise is uncertain. He was not a prolific engraver, and the few plates he did execute were mainly in mezzotint.

Thomas Wyndham.
The Countess of Clarendon after Kneller.
The Archbishop of Armagh after Ashton. 1728.

BECKETT (ISAAC)

Born in Kent in 1653, still living in 1719, the date of his demise is uncertain. He engraved mainly in mezzotint and although he produced a few landscapes, most of his works were portraiture.

Christopher, Duke of Albemarle after T. Murray. 13½ × 10.
Duchess of Grafton after Kneller.
George, Prince of Denmark after Wissing.
John Duke of Lauderdale after Riley. 13 × 10.
Madame Soames after Kneller.
John Lord Sheffield, Earl of Mulgrave after Kneller.
Beau Fielding after Wissing.
Lady Turner.
Henry, Duke of Norfolk, in armour.
The Duchess of Cleveland after Kneller.
The Confession after Heemskerk.
Thomas Cartwright, Bishop of Chester after Zoust.
The Earl of Melfort after Kneller.
Charles I, after Vandyke.
Charles II.
Henry Compton, Bishop of London after Ryland.

BELL (EDWARD)

The date of his birth is unknown, although he seems to have done most of his work between the years 1795 and 1810, during which time he was noted as an engraver in mezzotint, and for the number of plates he produced after George Morland.

Sheep after Morland.
The Washington Family after J. Paul Jnr, published 1800. 17½ × 21½.
Selling Peas after George Morland.
Selling Cherries after George Morland.
Mutual Confidence after Morland.
Cows after George Morland.
Viscount Nelson after Beechey, published 1806. 24 × 17.
Summer Morning after Singleton, published 1797. 20½ × 15½.
Winter Evening after Singleton, published 1797.

Plate 50. Favourites. By W. Gilder after Edwin Landseer, R.A. (25¼ × 20). Mixed.

BELLIN (SAMUEL)

Supposedly born in London in 1799 and died there in 1893. He was an engraver in pure line and later combined this technique with mezzotint.

The Heart's Resolve after Sarah Satchell. 22 × 27.

The Heather Belles after J. Phillips, published 1851. 17 × 26.

The Gentle Warning after Frank Stone, published 1848. 18½ × 24.

John Gibson R.A. the Sculptor after A. Geddes, published 1839. 12 × 9½.

Queen Victoria opening the Great Exhibition after H. C. Selous, published 1856. 25 × 36.

Jessie Bourne and Colin Grey after Sarah Satchell, published 1852. 20 × 26.

Charles I parting from his Children after John Bridge, published 1841. 20 × 15½.

Imperial Homage to Art, Charles V and Titian after Fisk.

The Heart's Misgiving after Frank Stone.

The Brunette after C. Baxter, published 1851. 11⅞ × 9½.

The Momentous Question after Sarah Satchell, published 1843. 19 × 22.

BENNETT (WILLIAM JAMES)

Born in London in 1787 and died in 1830 in New York. He travelled through Europe and settled in America, consequently many of his scenes in aquatint are on the American way of life and are very rare.

View of Charleston after Cooke.

The City of Washington from beyond the Navy Yard after G. Cook, published 1834. 25 × 21.

New Orleans by and after W. J. Bennett.

New York View, View of the New York Quarantine, Staten Island by and after W. J. Bennett.

Sir W. Hoste's Naval Action off Llissa on March 13th, 1811 after Waldegrave. 5½ × 9.

The Charterhouse from the Playground after Westall.

**The Meeting of the Royal British Bowmen* after J. Townsend, published 1823. 11¾ × 8¼.

BENTLEY (CHARLES)

Born in 1806 and died in 1854. Little is known of this artist, except that he worked mainly in water-colours. Many plates signed 'C. Bentley' are considered by experts to be the work of Joseph Clayton Bentley, or at least not the work of Charles Bentley.

The Falls of Niagara after Cockburn. A series of six aquatints by C. Bentley and others.

Views of Denmark, Norway and Other Northern European Countries. (A series of 24).

BEUGO (JOHN)

Born at Edinburgh in 1750. Chiefly known as an engraver in line. His best print was a portrait of Robert Burns.

Robert Burns after Nasmyth.
Lord Heathfield the Defender of Gibraltar after Koehler.

BEWICK (THOMAS)
Born at Newcastle in 1753 and died at Gateshead in 1828, Bewick revived the art of woodblock engraving at a time when it had almost become extinct in England. His work in this field compares favourably with that of any of the old masters. Much of his work was used to illustrate books.

The Angry Lion.
The Lancashire Bull. $10 \times 13\frac{1}{2}$.
The Elephant.
Chillingham Wild Bull, published 1789 (very scarce). $9\frac{3}{4} \times 7\frac{1}{4}$.
**The Remarkable Kyloe Ox, bred in the Mull, Argyllshire.* Published 1790. $10 \times 13\frac{1}{2}$.

BICKHAM (GEORGE—FATHER AND SON)
Both father and son were engravers of very average merit. The son was noted for his portraits of his father. The father died in 1769 and the son in 1758.

The Whig's Medley.
George Shelley.
John Clarke after Fisher.
George Bickham the elder by his son.
Elizabeth of York.

BIRCH (WILLIAM)
Born at Warwick in 1760. This artist went to America in 1794 but little is known of him after this time. He was known as an average engraver and enamel painter.

Mrs Robinson after Reynolds, published 1792. 7×4.
The Porcupine Inn Yard, Rushmore Hill.
Cottage Children after Gainsborough. $22\frac{1}{2} \times 15\frac{1}{2}$.

BIRCHE (HENRY)
Little is known about this engraver except that he was working in London at the end of the eighteenth century.

Boys and Dogs after Gainsborough, published 1791. $17\frac{1}{4} \times 15\frac{1}{4}$.
Labourers; Gamekeepers, both after George Stubbs, published 1790. 6×10.

BIRD (CHARLES)
Little is known about this artist except that he worked as a contemporary mezzotint engraver.

The Shepherdess after Boucher.
Blackaders Crypt, Glasgow Cathedral.
Amiens Cathedral. $26\frac{1}{2} \times 17\frac{3}{4}$.
Henry the Seventh's Chapel, Westminster. $23\frac{1}{2} \times 15\frac{1}{4}$.

John Cabot and Sons. $11\frac{1}{2} \times 15\frac{1}{2}$.

The Blue Boy after Gainsborough.

BLACKMORE (JOHN OR THOMAS)

Born in London in 1740, died in 1780. Best known as a brilliant mezzotint engraver.

Portrait of Henry Bunbury after Reynolds. 13×10.

A Man in a Cloak after Vandyck.

Sigismunda after Cosway. $13\frac{1}{2} \times 11$.

A Dutch Lady after Hals.

BLAKE (WILLIAM)

Born in London 1737, died in 1827. Blake was a pupil of Basire, and was much preoccupied by the mystical and spiritual aspects of life.

Chaucer's Canterbury Pilgrims. 1810. 14×28.

Les Fetes Chanpetres after Watteau.

The Idle Laundress after Morland. 1783. 8×6.

Lambeth. 1796.

Joseph of Arimathrea among the Rocks of Albion. 1773.

The Industrious Cottager after Morland. 1783. $18\frac{1}{2} \times 15$.

BLUCK (J)

Little is known about this artist except that he was working in London at the beginning of the nineteenth century. He was known for his talents in aquatint.

Chelsea Hospital Interior after Rowlandson and Pugin. $7\frac{3}{4} \times 10$.

Deadman's Bay, Plymouth after W. J. Huggins.

View of Mounts Bay, Cornwall after Tompkin.

Pennsylvania Castle after Upham.

The Custom House after Rowlandson and Pugin, published 1800. $7\frac{3}{4} \times 10$.

View of Regent Street (The Quadrant) after T. H. Shepherd.

View near Haversham, Westmorland after Paine.

Somerset House, Strand after T. H. Shepherd, published 1819.

* *Water Engine—cold bath, Fields Prison* after Pugin and Rowlandson, published 1808. $7\frac{3}{8} \times 10$.

BODGER (JOHN)

Little is known about this engraver, except that he lived at Stilton during the latter years of the eighteenth century.

A Carriage Match on Newmarket Heath. Published 1789. $17\frac{1}{2} \times 28$.

BOND (WILLIAM)

Little is known about this artist, except that the dates of his work range from 1772 to 1807 and his prints are often of value.

The Laughing Girl after Sir Joshua Reynolds. $7 \times 5\frac{3}{4}$.

The Soldier's Reward after Singleton. 14×20.

The Wood Boy after Barker, published 1802. $20 \times 14\frac{1}{2}$.

Plate 51. Blasting Rocks, Linslade, Bucks., Oct. 1837. By and after J. C. Bourne. Published 1837. (13½ × 9½.) Lithograph.

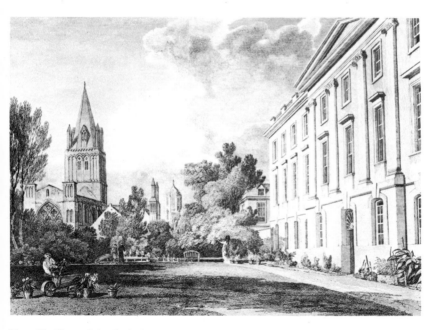

Plate 52. View of the Cathedral of Christ Church and part of Corpus Christi College. By James Basire after J. H. W. Turner. (17¾ × 12½.)

Love Returned after Singleton. 1814. 16 × 12.
The Shepherd Boy after De Koster. 20 × 14½.
The Forester after Barket. 1802. 20 × 14½.
St. Cecilia after J. Russell.
Lady Apsley after Lawrence.
Education after Singleton 1793.
The Visit Returned after Morland.
The Marchioness of Thomond after Lawrence.
Samson and Delilah after Singleton.
The Woodland Maid after Lawrence.

BONE (MUIRHEAD)
Born at Glasgow in 1876, he was a brilliant contemporary etcher, mainly
in dry-point.
Moore's Yard, Cambridge.
The Provost Boat House.
Demolition of St. James's Hall, Interior. 16 × 11.
Ayr Beach.
A Rainy Night in Rome.
A Workshop. 14 × 8¾.
Brewhouses Southampton. 6 × 8.
Oxfordshire. 6 × 9.
The Great Gantry, Charing Cross Station. 10½ × 16½.
Demolition of St. James's Hall, Exterior. 11½ × 11.
Ayr Prison. 5 × 7.
Near Chichester.
Libery's Clock. 8⅜ × 4⅜.
Building Ships.
Chiswick. 7¼ × 8¾.
Stirling Castle.

BOWLES (CARRINGTON)
All that is known about this artist is that he worked in London during the
late eighteenth century, and was known as a printseller who published large
numbers of mezzotint prints.
The Fair Nun Unmasked. 1769. 5½ × 4½.
The Pretty Oyster Woman. 1769. 6 × 4½.
The Cunning Harlot.
The Unfortunate Discovery. 1777. 10 × 13.
Paul Jones, Shooting a Sailor.
The Pretty Barmaid after Collet.
The Sentimental Charmer.
The Bashful Lover.
Expectation.

The Prodigal Son.
South East View of Boston, in New England.
The Roman Emperors. $18\frac{1}{2} \times 13\frac{1}{2}$.
Diana. 13×10.
The Mad Bull.
Love and War. $12\frac{1}{2} \times 10$.
The Death of a Hare. 1790.
Six weeks after Marriage.
The Macaroni Painter. 13×10.
Lady Night Cap at Breakfast.
The Wife at Confession.
John Wilkes. 1770. $12\frac{1}{2} \times 10$.
Repentance. 12×15.
The Beauty Unmasked. 1770. $5\frac{1}{2} \times 4\frac{1}{2}$.

BOYDELL (JOHN)
Born at Dorrington, Staffordshire in 1719, died in London in 1804.
A Country Wake after Ostafe, 1772. 18×24.
Charles I. after Vandyck.
A view near Hadley in Suffolk. 9×13.
The Surrender of Calais. $16\frac{1}{2} \times 22\frac{1}{2}$.
Claude Lorraine.
The finding of Cyrus after Benedetto Castiglione. 1767. $20 \times 14\frac{1}{2}$.
Jason and Medea.

BRANDARD (ROBERT)
Born at Birmingham in 1805 died in London in 1862. This artist is known mainly for his numerous excellent landscapes and as an illustrator of books.
Crossing the Brook after J. M. W. Turner.

BRANGWYN (FRANK WILLIAM R.A.)
Born in Belguim in 1867 of English parents.
The Beggar, Assisi.
Santa Maria from the Street. $22 \times 17\frac{1}{4}$.
Old Cannon Street Railway Station. $27\frac{3}{4} \times 28\frac{3}{4}$.
The Storm. $17\frac{3}{8} \times 18\frac{1}{2}$.
Old Hammersmith.
The Cornfield.
Pont Neuf. $27\frac{7}{8} \times 29\frac{3}{4}$.
Shipbuilding. $15\frac{3}{4} \times 23\frac{1}{2}$.
Notre Dame. $20\frac{3}{4} \times 30\frac{1}{4}$.
The Bridge of Sighs. $27\frac{5}{8} \times 17\frac{5}{8}$.
The Gate of Naples. $20\frac{7}{8} \times 17\frac{7}{8}$.
The Rialto.

Bridge of Valentre. $21\frac{1}{2} \times 32$.
The Black Mill. $23\frac{3}{4} \times 36\frac{3}{4}$.
Browning's House at Venice.
BRETHERTON (JAMES)
Little is known about this artist except that he worked as an etcher and
aquatint engraver during the last quarter of the eighteenth century.
Oliver Goldsmith after Bunbury.
The Easter Hunt at Epping after Bunbury. 23×19.
Pot Fair, Cambridge 1777. $14 \times 18\frac{1}{2}$.
BREWER (J. A.)
Little is known about this artist except that he was an etcher.
Bruges Cathedral.
Venice.
Church of Notre Dame.
Evening on the Meuse.
A Street in Seville.
BRIDGEWATER (HENRY SCOTT)
Nothing is known about this artist except that he was an engraver in
mezzotint.
Mrs Banks after Romney.
Lady Harrington after Reynolds.
Le Baisler Envoye after Greuze.
Mrs Trotter of Bush after Romney.
Mrs Grove after Romney. 19×15.
The Countess of Devonshire after Downman.
The Angel Inn, Manchester after Margetson. $22\frac{1}{2} \times 14$.
Lady Mildmay and Child after Hoppner. $25\frac{1}{4} \times 16$.
Phyllida after Luke Fildes.
Mrs Lee Acton after Romney.
Lady Hamilton as 'Emma' after Romney.
Mrs Carmac after Sir Joshua Reynolds. 24×15.
Lady Leitrim and Child after Sir Thomas Lawrence.
The Frankland Children after Hoppner. $22 \times 17\frac{1}{2}$.
Lady Arabella Ward after Romney.
Lady Payne Galway after Reynolds. $19\frac{5}{8} \times 15\frac{3}{8}$.
Mrs Thornton after Sir Thomas Lawrence.
Lady Waldegrave after Hoppner.
BROCAS (HENRY)
Born in Dublin in 1765, this artist gained a small reputation as a painter
of landscapes.
Four Courts after S. F. Brocas. 1820. 10×16.
The Liffey after S. F. Brocas, 1820. 10×16.

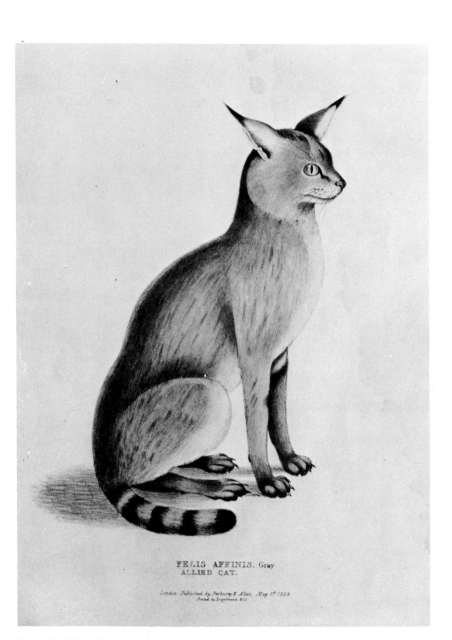

FELIS AFFINIS. Gray
ALLIED CAT.

London. Published by Parbury & Allen, May 1st 1829.
Printed by Engelmann & Co.

Plate 53. Felis Affinis. Gray. Allied Cat. Published 1829. (Lithograph.)

117

BROME (C.)

Nothing is known about this engraver except that he was working in London in 1827.

Lady Hamilton as 'Ariadne' after Romney, 1827. $12\frac{1}{2} \times 10\frac{1}{2}$.

BROMLEY (FREDERICK)

Little is known of this artist except that he was working in London during the middle of the nineteenth century.

Irish Courtship after Topham, 1849. $19\frac{3}{4} \times 25$.

The Gentle Shepherd after Alexander Johnston, 1841. $24 \times 21\frac{1}{2}$.

Sir Richard Sutton and the Quorn Hounds after Sir F. Grant. 20×35.

BROMLEY (JAMES)

Born in 1800, died in 1838. This artist was an engraver in mezzotint.

The Duchess of Kent after G. Hayter.

The Persian Mother after H. Corbould, 1826. 16×11.

Trial of William Lord Russell after Hayter, 1825. 14×21.

George IV after R. Bowyer.

BROMLEY (WILLIAM)

Born at Carisbrooke 1769, died in 1842. Best known for his work as a line engraver.

A Spanish Girl with her Nurse after Murielo. Dr. Fare.

John Abernethy, F.R.S. after Lawrence, 1827.

Charles James Fox after Bowyer.

The Contented Captive after H. Corbould. 12×16.

King George IV. 1827.

Eve of the Battle of Edgehill, 1642, after C. Landseer, 1852. 22×34.

Lord Landsdawne after Sir Thomas Lawrence.

The Seven Ages of Man after Stothard, 1799.

William Pitt after Gainsborough 1808. 24×16.

Cromwell at Marston Moor after A. Cooper, 1826. $10\frac{1}{4} \times 8$.

The Examination of a Village School after G. Harvey, 1841. $18\frac{1}{2} \times 24\frac{3}{4}$.

Lady Jane Grey's reluctance to accept the crown after Leslie, 1829. $15\frac{1}{2} \times 26$.

Sunday Morning—Sunday Evening, both after Alexander Johnson, 1842. 23×18.

The Royal Cortege in Windsor Park after R. B. Davies. 1840. 17×29.

Billy, Rose and Tumbler—three Bulldogs, after D. Wolstenholme, 1834. $13 \times 16\frac{1}{2}$.

Maria, Lady Nugent after Stewart. $11\frac{1}{8} \times 9\frac{1}{8}$.

Mrs Siddons as the Tragic Muse after Reynolds.

The Death of Harold at the Battle of Hastings after A. Cooper. 17×22.

The Reform Banquet, held on July 11th, 1832 after Haddon. 22×17.

BROOKS (JOHN)

Born in Dublin in 1710, the date of his demise is unknown. This artist who worked in London engraved in mezzotint, and line.

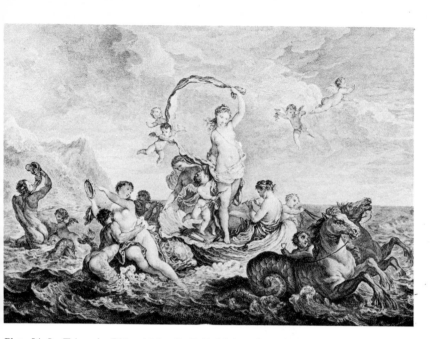

Plate 54. Le Triomphe D'Amphioite, By P. E. Moitte after Mr. Natoire. (16 × 11½.) Line engraving.

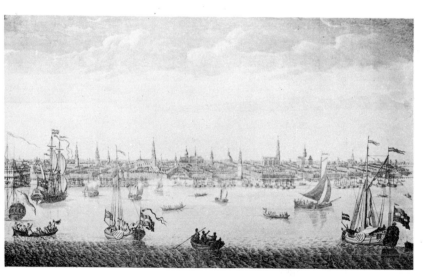

Plate 55. A General View of the City of Amsterdam from the Tye. By T. Bowles after Peter Van Ryne. Published 1794. (15¼ × 9¼.) Line engraving.

119

The Rev. John Abernethy after Latham.

Clement Nevill after Hoare.

Sir John Ligonier after Latham.

Baron Wainwright after Latham.

William Aldrich, Lord Mayor of Dublin in Robes after Lee.

BROOKSHAW (RICHARD)

Born in 1735, still living in 1804, the date of his demise is not known. An engraver in mezzotint Brookshaw lived in Paris for some years.

The Enchantress after Murray.

Samuel Foote, the Actor after Cotes. 1773.

Monsieur Masson, the Tennis Player after Motimer.

The Flight into Egypt after Rubens.

Louis Philippe Duc d'Orleans.

A Dutch River scene, Moonlight, after H. Kobell. $13\frac{1}{2} \times 18\frac{1}{2}$.

Miss Greenfield.

Flora after Ryle.

The Misses Crieuse after Reynolds.

BROWN (ALEXANDER)

Little is known of this artist except that he was living in London in 1675 and worked mainly in mezzotint.

James Dube of York.

Madam Lucy Loftus.

Lady Katharine Seymour, after Hely. $13\frac{1}{2} \times 10$.

Sir John Chichley. $12\frac{3}{4} \times 9\frac{1}{2}$.

Barbara Duchess of Cleveland, after Hely. 18×12.

Henry Sidney, Son of the Earl of Leicester.

BROWN (HABLOT KNIGHT)

Born in Kennington, London in 1815, died in Brighton 1882. This artist was known mainly as a book illustrator and gained reputation illustrating novels of this period by authors such as Ainsworth, Lever and Dickens. He was known as using the pseudonym of Phiz.

The Tumbledown Steeplechase. Twelve coloured plates.

Dame Perkins and her Grey Mare.

The Fine Sons. 1852.

BROWN (JOHN)

Born at Finchingfield, Essex 1741 died in Walworth, London 1801. This artist was mainly an engraver of landscapes.

The Watering Place after Rubens. 1770. 17×22.

The Cascade after Poussin. 1786. 17×23.

The Market Cart after Rubens. 1776.

A Study of Nature after Gainsborough. 18×12.

120

Plate 23. Map of Surrey by Jan Jansson, 1659 (*Richard A. Nicholson*).

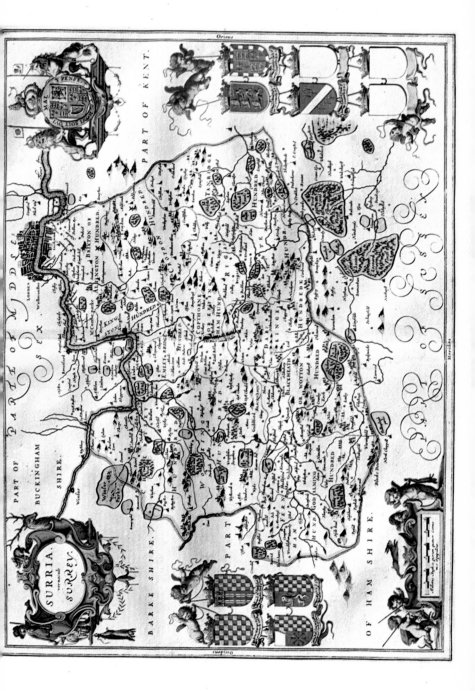

SURRIA vernacule SURREY.

The Sportman after Poussin. 1755. $18 \times 14\frac{1}{2}$.
Philip Baptising the Eunoch, 1772. 17×23.
St. John Preaching after Salvator Rose. 1768. $17 \times 22\frac{1}{2}$.
The Cottage after Hobbema. 1773.

BROWN (RICHARD)

Born in London 1770, died in 1845. This artist was known mainly for his engravings of buildings and Cathedrals.
The Attentive Shepherd after George Morland. 23×17.

BRUCE (JAMES)

Little is known about this artist except that he worked in aquatint at the beginning of the nineteenth century.
View of Kemp Town, Brighton. 12×17.
A series of four views of Brighton.
The Chain Rev at Brighton, during the Storm by and after Bruce. 1820. 8×13.

BURFORD (THOMAS)

Born in 1710, died in London in 1770. This artist is best known for his work in mezzotint.
Doctor Warburton after Phillips.
Going out in the Morning (Horseman and Hounds).
The Contented Shepherd after Teniers. 9×12.
Horse and Hounds, in a Stable.
Flushing Mr Woodcock. 1787. 14×10.
Partridge Shooting, 1787. 14×10.
Vice Admiral John Norris.
Mr Charles Churchill.
William Duke of Cumberland after Murray.
Johnathon Swift after Markham.
Peace, 1789.
Plenty, 1789.

BURKE (THOMAS)

Born in Dublin in 1749, died London 1815. Initially an engraver in mezzoint, Burke later adopted the stipple method whch had become popular through the work of Bartolozzi.
The Battle of Agincourt after J. H. Mortimer, published 1783. $16\frac{3}{4} \times 23$.
Eclipse (a Racer) after G. Stubbs, published 1804. 10×16.
Antony and Cleopatra after Angelica Kauffmann, published 1786.
George Prince of Wales after Cosway, published 1791. 4×3.
The Gleaning Girl after De Koster. $18 \times 14\frac{1}{2}$.
Happiness after J. F. Rigaud, published 1799. 24×18.

BURNET (JOHN)

Born near Edinburgh in 1784, died in London in 1868. Burnet was a

Plate 24. Map of Derbyshire by Saxton. Published 1577 (*Parker Gallery*).

competent painter as well as an engraver, many of his engravings were
after Wilkie.

The Jews Harp after Wilkie.

The School after Wilkie, published 1854.

The Blind Fiddler after Wilkie. $16\frac{1}{2} \times 22$.

Fishing Boats after J. M. W. Turner.

The Frugal Meal after J. F. Herring. 21×30.

The Tethered Ram after E. Landseer, published 1845. $18\frac{1}{2} \times 24\frac{1}{2}$.

The Battle of Waterloo after J. A. Aikinson and A. W. Devis. $16\frac{1}{2} \times 23$.

The Letter of Introduction after Wilkie, published 1823. 18×12.

BUTLER (A.)

Little is known about this artist except that he was living in 1848.

BYRNE (WILLIAM)

Born in London *c*.1740 and died there *c*.1805, most of his work was in line
and his subjects landscapes.

Niagara after Wilson.

Carnavon Castle after Richard Wilson, published 1776. $20\frac{1}{2} \times 14\frac{1}{2}$.

Views of Australian Scenery, a set of nine.

The Death of Captain Cook, published 1784. 24×19.

Landscape with Windmill, river and bridge after John Collet.

CADWALL (JAMES)

Born in London in 1739, and was still living in 1809. He engraved in line
and made frequent use of the etching needle.

The Children in the Woods after Sir Joshua Reynolds, published 1793. 13×11

View of Edinburgh after A. Collender, David Hume.

The Smoking Club after Teniers. $6\frac{1}{2} \times 9$.

Naval Engagement between the 'Quebec' and the 'Surveillante' after G. Carter
published 1780. $17 \times 23\frac{1}{2}$.

The Grand Encampment on Coxheath after Hamilton, published 1778. 20×11

CAREY (W. P.)

This engraver appears to have flourished between 1780 and *c*.1800 other
wise little is known of him.

The Balloon. $5 \times 3\frac{1}{2}$.

A Sketch from Nature after Rawlandson. 12×16.

CATTON (CHARLES)

This engraver was reputedly born in London in 1756, then he emigrated to
America in 1804 and presumably died there. Catton was also a noted artist

Snipe Shooting after Morland, published 1800. 12×15.

Partridge Shooting after Morland. 12×15.

Duck Shooting after Morland. 12×15.

Woodcock and Pheasant Shooting after Morland. 12×15.

Plate 56. Evening. By J. Scott after Paul Potter. (12¾ × 11.) Published 1814. Stipple and line.

Plate 57. Mid-day. By I. H. Wright after Claud Lorraine. Published 1809. (13 × 9.) Aquatint and line.

CECIL (THOMAS)

Cecil worked mainly with the graver in a rather neat style, he flourished about 1630.

Sir John Burgh in armour.

Archibald Armstrong, Jester to James I.

Thomas Kederminster of Langley dated 1628.

CHAMBERS (THOMAS)

Born in London about 1724, an artist who worked entirely with the graver, and was occasionally employed by the famous Boydell.

A Concert after Michelangelo, published 1764. 20 × 15.

The Chavalier D'Eon after Cosway, published 1787. 7 × 4½.

St. Martin Dividing his Cloak after Rubens, published 1766. 24 × 20.

CHEESMAN (THOMAS)

Born in 1760, died *c*.1835, Cheesman engraved mainly in mezzotint and stipple and was considered to be one of the most accomplished of Bartolozzi's pupils.

Love and Beauty after Bartolozzi. 12 × 10.

Death of General Montgomery after Trumbull.

The Lady's last Stake after Hogarth, published 1825.

The Seamstress (Miss Vernon) after Romney.

The Spinster (Lady Hamilton) after Romney, first published 1789. 14 × 10½.

Maternal Affection after R. Westall.

The Songstress by and after Cheesman.

George Washington, Horse in background after Truumbll.

Mrs Waddy after Buck, published 1804. 11 × 7½.

CHESHAM (FRANCIS)

Born *c*.1749, and died in London in 1806, much of Chesham's works were Biblical subjects, but his naval actions are very desirable aquisitions.

The Battle of Copenhagen by Chesham and Wells, after T. Whitcombe.

The Battle of the Nile by Chesham and Wells. A set of four plates.

The Engagement on the Dogger Bank after R. Dodd.

CLARK (J.)

Clark flourished in London between *c*.1789 and *c*.1830. He died *c*.1830. He worked mainly in aquatint but he also engraved in stipple. Many of Clark's prints are ideal subject matter for modern collectors.

Fox Hunting after H. Alken, published 1820. A set of four. 11 × 14½.

A Tandem of the Past after Lt. Downman.

Racing from Newmarket Heath after H. Alken.

The Earth Stopper, published 1820. 12 × 8.

Morning, Noon, Evening and Night by Clark and Jeakes, after Wolstenholme. A set of four.

Sledging after H. Alken, published 1820. 6 × 8½.

Plate 58. Marne rue au Soleil Couchant. By Schroeder after Vernet, Line engraving.

Coursing: and Badger Catching both after H. Alken, published 1820. $8\frac{1}{2} \times 11$.
Cock Fighting after H. Alken. A set of two.
View of St. Helena after Humble. 19×26.

CLINT (GEORGE)

Born in 1770, died in 1854. He engraved in mezzotint and outline lithography, his subjects of interest being theatrical and other portraits, but not exclusively so.
The Duke of Hamilton after J. Lonsdale, published 1804. $17\frac{1}{2} \times 14$.
William Pitt after J. Hoppner, published 1806. 20×14.
The Duke of Wellington after J. Hoppner.
Mr. Antrobus after Lawrence.
Lady Mulgrave after Hoppner.
Mrs. Bannister by and after Clint.
James Belcher, the Pugilist after Allingham.
A Peat Bog in Scotland after J. M. W. Turner.
The Frightened Horse after Stubbs.
Mr Lord, Headmaster of Tooting Schools after Ashby, published 1810. 20×14
A Schoolmaster and his Scholars after Gerrard Down. $10 \times 7\frac{1}{2}$.

COCKSON (THOMAS)

This engraver flourished between *c*.1609 and *c*.1636. The majority of the known works of Cockson are portraits executed in line engraving.
Louis XIII, King of France.
King Charles I, Sitting in Parliament.
The Most Mighty Prince Demetrius of Russia.
John Taylor, Water Poet.
The Most Puissant Prince Matthias.

COLLYER (JOSEPH)

Born in London in 1748, died 1827. He worked with the graver producing line engravings, and later included stipple.
The Volunteers of Ireland after Wheatley, published 1784. 19×26.
The Village Holiday after Teniers. $19\frac{1}{2} \times 30$.
Princess Louisa after Bardon.
Felina after Sir Joshua Reynolds.
Miss Theophila Palmer after Reynolds.
George, Prince of Wales after Russell, published 1793. 14×10.

COOK (THOMAS)

Thomas Cook was born in London *c*.1740 and died there in 1818. He worked mainly in line in a style similar to Simon Francois Ravenet. This is not surprising as he was, at one time, a pupil of Ravenet's.
The Masquerade at Somerset House after Hogarth.
The English Setter. Published 1770.
Dr Samuel Johnson after Reynolds, published 1798. 16×10.

COOKE (EDWARD WILLIAM)

Born in London in 1811, died 1880. He was the son of George Cooke the engraver; One of Edward Cooke's earliest published works was a set of 65 etched plates of 'Shipping and Craft', beautifully composed and accurate in detail. In 1832, he foresook engraving for oil painting and eventually became a Royal Academician in 1864.

COOKE (WILLIAM BERNARD)

Born in London in *c*.1778 and died there in 1855. He worked entirely in line, mainly in connection with book illustrations.

Bridport, Dorsetshire after J. M. W. Turner. $7\frac{1}{2} \times 11$.
Old London Bridge after E. W. Cooke.
Plymouth Citadel after J. M. W. Turner. $7\frac{1}{2} \times 11$.

COUSEN (JOHN)

Reputed to have been born in Bradford in 1803 and died in the vicinity of London in 1880. He worked mainly in line.

The Morning after the Wreck of a Dutch East Indiaman after Stanfield. $10\frac{1}{2} \times 16$.
Venice after C. Stanfield.
St. Michael's Mount after J. M. W. Turner.
The Cover Side after J. R. Lee. 12×9.

COUSINS (SAMUEL)

Cousins was born in Exeter in 1801 and died in 1887. He was a most famous mezzotint engraver, and prolific—he engraved some 200 plates, the majority of which were portraits.

Mrs Braddyll after Reynolds.
Sir Ashley Cooper.
John Wilson Croker after Lawrence.
Lady Acland after Severn, published 1856. $9\frac{3}{4} \times 7\frac{1}{2}$.
H.R.H. Prince Albert after J. Lucas.
Master Hope after Lawrence, published 1836. $7\frac{1}{4} \times 7$.
William Wilberforce after Richmond.
Cherry Ripe after Millais. 20×14.
The Maid of Saragossa after Wilkie.
Playmates after H. Merle.
Yes or No after Millais.
The Early Dawn after Cristall.
A Message from the Sea after Howard. $13 \times 10\frac{1}{2}$.
A Midsummer Night's Dream after Landseer. 21×34.
A Piper and a Pair of Nutcrackers after Landseer.
The Picture of Health after Millais.
Elizabeth Fry after G. Richmond.
The Duchess of Devonshire after Reynolds.
Earl Grey after Lawrence.

The Golden Pippin after Greuze.

Beatrice Cenci after Guido Reni, published 1835. 10 × 8.

DANIELL (JAMES)

An engraver in mezzotint who worked in London during the latter part of the eighteenth century, apart from this information little is known about him.

Nelson at the Battle of Cape St. Vincent after Singleton.

Young Cottagers after Livesey.

Attack on Fort Royal, Martinique by the Zebra after Singleton.

Samuel and Eli after Copley, first published 1797.

DAVEY (WILLIAM TURNER)

Davey appears to have been born in London in 1818, but his death is unrecorded. Despite the lack of information about Davey, he did produce a large number of desirable plates.

Dray Horses after Herring. 12 × 15½.

Deer Stalking near Balmoral after Ansdell, published 1854. 17 × 32.

Eastwood Ho after Henry O'Neil, published 1860. 26 × 32.

Home Again after Henry O'Neil, published 1861. 26 × 32.

The Fathers of the Pack (Pytchley Harriers). 24° circular. Published 1880.

Misers Alarmed. 14 × 17.

The Straw-yard after Herring, published 1848. 19¾ × 25¾.

DEAN (JOHN)

Born in London c.1750, died there 1805. Dean was a pupil of Valentine Green and a mezzotint engraver of average ability.

The Happy Family after Morland, published 1787. 18 × 14.

The Earl of Darlington and His Foxhounds after B. Marshall, published 1810. 22 × 24.

The Marriage after Wheatley, published 1787. 18 × 14.

A Shepherdess after Hoppner. 15¼ × 11.

Mrs. Hoppner (The Salad Girl).

Valentine's Day after G. Morland. 18 × 14.

Marriage a-la-Mode after Hogarth, a set of six.

DICKINSON (WILLIAM)

Born in London in 1746, and died in Paris in 1823. He was a Mezzotint engraver, but he also produced some plates in stipple. His Mezzotint engravings, mainly portraits, rank among the best examples of the techniques ever produced.

George II after Pine.

The Deserter after Bunbury.

The Country Club after Bunbury, published 1782. 18½ × 14½.

Lady Sefton after R. Cosway. Published 1783.

Napoleon Bonaparte after F. Gerard.

Earl Temple after Reynolds, published 1778. 17 × 14.
Admiral Augustus Kepple after Romney.
Black Eyed Susan after Bunbury.
The Duchess of York after J. Hoppner.
Helena Forman, wife of Rubens after Rubens.
Imogens Chamber, published 1786. 13 × 8½.
Miss Benedetta Ramus after Romney.
The Fortune Teller, published 1802. 9 × 7¼.

DICKSEE (HERBERT)
Dicksee was born in London in 1862, he primarily worked as an etcher, and many of his plates were published in the early part of the twentieth century, a little late for most collectors, but some of his early works are worthy of attention, the majority of which were on vellum.
My Lady Sleeps.
Rouders. 15½ × 25.
Nearing Home.
Primrose Gatherers.
The Monarch of the Desert.
A Lion's Head.
Geese.
Maternal Care.
The Death of Gordon.

DIXON (JOHN)
Born in Dublin *c.*1740 and died in London *c.*1780. He worked mainly in mezzotint.
Betty after Falconet.
A Political Lesson by and after Dixon.
David Garrick as 'Abel Drugger' in 'The Alchemist' after Zoffany, published 1776. 14½ × 11.
Miss Annabella Blake after Reynolds.
A Tigress after Stubbs.
Henry, Earl of Pembroke, published 1771. 17 × 13.
Nelly O'Brien after Reynolds.
Countess of Pembroke and Son after Reynolds.
Henry, Duke of Buccleuch after Gainsborough.

DODD (ROBERT)
Robert Dodd was reputed to have been born about 1748, and was still living in 1816. He was fundamentally a marine artist who worked in oils, but he was also an extremely competent engraver in line and aquatint. He produced many plates after his own paintings, and these he invariably

published himself. A name to be remembered for the collector's interested in marine subjects.

Mutineers of the Bounty, turning Lieutenant Bligh adrift, published 1790. 18×24.

The Wreck of the Ramilles. Published 1782. A series of four. 14×20.

The Royal Dockyard at Woolwich.

The Battle of Trafalgar by and after R. Dodd, published 1806, a set of two. 16×24.

The 'Clorinde' Brought into Action by and after R. Dodd. Published 1814.

The Battle of the Nile. First published 1799. A set of four plates. $16\frac{3}{4} \times 20\frac{1}{2}$.

The Racehorse 'Escape' after Sartorious.

'The Night of the Action' and the Sequel to the Action by and after R. Dodd. published 1799. $17\frac{1}{2} \times 24$.

The Action of the Night of April 21st. 1798 by and after R. Dodd, published 1798. $17\frac{1}{2} \times 24$.

Part of the Crew of H.M.S. Guardian, endeavouring to escape in boats when blocked by the Ice by and after R. Dodd, First published 1789. 24×16.

The Mars bringing her prize out of the Passage du Raz, the 'Jason' Frigate having come up some time after the Enemy had struck by and after R. Dodd, published 1799. $17\frac{3}{4} \times 25\frac{3}{8}$.

Coming up with the Chase. $11 \times 7\frac{3}{4}$.

DUNCAN (EDWARD)

Duncan was born in London in 1803 and died in 1882. He was a water-colour artist who specialised in landscapes, but he also engraved etchings, lithographs and aquatints, the latter, no doubt, learnt whilst he was apprenticed to Robert Havel, the aquatint engraver. Much of the work of this engraver will appeal to modern collectors, as they include a preponderance of naval and sporting subjects.

South Sea Whale Fishery after Garnery, first published 1836, comprising a pair. $16\frac{1}{4} \times 25$.

The London and Croydon Railway. Published 1839.

Vie off Gravesend after Huggins.

View off Portsmouth after Huggins.

The Racehorse 'Cotherstone'

The Racehorse 'Deception', winner of the Oaks after G. Hancock, published 1839. $15 \times 19\frac{1}{2}$.

Capture of the Slave Brig. 'Midas' by H.M. Schooner 'Monkey'.

Hurricane off Port Louis, Isle of France after Huggins. $18 \times 25\frac{1}{2}$.

H.M.S. Cambrian after N. M. Condy. 13×18.

St. Giles, winner of the Derby in 1832 after Ferneley, published 1832. $12 \times 16\frac{1}{2}$.

St. Helena after Huggins. 12×29.

Defeat of the Squadron of Don Miguel on the Night of the 10th October off Vigo after Huggins. $13\frac{1}{4} \times 21$.

View of Swan River Australia.
**Launch of the East India Company's ship 'Edinburgh'* after Huggins, published 1827. 16×23.
**Lord Lowther leaving Prince of Wales Island* after Huggins, published 1828. $14\frac{5}{8} \times 22$.

DUNKARTON (ROBERT)

Born in London in 1744, and still living in 1811. He was an engraver in mezzotint and an extremely competent one. The majority of his prints were portraits or similar.

The Sailor's Orphans after Biggs. 18×23.
John Monk, the Hertfordshire Huntsman after Morland.
The Harvest Man after W. Artand, published 1805. $14 \times 17\frac{3}{4}$.
The Young Anglers.
William Pitt after A. W. Devis, published 1805. $25 \times 16\frac{1}{2}$.
Henry Addington, Viscount Sidmouth after Copley, published 1799. 26×18.
The Welcome Home after W. R. Bigg. 19×24.
Jonas Hanway after E. Edwards, published 1780. $22\frac{1}{2} \times 17$.
Joseph Sold by his Brethren, published 1782. $24 \times 19\frac{1}{2}$.
The Water Mill after J. M. W. Turner, published 1812. 8×11.

DUTTON (T. G.)

Dutton was working in London between the years 1845 and 1878. He was a skilled lithographer who concentrated mainly on naval subjects, his work is now in high demand because of their excellence and the current interest in shipping prints.

The English and French Fleets in the Baltic after O. W. Brierly, a series of five.
H.M.S. 'Forte' at Rio de Janeiro after Tupman, published 1862. 17×22.
Yacht 'Aline' View at Sea by and after T. G. Dutton, published 1867. $14\frac{1}{2} \times 24$.
Yacht 'Cambria' A Starboard View off the Needles, Isle of Wight, at the finish of the Anglo-American Yacht Race of August 1868 by and after T. G. Dutton, published 1868. $14\frac{1}{4} \times 23\frac{3}{4}$.
** The Great Atlantic Yacht Race. The Start off Sandy Hook, with the Yachts 'Henrietta', 'Vesta' and 'Fleetwing'* by and after T. G. Dutton, published 1867. 14×24.
Yacht 'America' Port View off Cowes after O. W. Brierly, published 1851. 12×18.
Steamship 'Orient' Port View under Sail and Steam by J. B. Day, after T. G. Dutton, published 1879. $10\frac{7}{8} \times 17\frac{7}{8}$.
H.M.S. 'Victory' March 17th, 1847 by and after Dutton, published c.1847. $11\frac{3}{4} \times 18$.
The Saving of H.M.S. 'Sappho' off Honduras December 11th, 1849, under Commander R. C. Michell by and after T. G. Dutton, published c. 1840. $10 \times 14\frac{1}{4}$.

H.M.S. 'Penelope' Port View at Sea under Steam and Sail by and after T. G. Dutton, published 1843. $11\frac{1}{2} \times 15\frac{1}{2}$.

**Clipper Ship 'True Briton' Port View at Sea under Sail* by and after T. G. Dutton. Published 1861.

**Cynthia with Mosquito and Heroine in Torbay* 1849 after Condy. Published 1850. $12\frac{1}{4} \times 17\frac{5}{8}$.

**Taeping in the China Seas with Fiery Cross* 1866 after Dutton, published 1866. 12×18.

EARLOM (RICHARD)

Born in London in 1743, and died there in 1822. Most of his plates were executed in mezzotint, but he also worked in stipple.

The Royal Academy of Arts after Zoffany, published 1773. 19×28.

Lord Nelson after Beechey. $7\frac{3}{4} \times 14$.

Admiral Barrington after B. Wilson, published 1779. $13\frac{1}{2} \times 11$.

G. B. Cipriani after Rigaud, published 1789. $6\frac{1}{2} \times 4$.

Dutch Conversation after Heemskerk. 11×14.

Marriage à la Mode after Hogarth, a set of six.

A Landscape, with a water-mill after Hobbenia. Published 1769.

The Brewery, Chiswell Street after George Garrard, published 1791. 17×22.

A Concert of Birds after Mario de Fiori, published 1778. $16\frac{1}{2} \times 22\frac{1}{2}$.

The Holy Family after Rubens, published 1771. 24×15.

Lioness and Whelps after Northcote, published 1793. 20×25.

The Singing Lesson after Scalken, published 1770. 20×16.

**The Honourable Samuel Barrington, Admiral of the Blue* after Sir Joshua Reynolds, published 1791. $10\frac{7}{8} \times 13\frac{1}{8}$.

**Sir Charles Thompson, Baronet, Vice Admiral of the Red* after Gainsborough, published 1799. 11×13.

EGINTON (FRANCIS)

Born in Birmingham in 1775 and died in Shropshire in 1823. The works of this engraver included a considerable number of plates for book illustrations as well as a number of individual plates. He illustrated Shaw's 'History of Staffordshire' and Wheler's 'History of Stratford-on-Avon'. He was also well known as a glass painter.

Setting out to the Fair after Wheatley, published 1792, $18\frac{1}{4} \times 22$.

The Jealous Rival after Wheatley. $12\frac{1}{2} \times 10$.

Ophelia. Published 1787. $9\frac{3}{4} \times 8$.

Filial Piety after Wheatley, published 1792. 12×10.

Portrait of George III by and after Eginton. 6×5.

ELLIS (WILLIAM)

Born in London 1747 and died there 1802. He engraved in line and aquatint, his subjects being mainly landscapes although not exclusively so.

The Memorable Victory of the Nile after Chesham. 17×15, a series of four.

Shakespeare's Birthplace after T. J. Clark.
Robinson Crusoe and his Dog after Pollard, published 1800. 16 × 22.
View of London from Greenwich after Herne and *View of London from Wandsworth* after C. Tomkins comprising a pair.

ENGLEHEART (FRANCIS)

Reputed to have been born in London *c.*1775, and to have died there in 1849. Most of Engleheart's plates were produced to illustrate books, but he did also produce a few individual plates.

FAIRLAND (THOMAS)

Born in London in 1804, died there in 1852. He was both a line engraver and lithographer.
The East India Company's Frigate 'Memnon'.
View of Cape Town after Gunston. 16 × 21.
The Long Sermon after W. Hunt. 14 × 9.
The Keeper's Pony after W. Barrund. 11½ × 14.
Dray Horses after A. Cooper. 16¾ × 20⅝.
William Penn's Treaty with the Indians. 12¾ × 18½.

FAITHORNE (WILLIAM) the elder

Born in London *c.*1616 and died there in 1691, he worked almost exclusively with the graver, and most of his engravings were portraits. Faithorne also had a print shop, where he sold his own engravings and those by other artists.
The Most Mightie and Illustrious Prince Charles.
Prince of Great Brittaine after Dobson.
Charles I, King of England.
Charles II, 'Heire of ye Royall Martyr', (the first state before the arms and the inscription) *'The Second Charles' Heire of the Royall Martyr'. Queen Elizabeth, seated between Lord Burleigh and Sir F. Walsingham.* Published 1655.
Charles I on horseback with view of London 1643.
Queen Henrietta Maria.
The most Renowned and Hopeful Prince William, Prince of Orange:
William II, Prince and *Mary, Princess of Orange* (2):
Mary, Princess of Orange after Vandyck:
Charles II, Proclaimed King at Worcester:
Carolus II, in armour:

FIELDING (NEWTON SMITH)

Born in Huntingdon in 1799, died in France in 1856, he was a competent artist, and executed a few lithographs of general interest.
View of Cape Town and The Environs:
Roebuck Shooting, Scotland. Roebuck Shooting France, by and after Fielding a pair, published 1838, 9 × 12.
Cock-Fighting by and after N. Fielding, set of six. Published 1853. 5¾ × 7¾.

FINDEN (WILLIAM AND EDWARD FRANCIS)

William Finden was born in 1787 and died in 1852, his brother Edward died in 1857. William was a line engraver of considerable merit, and he worked with his brother Edward, chiefly on plates for book illustrations.

The recent popularity of the small book plate has resulted in a demand for books illustrated by these brothers, which are then broken and the prints sold separately, especially those showing English views.

FINLAYSON (JOHN)

Reputed to have been born *c*.1730 and supposedly died *c*.1776. He was an engraver in mezzotint and most of his plates were concerned with portraiture. After his death, Boydell apparently acquired his plates and produced prints from them without any alteration of the address.

Elizabeth, Lady Melbourne after Reynolds.

Lady Charles Spencer after Reynolds.

Robert, Lord Romney after Reynolds. $23\frac{1}{2} \times 15$.

Samuel Foote and Thomas Weston as the President and Dr Last after J. Zoffany.

David Garrick, in the character of Kitely after Reynolds. Published 1769. 14×11.

William Drummond, of Hawthornden after Janson.

FISHER (EDWARD)

Born in Ireland *c*.1730 and died in London *c*.1785. He was an engraver in mezzotint, many of which were after Reynolds.

The Ladies Yorke after Reynolds.

The Marquis of Rockingham after Reynolds, published 1774. $22\frac{1}{2} \times 14$.

Mark Akenside, the Poet. Published 1772.

Hope Nursing Love (Theophila Palmer) after

Sir Joshua Reynolds. Published 1771. 20×14.

Christian VII, King of Denmark after Dance.

John, Earl of Bute after Reynolds.

Lady Elizabeth Lee after Reynolds.

John, Lord Ligonier after Reynolds. 20×18.

FITTLER (JAMES)

Born in London in 1758 and died at Turnham Green in 1835. He was a celebrated artist and a very competent line engraver. Although much of his work was executed for book illustration, he also produced a number of interesting individual plates, including landscapes and marine subjects.

Selina, Countess Dowager of Huntingdon after Bowyer, published 1790.

Views of Windsor Castle a pair, after George Robertson.

The Iron Bridge over the Severn after Robertson. $14 \times 20\frac{1}{2}$.

The Battle of the Nile after De Loutherbourg, published 1803. 20×30.

Battle of Quebec by Fittler and Lerpiniere, after R. Paton, published 1783. 20×30.

The Turnpike after George Morland, published 1796. 8×10.

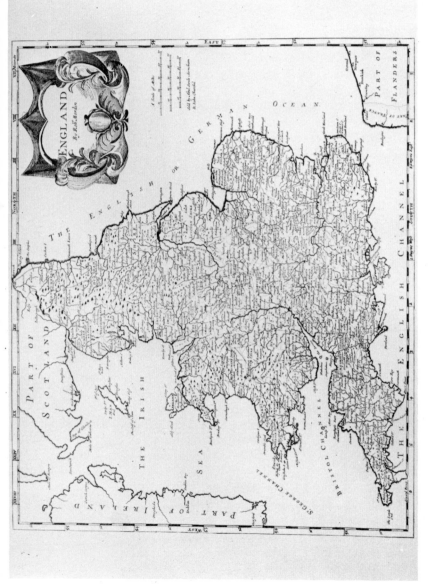

Plate 59. England. By Robert Morden. Published 1695 and 1753.

135

FRYE (THOMAS)

Born about 1710 in Dublin, died in London in 1762. He was a mezzotint engraver most of which were portraits.

Frederick, Prince of Wales.

Queen Charlotte.

Captain Cook.

A series of eighteen life-size heads.

Man with a Finger pressed against Cheek.

Old Man with Spectacles in Right Hand.

GILES (J. WEST)

Giles was apparently working in London about 1850. He was a lithographer, noted for his sporting subjects.

Famous Huntsmen, a set of four after R. B. Davis.

A scene in the Highlands after Herring. 21×32.

Fox Hunting: The Meet, The Start, The Run and The Death, a set of four after J. F. Herring, published 1854. $22\frac{1}{2} \times 33\frac{1}{2}$.

The Donkey Race, The Start, Coming In, published 1850.

An Officer of the 2nd Life Guards after Martens. 12×9.

GODBY (JAMES)

Godby was working in London between 1800 and about 1820. He engraved in stipple, and produced many stipple engravings printed in colour. Other than the fact that his work was of excellent quality, little else is known about him.

Britain's Glory, Britain's Pride, a pair after Singleton, published 1808.

Fortitude after M. David. $11 \times 7\frac{1}{2}$.

The Meeting of Isaac and Rebecca after Smirke. 21×17.

The Miraculous Draught of Fishes after Raffaelle.

Dido's Sister after Guerin. 7×5.

My Dogs after Craig.

Christ in the Judgment Hall after Smirke. 21×27.

Hare Hunting by Godby and Merke, after S. Howitt. published 1807. $13\frac{3}{4} \times 19$.

GOODALL (EDWARD)

Born in Leeds in 1795 and died in London in 1870, best known for his interpretative plates after Turner.

The Ferry after F. R. Lee. $11\frac{1}{2} \times 15$.

The Piper after F. Goodall, published 1857. $19 \times 13\frac{1}{2}$.

The Soldier's Dream of Home after F. Goodall, published 1847. 25×30.

An Italian Seaport after Claude. 18×16.

GREEN (VALENTINE)

Born at Salford (near Evesham) in 1739 and died in London in 1813. He was a mezzotint engraver, and such was his mastery of the style, that his

works are regarded as being among the best ever produced.

Lady Caroline Howard after Reynolds.

Frederica, Princess of Orange, published 1773. $11\frac{1}{2} \times 9$.

Jane, Countess of Harrington after Reynolds, published 1780. $23\frac{1}{2} \times 15\frac{1}{4}$.

Mark Beaufoy after Gainsborough. $17\frac{3}{4} \times 14\frac{3}{4}$.

Lady Townshend after Reynolds. $23\frac{1}{2} \times 15$.

Valentine Green after Abbott, published 1788. $17\frac{1}{4} \times 14\frac{3}{4}$.

A School after Opie, published 1785. $20 \times 24\frac{1}{2}$.

The Air Pump after J. Wright.

Jupiter and Io after Hoppner, published 1785. 21×17.

Venus rising from the Sea after Barry, published 1772. $24 \times 15\frac{1}{2}$.

Lady Henrietta Herbert after the same. $16\frac{7}{8} \times 13$.

The Duchess of Rutland after Reynolds, published 1780. $23\frac{1}{2} \times 15\frac{1}{4}$.

Garrick, standing by a bust of Shakespeare after Gainsborough. $23\frac{3}{4} \times 15\frac{1}{8}$.

John Boydell, engraver after Josiah Boydell, published 1772. $13 \times 16\frac{1}{4}$.

GROZER (JOSEPH)

This engraver in mezzotint and stipple was born in London some time during the middle of the eighteenth century. Unfortunately the date of his death is unknown.

The Industrious Mother after W. Singleton.

James Brudenell, Earl of Cardigan after Romney.

A Child with a pet lamb after J. Westall.

Children Gathering Blackberries after George Morland.

The Envied Glutton after H. P. Dantoux. 12×10.

A Litter of Foxes after Lorraine Smith and George Morland, published 1797. 18×24.

Mrs Seaforth and Child after Reynolds ('Lady and Child'), published 1787.

Morning, or the Benevolent Sportsman after Morland.

The Death of Dido after Reynolds. 28×18.

HADEN (SIR FRANCIS SEYMOUR)

Born in London in 1818, and died 1910. He was an etcher of outstanding sikll, who founded the Royal Society of Painter-Etchers.

The Water Meadow, 1859. 6×9.

Out of the Study Window. $4\frac{1}{8} \times 9\frac{7}{8}$.

Mytton Hall, 1859. $4\frac{3}{8} \times 10\frac{1}{8}$.

Coombe Bottom, 1860. $4\frac{1}{2} \times 8$.

The Two Asses.

Whistler's House, Old Chelsea. $6\frac{7}{8} \times 13$.

Horsley's Cottages. $6\frac{7}{8} \times 9\frac{3}{4}$.

Battersea Bridge. 7×10.

Breaking up of the Agamemnon 1886. $10\frac{1}{4} \times 19$.

The Cabin. $5\frac{1}{2} \times 8\frac{7}{8}$.

A Backwater. $5\frac{1}{2} \times 8$.

Inside the Cork Convent, Cintra. $6 \times 8\frac{7}{8}$.

Little Calais Pier, View from the Sea. $3 \times 6\frac{1}{8}$.

The Three Calves. $6 \times 9\frac{1}{2}$.

Harlech. $8\frac{7}{8} \times 12\frac{3}{8}$.

HARRIS (JOHN)

Working in between *c.* 1798 and *c.* 1857, Harris concentrated on sporting subjects many of which were after Robert Pollard, other than this, little is known about him. However, his prints, many of which were printed in colour, will undoubtedly interest the collector of sporting subjects, although he also produced other subjects.

Portsmouth Harbour.

Scenes on the Road to Epsom after Pollard. published 1888. 13×20.

Aylesbury Grand Steeplechase after Pollard.

Fox Breaking Cover after F. C. Turner. $17\frac{1}{4} \times 20\frac{1}{2}$.

The Margate Hoy 1795.

The Bombay Lancers after Henry Martens.

Battle on the Gwanga, June 1846, after Henry Martens. 26×20.

The Merry Beaglers.

Horse Dealing after Scanlon. 1841. $10 \times 15\frac{3}{4}$.

* *The Game Secured* after W. J. Shayer, published 1830. $13\frac{1}{2} \times 18\frac{3}{8}$.

**Flooded* after C. C. Henderson. $23\frac{3}{8} \times 12\frac{3}{4}$.

HAVELL (DANIEL AND ROBERT)

The Havells were Father and Son, and they flourished in London between 1800 and 1840. They employed a large complement of artists and produced a large number of plates in aquatint, both for book illustrations and individual plates.

The Royal Exchange after Shepherd.

Muckross Abbey after R. Walmseley. 1809. $20 \times 24\frac{1}{2}$.

The Niagara Falls by and after R. Havell.

The Reading Telegraph.

The Opening of London Bridge.

Fox Hunting after R. Pollard. $13\frac{1}{2} \times 18\frac{1}{4}$.

HEATH (JAMES)

Born in London 1757, died there in 1834. Heath worked generally in line and produced many plates for book illustrations, but he also engraved many individual plates.

The most Noble Richard Colley Wellesley after Robert Home.

The Woman taken in Adultery.

The Drowned Fisherman after Westall. $16\frac{1}{2} \times 23$.

Maria after F. Burney.

The Children in the Wood after Westall.

Plate 60. Gate of the Viverrambla Grenada. By and after T. S. Boys. Published 1837. ($15\frac{1}{2} \times 10\frac{3}{4}$.) (Lithograph.)

The Riot in Broad Street on the 7th June 1780 after Wheatley. 1790. 18 × 24.
Mrs. Jordan.

HESTER (EDWARD GILBERT)
Born in London in 1843, he worked mainly in mezzotint.
Prince Charlie, Winner of the Middle Park Plate, published 1874. 15 × 20.
Portrait of a Young Lady after Marcus Stone. 13 × 10.
A Fast Twenty minutes after Sheldon Williams. Published 1872. 14 × 23½.
The Liverpool Grand National Steeplechase.
The Doncaster Grand Steeplechase both after Sturgess. 18⅞ × 29½.

HILL (JOHN)
John Hill flourished in London between 1800 and 1814. Eventually he
emigrated to America and died there *c.* 1825. He was an engraver in
aquatint and was employed at one time by Ackermann the publisher. As may
be expected, his American views are scarce, and valuable aquisitions for the
collector.
The School House, Rugby, published 1816.
New York from the Heights near Brooklyn, published 1828.
View of Highate Archway after A. Pugin, published 1812. 15 × 21.

HODGES (CHARLES HOWARD)
Born in London in 1764, died in Amsterdam in 1837. He was a mezzotint
engraver and portrait painter.
Silenus after Rubens, published 1789. 17⅛ × 23.
Protector after Geo. Stubbs.
Potato after Gilpin.
Mrs William Hope, of Amsterdam after Reynolds. 16 × 14½.
Guardian Angel after Reynolds, published 1786.
Mrs Musters as Hebe after Reynolds.

HOGARTH (WILLIAM)
Born in London in 1697, died there in 1764. He commenced his career as
an engraver, but later became a celebrated painter depicting morality of
the times. He was a prolific artist and judged by the number of his prints
available today, it is obvious that they are not in any great demand by
collectors.
The Rake's Progress. 12 × 15.
Marriage à la Mode, by Earlom, 1795–1800. Set of six. 12 × 15.
Lady's Last Stake (Portrait of Miss Salisbury, afterwards Mrs. Thrale).
Sarah Malcolm, executed in Fleet Street, March 7th 1732.
Portrait of Lord Loyat.
The Engraged Musician.
Four Times of the Day.

HOUSTON (RICHARD)
Born in Dublin *c.* 1722, Houston was mainly a mezzotint engraver, but he

was also responsible for a few etched plates.

Mrs Woodhull after Zoffany.

James Sayer aged 13 years after Zoffany.

Peace and Plenty after Pyle, a pair. $5\frac{3}{8} \times 4\frac{1}{2}$.

The Syndicate of Burgomasters at Amsterdam in 1661 after Rembrandt.

Mary, Duchess of Ancaster after Reynolds. 11×9.

The Seasons after Mercier.

Love and Fortune, by Cipriani. 9×12.

A Man Mending a Pen after Rembrandt.

The Set of twelve Racehorses with their Jockeys up after Seymour.

HOWITT (SAMUEL)

Howitt was born *c.* 1765 and died in London in 1872. He was a sporting artist, and painter of natural history subjects. He was responsible for the illustrations in a number of books, the best known of these being 'Field Sports' published 1807, Folio. He also produced a number of individual plates mostly aquatinted.

The Wild Beasts at Exeter Change 1813.

Pheasant, Partridge, Woodcock and Grouse Shooting. Published 1791.

In Full Cry.

HUNT (CHARLES)

Hunt flourished in London during the early part of the nineteenth century. He was an engraver of sporting subjects and noted for his accurate detail. He produced a considerable number of individual plates after Alken, Pollard and others that will greatly interest sportsmen collectors.

Doncaster Races after J. Pollard.

The Rival Whiskers after Theodore Lane. $12\frac{3}{4} \times 10$.

The Highgate Tunnel after Pollard.

The Dying Fox Hunter after F. C. Turner, published 1837. 15×18.

Life and Death of Tom Moody after Pollard, published 1829. $12\frac{1}{2} \times 16\frac{1}{2}$.

The Prize Cow called the Haberloft, after B. Hubbard, published 1841. 16×22.

Post Horses after Herring, published 1841. $21\frac{1}{2} \times 29$.

Trotting after Alken.

The Elephant and Castle, Walworth after S. E. Jones. 17×24.

Quicksilver Royal Mail after J. Pollard, published 1835. $15\frac{1}{2} \times 18\frac{1}{2}$.

A New London Royal Mail, published 1851. $12\frac{1}{2} \times 20$.

Newton Races 1831 after C. Towne.

Liverpool Grand Steeplechase 1839 by and after C. Hunt, published 1839. 22×32.

'Zincance' after J. F. Hunt. $11\frac{1}{2} \times 13$.

'Eclipse' after George Stubbs. $12\frac{1}{2} \times 16\frac{1}{2}$.

The Red Rover, the Southampton Coach.

Views of Quebec. Published 1833.

**The 'Enterprise' Steam Omnibus* after W. Summers, published 1833. $17 \times 12\frac{5}{8}$

JEAKES (JOSEPH)

Little is known about this engraver, exept that he worked in London during the early part of the nineteenth century and usually in aquatint.

View of Kingston, Jamaica. Published 1814. $20\frac{3}{4} \times 35$.

The Battle of Trafalgar and Death of Nelson.

JONES (JOHN)

Born in London about 1750, and is said to have died there in 1797. He was mainly a mezzotint engraver, and he produced many fine portraits in this medium, but he also worked in stipple.

Admiral Lord Hood.

The Honourable Thomas Erskine after Sir Joshua Reynolds.

The Sleeping girl after Reynolds, published 1790. $11 \times 9\frac{1}{2}$.

Juvenile Mischief and Juvenile Impatience after Singleton.

The Ballad Singers after John Rising.

Robinetta after Reynolds, published 1787. 12×10.

Lady Caroline Price after Reynolds.

JUKES (FRANCIS)

Born in Worcestershire in 1745, died in London in 1812. He was an engraver in aquatint who produced many plates, all of the highest quality, covering a wide range of interesting subjects.

The Broken Pitcher after Hoppner.

View of Charlotte Sound, New Zealand after J. Cleveley, published 1788. 19×24.

Melrose Abbey after Catton. published 1811. 16×24.

**The 'Essex' East India man* after T. Luny, published 1785.

View of Millbank after La Porte.

Vauxhall Gardens after Rowlandson.

The Commencement of the Defence of the Arrow after F. Sastorus. published 1805. $17\frac{3}{4} \times 25$.

KNIGHT (CHARLES)

Born in 1743 and still living in 1828. The majority of his works are in stipple, and it is reputed that he was a one time pupil of Bartolozzi.

Cleopatra and Mark Antony after Cipriani. published 1796. 16×12.

The Return from Market after Wheatley. 20×13.

Bait the Bear.

Lady Louisa Manners after Sir Joshua Reynolds.

Love and Hope after Bunbury, published 1786.

Tom and his Pigeons after Russell.

British Plenty, Scarcity in India both after Singleton, published 1794. 16×20.

Winifreds after Banbury.

Plate 61. The Escurial. By and after T. S. Cooper. ($15\frac{1}{2} \times 10\frac{3}{4}$.) Lithograph.

143

Page 62. Bull Fight, Seville. By and after L. Hague. (11¾ × 16¼). Lithograph.

144

The Industrious Cottager after Wheatley.
Surprise (Mrs Wakefield) after Westall, published 1794. $8 \times 6\frac{3}{4}$.

LAURIE (ROBERT)
Born in London about 1740, died there *c.* 1804. He was a mezzotint engraver who specialised, mainly in portraiture.
The Lion and Horse after Geo. Stubbs, published 1791. 18×22.
The Shipwreck after Vernet. 17×22.
A Hard Gale after Vernet. 17×22.
Mrs Frederick after Hamilton, published 1777. 13×10.
Sir Horatio Nelson.
Earl St. Vincent after T. Stuart. $12\frac{3}{4} \times 11$.

LEWIS (CHARLES GEORGE)
Born at Enfield in 1808 and died, near Bognor in 1880. He was a versatile engraver who engraved in line, mezzotint and he also etched.
The Otter Hunt after Landseer.
The Shoeing after Landseer. 31×24.
The Surrender of Kars after T. J. Barter, published 1860. $25\frac{1}{2} \times 50$.
Morning in the Highlands after Rosa Bonheur.
The Melton Breakfast by F. Grant, published 1839. $12\frac{1}{2} \times 28\frac{1}{2}$.

LEWIS (FREDERICK CHRISTIAN)
Born in London in 1779, died at Enfield 1856. A versatile and extremely talented engraver in mezzotint, aquatint and stipple.
View of the Falls of Niagara after J. Vanderlyn.
The Lovely Sisters after Sir T. Lawrence, published 1841. $22\frac{1}{2} \times 18$.
View of Peterhead. $24 \times 16\frac{1}{2}$.
The Quorn Hunt after Alken, published 1835. $12\frac{1}{2} \times 20$.
William IV after Lawrence. 23×13.

LUCAS (DAVID)
Born in 1802, died in 1881. A Mezzotint engraver of great skill, noted for the number of plates he produced after Constable.
The Approaching Storm.
The Departing Storm.
The Lock.
The Vale of Dedham. Published 1836.
View on the River Stour.
Castle Acre Priory.
Sir Richard Steele's Cottage.
A Mill.
A Heath.
Mill-Stream.

LUPTON (THOMAS GOFF)

Born in London in 1791, and died there in 1873. He was an engraver in mezzotint.

Joseph Hutton, LL.D. after C. Baxter, published 1847.

The Meet at Blagdon after J. W. Snow, published 1840. 22 × 32.

Thomas Waring Esq. after A. Cooper, R.A. 24 × 18.

Sir Robert Sale after Clint. 17 × 13.

Sir George Abercrombie after Raeburn.

MACARDELL (JAMES)

Born in Dublin about 1729, died in London in 1765. This engraver in mezzotint has the reputation of being the best engraver in this medium that the British ever produced.

Jacob, Earl of Radnor after Reynolds.

Rubens with his Wife and Child after Rubens.

Helena Forman, second wife of Rubens after Van Dyck. 13½ × 10.

Le Due de Nivernois after Ramsey. 9¾ × 9.

Dean Swift.

John Lockhart after Reynolds.

Edward Boscawen, Admiral of the Blue after Reynolds.

A Boy with a Top after Mercier.

The Tribute Money after Rembrandt. 15 × 20.

Lady in a hat with ribbons after Van der Myn.

Interior with Two Women after Rembrandt.

MACKRELL (JAMES)

Mackrell worked in London about the mid nineteenth century. He worked both in line and aquatint and plates bearing his name will often be found to have been produced in conjunction with other engravers.

The Tipperary Hunt after F. C. Turner.

Lord William after Shayer. 17½ × 23¾.

'Sir Tatton Sykes' Winner of the St. Leger after Herring. 15 × 20.

MALTON (THOMAS)

Born in London in 1726, died in Dublin in 1801. He was an engraver in aquatint and an architectural draughtsman, therefore the majority of his works are of an architectural nature.

Attack on Gibraltar after Koehler, published 1783.

The Inn Yard on Fire after Rowlandson.

View of the Colleges in Oxford.

The Royal Exchange.

MARCUARD (ROBERT SAMUEL)

Born in 1751, and died *c.* 1792. Marcuard was a stipple engraver, who acquired much of his skill in this technique from Bartolozzi.

Children with a Mousetrap after W. Hamilton.

146

The Shepherdess, published 1786.
Susan and Osmund after Ramburg, published 1786.
Innocence after Angelica Kauffman, published 1782. 7 × 8.
The Mothers Care after Bartolozzi.

MASON (JAMES)
Born in 1710, and died in London about 1780. He was a line engraver who specialised in landscapes, some of which are of particular interest and were published by Boydell.
The Fisherman after Poussin, published 1777.
The Herdsmen after Moucheron, published 1774. 16 × 20.
View of Plymouth Fort after G. Lambert and S. Scott, published 1755. 13 × 24.
Landscape after Poussin, published 1744. $12\frac{1}{8} \times 15\frac{1}{4}$.
The Village Pond after Hobberna, published 1786. 19 × 24.
Expedition to Havannah in 1762.

MEADOWS (ROBERT MITCHELL)
Little is known about this engraver except that he was working in London between 1780 and 1810. Some of his stipple engravings are very delicate and beautiful, especially those printed in colours.
Venus and Cupids after R. Westall.
**The Old Shepherd in a Storm* after Westall, published 1813. 18 × 24.
Gathering Fruit and Gathering Wood after Morland, published 1816. 14 × 12.
Pigs after Morland, published 1806. $15 \times 19\frac{5}{8}$.
The Female Pedlar after Singleton, published 1806. $18 \times 15\frac{1}{8}$.

MEYER (HENRY)
Born in London in 1783 and died there in 1847. He worked in mezzotint and stipple and was, at one time, a pupil of the great Bartolozzi.
The Proposal after G. H. Harlow.
Hesitation after S. Drummond, published 1824. $12\frac{3}{4}$.
Lord Nelson after Hoppner.
The Cottage Door, published 1811. 19 × 14.
The Marquis of Huntley after J. Jackson
Boy with a Kitten after W. Owen.
Lord Lynedock after Sir Thos. Lawrence.

MURPHY (JOHN)
Born in Ireland *c.* 1748, died in London about 1800. He worked in both mezzotint and stipple and sometimes combined both techniques on a single plate.
Two Boys playing Marbles after James Ward. 18 × 22.
Morning: Evening: both after Morland.
A Tigress after Geo. Stubbs, published 1798. 19 × 24.
The Royal Family after Stothard, published 1794. 19 × 26.

The Good Children after W. Singleton, published 1798. 19 × 26.
William Pitt after Miller.

NEWHOUSE (C. B.)
Newhouse was working in London in 1845 and will interest collectors of coaching subjects. Prints by this engraver are reputed to be the best of their type ever printed.
Coaching Scenes.
Opposition Coaches.

NUTLER (WILLIAM)
Born in 1754 and died in London in 1802. He was another pupil of Bartolozzi and most of his work was engraved in stipple.
The Haymakers after Singleton.
George Washington after Stuart.
The Old Soldier after Wheatley.
The Stranger at home after Morland, published 1788. 14 × 15¼.
The Absent Father after Singleton, published 1809. 14 × 12.
The Rosebud after Westall. 18 × 21.
Children dividing Fruit after Westall.
The Warrener after S. de Koster. 19 × 24.
The Pheasants Little Maid after Russell, published 1799. 14 × 11

OGBORNE (JOHN)
Born in London about 1725, and died there about 1795. He was basically an engraver in stipple, a technique he learnt as a pupil of Bartolozzi, in his later works he combined line engraving into his stipple.
Mrs Jordan as the Romp after Romney.
Rural Misfortune after Bigg, published 1793.
Girl and Pigs after Westall, published 1802. 9½ × 12¾.
The Affectionate Sisters after Angelica Kauffman, published 1797.
Much Ado about Nothing after Smirke.
Caroline and Lindof after Stothard. 10½ × 13.
Nell Gwynne with the lamb after Lely, published 1802. 9 × 7.

ORME (DANIEL)
Born in Manchester in 1765 he flourished between *c.* 1790 and *c.* 1832. He was a miniature painter, and an engraver, mainly in stipple.
Caroline of Lichfield after Singleton.
The Battle of the Nile. 17 × 23½.
The Death of Chatterton after Singleton, published 1794. 15 × 19.
The Duke of Devonshire's Russian Car. Published 1824. 12 × 20.
The Battle of Trafalgar. Published 1806. 17 × 22½.
The Tomb of Juliet. 13½ × 12.
Bull Fighting. Published 1813.

Plate 64. Saturday Night. By F. Holl after J. Absolon. Published 1852. ($19\frac{3}{4}$ × $9\frac{1}{2}$.) Line engraving.

Plate 65. Sunday Morning. By W. Holl after J. Absolon. Published 1852 ($19\frac{3}{4}$ × $9\frac{1}{2}$.) Line engraving.

Plate 66. The Ice Islands seen the 9th of January 1773. By B. T. Pouncy after W. Hodges. Published 1777. (15 × $8\frac{1}{2}$.)

149

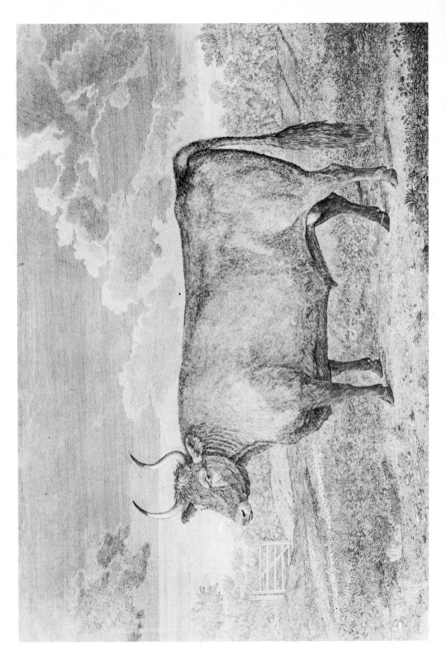

Plate 63. The remarkable Kyloe Ox, bred in the Mull, Argyllshire. By Donald Campbell. ($8\frac{3}{4} \times 12\frac{3}{4}$.) By T. Bewick.
(In the Victoria and Albert Museum.)

PARR (REMI)

Born in Rochester about 1725, and still living in 1755. He was a line Engraver who worked mainly for book illustrations.

Blind Man's Buff.

Old Age after Lancret. 13 × 18.

Famous Running Horses after Seymour, published 1739.

Capture of Portobello by Admiral Vernon after Monamy. 10½ × 14.

PAYNE (JOHN)

Born about 1606 and died in London 1647. He was exclusively an engraver in line, and noted for the quality of his plates.

Sir B. Rudyard after C. Janson.

Sir James Ley, Lord Chief Justice of the King's Bench.

Adrian de Rocquigny, published 1663.

PETHER (WILLIAM)

Born in Carlisle about 1738 died in London in 1821. He was a mezzotint engraver whose best work is considered to be his plates showing considerable contrast between light and shade.

A Farrier's Shop after Wright, published 1771. 17¾ × 23¾.

The Sailor's Farewell after Ramberg, published 1785.

The Hermit after J. Wright, published 1770. 22 × 18.

The Gladiator after Wright, published 1769. 22 × 17.

A Jewish Rabbi. Published 1764. 18 × 14.

The Orrery After J. Wright, published 1768. 19 × 23.

PLACE (FRANCIS)

Born in Yorkshire about 1645 and died in York in 1728. He was mainly an engraver in mezzotint, but he is also credited with a few etchings.

Richard Tompson after Zoust.

'By Yorke' view on the river, cathedral in the distance.

Richard Sterne, Archbishop of York after Tempest.

Oliver Cromwell in Armour after Walker.

Charles I. in his robes after Vandyck.

POLLARD (JAMES)

James Pollard seems to have been working in London between 1795 and 1825 and it is believed that he was the brother of Robert Pollard. The majority of his plates combine stipple, line and aquatint and are usually of a sporting nature or coaching.

On the Highgate Road 'The Woodman' Tavern.

Coursing near Epsom after Sartorias, published 1835. 16 × 21.

The New General Post Office by and after James Pollard.

Mail Changing Horse. Published 1832. 13½ × 17½.

Barefoot with Jockey up by and after James Pollard, published 1823.

POLLARD (ROBERT)

Born in Newcastle in 1755 and died in London in 1838. He was a landscape painter, who turned to engraving and produced plates combining stipple, line and aquatint. Many of Pollard's plates were after his own designs, his subjects were varied and they are usually in demand and will be found to be expensive.

The End of the Town after Singleton.

The Fox Chase after W. Ellis.

The West end of the Town after Singleton.

View on the road to Newmarket Races, Race for the Claret Stakes. Newmarket.

Nelson advancing to meet the French Squadron at the mouth of the Nile, after Pocock.

Dash, a pointer in the possession of Colonel Thronton. $21\frac{1}{2} \times 16$.

Bloomsbury Square after E. Dayes.

PRIOR (THOMAS ABIEL)

Supposedly born in 1809 and to have died in Calais in 1886. He worked exclusively in line and his best plates are considered to be those after J. M. W. Turner.

The Golden Bought after the same. $6\frac{1}{4} \times 10$.

Portsmouth Harbour and Dockyard, published 1853. $8\frac{1}{2} \times 16$.

Windsor Castle after E. Duncan. $8\frac{1}{2} \times 16$.

The Building of Carthage after J. M. W. Turner.

PROUT (SAMUEL)

Born at Plymouth in 1783 and died in London in 1852. Prout is of course, better known for his watercolours. However, he did produce some lithographs, the majority of which were European views. He also produced a few etchings. One must be a little wary when buying Prout's watercolours or prints, many bear his name, but many prove on close examination to be good fakes.

RAIMBACH (ABRAHAM)

Born in London in 1766, died at Greenwich in 1842. He was a line engraver whose style was strong and positive as can be seen from the plate of his 'Village Politicians' illustrated in this book.

The Errand Boy after Wilkie.

The Penny Wedding after Wilkie, published 1832. $16\frac{1}{2} \times 22$.

The Cut Finger after Wilkie, published 1819. 14×24.

Blind Man's Buff after Wilkie, published 1822. $16\frac{1}{2} \times 24\frac{1}{2}$.

* *The Village Politicians* after D. Wilkie.

REEVE (R. G.)

The majority of Reeve's work was executed in aquatint, and their subject matter was usually of a sporting nature. The quality of his work was excellent and consequently his prints are well sought after.

Little is known about him, except that most of his works were executed

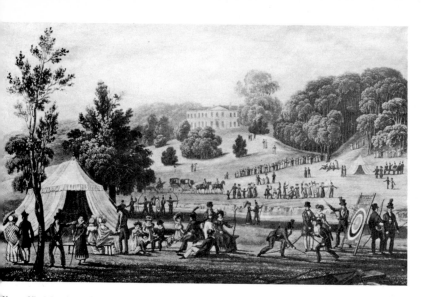

Plate 67. Meeting of the Royal British Bowman. By Bennet after J. Townsend. $11\frac{3}{4} \times 8\frac{1}{4}$. Published 1823. (Aquatint.) Parker Galleries, London.)

Plate 68. An interesting French book-plate 'Reliew'. By Bernard after Lacotte showing book-binders at work.

Plate 69. A Match at the Badger. By I. Clark after H. Alken. 8⅝ × 6⅛. Published 1820. (Aquatint.)
(Parker Galleries, London.)

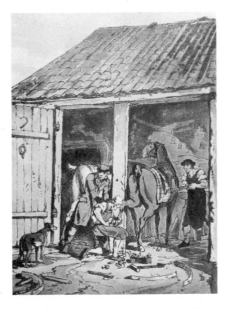

Plate 70. Farriers Shed. By and after J. A. Atkinson. 6¼ × 8½. Published 1807. (Aquatint.) (Parker Galleries, London.)

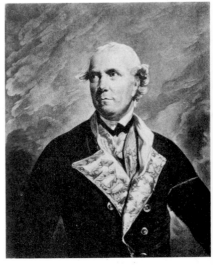

Plate 71. The Honourable Samuel Barrington, Admiral of the Blue. By R. Earlom after Sir Joshua Reynolds. 10⅞ × 13⅛. Published 1791. (Mezzotint).
(Parker Galleries, London.)

154

between 1800 and 1840.
Mail Coach in a Fog after Pollard. $13\frac{1}{4} \times 18$.
Mail Coach in a Flood.
Ascot Grand Stand and Goodwood Grand Stand after Pollard.
Rugby School, with Boys at Cricket after Pretty.
Hare-Hunting after Hodges.
Hobart Town after Evans.
A False Alarm on the Road to Gretna after C. B. Newhouse. $15\frac{7}{8} \times 10\frac{7}{8}$.

REEVE (THOMAS)

Reeve was known to have been working in London about 1820, otherwise little is known about him. Most of his subjects were sporting or allied to sporting and usually command a good price.
Cover Shooting after the same.
Frost Fair on the Thames after Luke Clennell, published 1814. 17×21.
London Fire Engines after Pollard.
Regent Circus, The Angel Inn both after Pollard.
The Fox Chase, set of four, after Wolstenholme. 14×20.
Hunting Scenes after Wolstenholme, set of four.

REYNOLDS (SAMUEL)

Born in London in 1773 and died there in 1835. He was a famous mezzotint engraver, but he also worked in aquatint, stipple, and by etching, sometimes combining more than a single style. His plates are numerous and cover many subjects.
Edmund Kean as 'Brutus' after Northcote, published 1819.
Garrick as Richard III after Dance, published 1825. 19×13.
Dr. William Armstrong.
The Rt. Hon. William Dundas after Hoppner, published 1801. 12×10.
James Heath. $12\frac{1}{8} \times 10\frac{1}{4}$.
Mrs Whitbread after Hoppner, published 1798. 24×15.
Sir John Sebright after P. Boileau, published 1834.
John Opie, the Painter after Opie, published 1798. $10\frac{1}{2} \times 8\frac{1}{2}$.
The Acquittal of the Seven Bishops, published 1840. 21×33.
Eagle and Dead Lamb after Northcote.
The Jew after Rembrandt, published 1846. 18×14.
Paying the Ostler after Morland, published 1805. $18 \times 23\frac{1}{2}$.
The Wounded Hussar after H. P. Briggs, published 1835. $15\frac{1}{2} \times 11$.
The Snake in the Grass after Sir Joshua Reynolds.
The Rustic Conversation after J. Ward.
Rembrandt's Mill after Rembrandt, published 1821. $17\frac{7}{8} \times 21\frac{3}{8}$.
Poor Relations after Stephanoff, published 1829. 17×12.

ROSENBERG (CHRISTIAN)

This engraver was working in London between 1790 and 1815. He worked

mainly in aquatint and often worked in collaboration with other artists who initiated the designs. He produced a large number of very interesting plates, all of excellent quality and very collectable,

Opposition Coaches at Full Speed after Newhouse, published 1832. $11\frac{1}{2} \times 15\frac{3}{4}$.

The Schooner 'Isabel' off Gibraltar after Huggins. 15×19.

Steamships 'Columbus' and 'Phoenix' both after Huggins.

Cape Coast Castle after W. Bartels.

'Viscount Melbourne' off Folkestone.

The Surrey Cricket Ground, a match in progress.

ROWLANDSON (THOMAS)

Born in London 1756 and died there in 1827.

This celebrated artist and etcher's works were mainly connected with books and in this respect he was prolific. He master-minded the production of his designs, often etching the outline personally and then supervising the following stages of aquatinting and colouring by others. This is manifest by the consistency of colour in Rowlandsons prints.

A Field Day in Hyde Park.

Ague and Fever, published 1792. $16\frac{1}{2} \times 22$.

Expedition or Military Fly.

College Jockeys.

Hunting Scene. The Chase.

The Rival Charmers, published 1786.

Duck Shooting after G. Morland.

Vauxhall Gardens.

Box Office Loungers after Wigstead. 16×33.

Racing.

Narcissus.

The Turnpike Gates.

Sly-Boots by and after Rowlandson. 7×5.

The Cries of London, series of 8 plates, published in 1799. $13\frac{1}{2} \times 10\frac{1}{2}$.

RYALL (HENRY THOMAS)

Born in Frome in 1811, died in Cookham in 1867.

An engraver in stipple and line often mixed on the same plates.

Returning from Hawking after F. Taylor. 22×34.

Landais Peasants after Rosa Bonheur.

The Last Supper after West, published 1797. $17 \times 23\frac{1}{2}$.

Flight of Prince Charles of Scotland after Duncan. 21×30.

Death of the Stag after Ansdell. $24 \times 36\frac{1}{2}$.

Just Caught after Ansdell, published 1848. 22×34.

The Holy Well after Burton. 17×23.

RYDER (THOMAS)

Born in London *c.* 1745 and supposedly died there in 1810. He was a

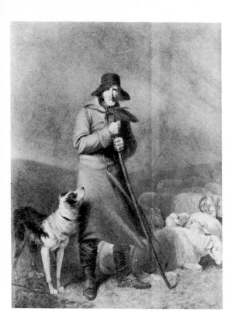

Plate 72. An Old Shepherd in a Storm. By R. M. Meadows after R. Westall, R.A. (Photo. D. C. Gohm.)

Plate 73. George, the Third, King of Great Britain, etc., etc. By W. W. Ryland after A. Ramsay, published 1794.

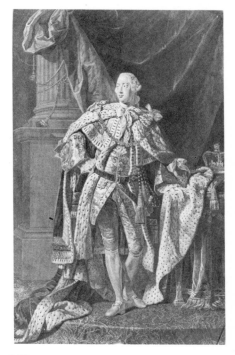

157

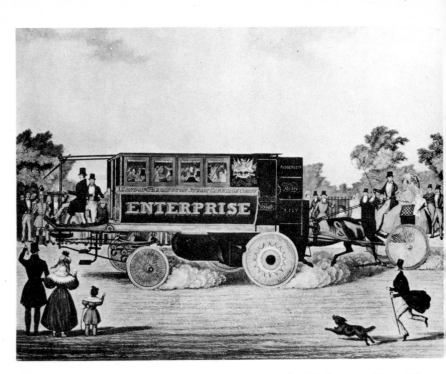

Plate 74. The 'Enterprise' Steam Omnibus. By C. Hunt after W. Summers. 17 × 12⅝
Published 1833. (Aquatint.) By Ackermann.
(Parker Galleries, London.)

Plate 75. John Boydell, Engraver, by
Valentine Green after Josiah Boydell.
13 × 16¼. Published 1772 by John Boydell.
(Mezzotint.)
(Parker Galleries, London.)

158

stipple engraver and was at one time employed by Boydell, and a pupil of Basive.

The Last Supper after West. 17 × 23.

The Honourable Anna Samen, after Angelica Kauffman. 8 × 6¼.

Henry Bunbury after Lawrence.

Signora Storace as 'Clara' after Craven.

The Politician (Dr. Benajmin Franklin) after S. Elmer, published 1824. 13¼ × 11½.

Contemplation after Downman.

RYLAND (WILLIAM WYNNE)

Born in London in 1732 unfortunately he met an untimely end, at the end of the hangman's rope in 1783 for reputed forgery.

He was mainly a stipple engraver and was probably the best exponent of this medium in Britain. His works, many after Angelica Kauffman, are very beautiful, but do not seem to excite modern collectors.

Charity after Vandyck.

Eloisa, after Angelica Kauffman.

Dormio Innocens after Angelica Kauffman, published 1776.

Maria after Angelica Kauffman, published 1779. 13 × 9.

The Judgement of Paris after Angelica Kauffman.

**George III* after A. Ramsey, published 1794. 24 × 15.

Domestic Employment.

Morning Amusement.

Spas after Angelica Kauffman, published 1775. 8 × 7.

St. Cecilia after Guercino. 13½ × 9.

SANDBY (PAUL)

Born in Nottingham in 1721, and died in London in 1809. Sandby is credited with introducing the aquatint from France to England. This may be in dispute, but he was certainly the first to practise the art in England. Sandby also produced a few etchings.

The Series of Etchings of Hyde Park.

Chepstow Castle.

The Newcastle at Naples, published 1778. 20 × 13.

Windsor from Eton.

The Meteor seen at Windsor in 1783 after T. Sandby.

SAY (WILLIAM)

Born in Lakenham in 1768, and died in London in 1834. He was a prolific engraver in mezzotint and is reputed to be the first engraver to use steel instead of copper for mezzotinting.

John, Marquis of Salisbury after Beechey.

The Shipwrecked Mariner after W. Thompson. 18 × 27.

Titania after Henry Thompson, published 1811. 22 × 16.

Peasant Girl after Rembrandt.
Hilaria after Henry Thompson.
Portrait of Neil Gow after H. Raeburn.
Love after Sir Joshua Reynolds, published 1813.
Psyche, discovering Cupid after Reynolds.
Lady Pitt after M. W. Sharp, published 1802. $16\frac{1}{2} \times 13\frac{1}{2}$.
The Duke of Wellington after Phillips, published 1814. 14×10.
Portraits of Vandyck and Morelli.
Lieutenant General A. Mackenzie after G. H. Harlowe.
Lady Hamilton after Masquerier.
Crossing the Brook after H. Thomson.
The Racehorse 'Copenhagen' after Smyth.
Lord Nelson after Beechey.

SCOTT (JAMES)
Believed to have been born in London about 1809 and known to be still living in 1875. He was a mezzotint engraver who covered many subjects, but those of a sporting nature are of the greatest interest.
Rebecca carried off by the Templar after L. Coigret. $20 \times 23\frac{1}{2}$.
The Fruit Girl after T. Harper, published 1836. $11\frac{1}{4} \times 9\frac{1}{4}$.
Infancy after Chalon. 10×9.
Sir Robert Peel after John Linnell, published 1840. 18×13.
The Man: The Spirit both after Edward Prentis, published 1845. $14 \times 11\frac{1}{2}$.
The Duke of Wellington after Lilley, published 1837. 24×16.
A Day's Pleasure after Edward Prentis. 18×23.
The Prodigal's Return after Edward Prentis, published 1840. 18×23.
Lingo and Cowslip after Singleton.
Godolphin (Arabian) after Stubbs.
The Gipsies' Warning after S. Jones. $15\frac{3}{8} \times 12\frac{1}{2}$.
Miss Frances Harris after Reynolds, published 1875. 19×15.

SHARP (WILLIAM)
Born in London in 1749, died in Chiswick 1824. A line engraver of some reputation.
Dorothy Dotton, published 1829.
The Children in the Wood after Benwell, published 1786. 8×9.
Thomas Paine, Author of 'The Rights of Man' after Romney, published 1793.
Filmer Honywood.
The Relief of Gibraltar after J. S. Copley, published 1799. 23×33.
The Magdalene after Guido.
The Holy Family after Reynolds, published 1792. 15×20.
The Doctors of the Church after Giudo.
King Lear Act III. Sc. 4. 24×15.
John Hunter after Reynolds, published 1788. $22 \times 17\frac{3}{4}$.

SHEPHERD (THOMAS HOSMER)

This artist is reputed to have been born about 1824 and to have died in 1842. Very little is known about him, however, it is known that he was a topographical artist and that he illustrated several books on London.

SHERWIN (JOHN KEYES)

Born in Sussex in 1751, died in London 1790. An engraver in line and stipple, at one time pupil of Bartolozzi.

Sylvia and the Dog, published 1792. $7\frac{1}{2} \times 6$.

The Madonna after Ferrata, published 1775. $9\frac{1}{2} \times 8$.

Pericles and Aspasia after Angelica Kauffman, published 1784.

Meditation.

William Pitt, Earl of Chatham after Gainsborough, published 1789.

A Tale of Love after Bunbury.

Sir Joshua Reynolds

Thomas Pennant after Gainsborough.

Love, Woman and Wine.

Venus at her Toilet.

Bacchus and Ariadne, published 1878.

SIMMONS (WILLIAM HENRY)

Born in London in 1811, and died there in 1882. He was apprenticed to William Finden with whom he studied line engraving, but later he concentrated on mezzotint and produced numerous plates.

May and December after J. Lamont Brodie, published 1852. 19×26.

The Horse Fair after Rosa Bonheur, published 1871. $8 \times 16\frac{1}{2}$.

Punchestown after Heyes, published 1854.

Rotten Row after Barraud, published 1867.

A Rustic Beauty after Sir E. Landseer, published 1851. $20\frac{1}{2} \times 13\frac{1}{4}$.

Napoleon at Waterloo after Steuben, published 1838. 17×22.

The Bedale Hunt after A. A. Martin. 18×30.

The Blind Beggar after T. Dyckmans, published 1877. 15×20.

Rosalind and Celia after Millais.

The Baptism of Christ after John Wood, published 1858. $26 \times 33\frac{1}{2}$.

Sweet Anne Page, published 1855. $14 \times 10\frac{3}{4}$.

Gaffing a Salmon after Ansdell, published 1857. $13\frac{1}{2} \times 25\frac{3}{4}$.

His only Pair after Thomas Faed, published 1862.

SMITH (JOHN RAPHAEL)

Born in Derby in 1752, died in Doncaster in 1812. He produced an extremely large number of plates in mezzotint, covering portraits and a wide range of other subjects.

John Bannister after Brown.

Erasmus Darwin after Wright, published 1797. 14×11.

Catherine Frederick by and after J. R. Smith, published 1777. $9\frac{1}{4} \times 8$.

Countess Gower and Family after Romney. 20 × 23.

James Heath after L. F. Abbott. 14 × 11½.

The Jerningham Children, published 1777. 14½ × 18.

Sir Brooke Boothby after Sir Joshua Reynolds. 13½ × 11.

Sir William Boothby after Sir Joshua Reynolds. 13½ × 11.

Lord Richard Cavendish, after Sir Joshua Reynolds, published 1781. 18 × 14.

Lady Elizabeth Compton after Peters, published 1780. 13½ × 11.

Susan, Countess of Westmorland after Romney.

Benjamin Thompson.

Lieut-Col. Tarleton after Reynolds.

Mrs Stanhope (Melancholy) after Sir Joshua Reynolds, published 1783. 17¾ × 14.

Mrs Robinson after Romney, published 1781. 11 × 9½.

Miss Harriet Powell after Peters, published 1776. 5⅛ × 4¼.

Mrs North after Romney, published 1782. 18 × 4.

Mrs Morris after Sir Joshua Reynolds.

Mrs Montagu after Sir Joshua Reynolds.

Mrs Mills after Engleheart, published 1786. 10½ × 9.

The Recruit and the *Wounded Soldier* both after W. Ward, published 1803.

The Watercress Girl after Zoffany.

Stella. 4½ × 3½.

The Spell.

Milkmaid and Cowherd after Morland.

Peasant and Pigs after Morland, published 1800. 16½ × 21½.

The Public House Door after Morland, published 1801. 17½ × 21.

Rabbits after Morland, published 1807. 23¾ × 18½.

Rubbing down the Post Horse after Morland.

The Sheperd's Meal after Morland.

Smugglers after Morland.

A Boy and Pigs after Morland.

The Calling of Samuel after Reynolds, published 1783. 12¼ × 10¼.

A Christmas Holiday by and after J. R. Smith.

The Corn Bin after Morland, published 1797. 23 × 31.

Maria after Joseph Wright. 18½ × 13½.

A Maid by and after J. R. Smith.

Lady with a Fan.

The Horse Feeder after Morland. 23 × 31.

Hebe after Peters.

The Fisherman's Hut after Morland.

The Dream after Westhall.

STUBBS (GEORGE AND G. T.)

George Stubbs was born in Liverpool in 1724. George Townley Stubbs, his

son, was born in 1756. The Stubbs were, of course, famous horse artists, the senior being mainly an artist, and the son the engraver, although the father did produce a few etched and mezzotinted plates.

The Farmer's Wife and the Raven by Geo. Stubbs, published 1788. 20 × 27.
Labourers by Geo. Stubbs, published 1789. 20 × 27.
Brighton Races after James Barenger, set of three.
Warren Hastings by G. T. Stubbs after Geo. Stubbs.
Gimcrack (a Racehorse) by Geo. Stubbs. 16 × 20.
Earl of Eglinton and Hound after G. Stubbs.
The Brown Horse 'Mask' by G. Stubbs, published 1773. 16¼ × 22½.
Bulls Fighting by and after G. T. Stubbs, published 1788. 18 × 24.
Horse Fighting by G. T. Stubbs, published 1788. 18 × 24.
Lady Hamilton Dancing by G. T. Stubbs, after Grignon, published 1798. 18 × 13.

SUTHERLAND (THOMAS)
Born about 1785, he flourished in London between *c*.1810 and *c*.1840. The majority of his plates were executed in aquatint and were of an interesting sporting character.

The Bombardment of Algiers after Whitcombe. 12 × 20.
The High Mettled Racer after Alken, set of six. 11 × 14.
Fox Hunting after Wolstenholme, set of four.
The Chase and *The Death* after R. B. Davis.
Going Out after R. B. Davis.
Cock Fighting set of four plates by Sutherland and Harris after Alken. Re-published 1841. 6⅜ × 8⅛.
Epsom Races after H. Alken. (a pair).
**View of Teignmouth from Shaldon* after T. Fidlor. 16 × 10¼.

TOMKINS (PELTRO WILLIAM)
Born in London in 1769 and died there in 1840. He worked as an etcher and also in stipple. At one time a pupil of Bartolozzi, he executed many plates for book illustrations.

Children Feeding Goats after Morland, published 1794.
The Cottager and *The Villager*, a pair.
Love Enamoured after Hoppner, published 1789. 12⅞ × 9¾.
Zella in the Temple of the Sun after Drax. 14¼ × 11½.
Lavinia and her Mother after Bunbury. 12¾ × 10.
Morning Amusements after Bunbury.
Morning Employment after Bunbury. 17 × 16.
The First Lesson in Love.
Maria after Ramberg.
Battle of Copenhagen after Serres, published 1801. 18 × 29.
A Girl of the Forest of Snowden after H. Bunbury. 8⅛ × 6.

Dressing Room à la Française.
Spring after Wheatley.
Summer after Bartolozzi.
The Tobacco Box after Walton.
TOMLINSON (J.)
Tomlinson was an engraver who flourished in London during the early part of the nineteenth century. He eventually went to Paris and settled there, but unfortunately he took to drinking and other dissipating pastimes and eventually drowned himself in the Seine in 1824.

The majority of prints by Tomlinson were views and landscapes, often executed for book illustrations.

TURNER (CHARLES)
Born at Woodstock in 1773, died in London in 1857. He worked in stipple, mezzotint and aquatint.
Viscount Althorp after Phillips, published 1831.
Nicholas Bergham after Rembrandt. 21 × 15.
Miss Bowles after Sir Joshua Reynolds.
Earl Buchan after Watson.
Robert Cathcart after Raeburn, published 1813. 18 × 15.
The Earl of Chatham after Hoppner.
John Clerk of Elden after Raeburn.
Admiral Collingwood in Uniform. $17\frac{1}{2} \times 13\frac{3}{4}$.
T. W. Coke after Lawrence.
James Gillray.
Lady Hood after Lawrence. $25\frac{3}{4} \times 16$.
Lady Leicester after W. Owen.
Lady Louisa Manners after Hoppner.
The Marlborough Family after Reynolds.
Charles Mathews after Lonsdale.
Viscount Nelson after Hoppner. $23\frac{1}{2} \times 16$.
Thomas Oldacre after Ben Marshall.
The Penn Family after Sir Joshua Reynolds, published 1819. 24 × 17.
The Prince Regent after J. S. Copley, published 1813. 31 × 23.
The Duke of Rutland after Hoppner.
George Stevenson after H. P. Briggs, published 1838. $12\frac{1}{2} \times 9\frac{1}{2}$.
Mrs Stratton after Sir T. Lawrence.
Thomas Wallace after T. Clarke.
Lady Eleanor Wigan after Lawrence.
Black Game after Elmore, published 1835. 16 × 13.
Beggars after W. Owen, published 1805. $23\frac{3}{4} \times 16$.
The Ale House Door after J. J. Chalon, published 1804. 18 × 23.
The Cottage Girl after Gainsborough, published 1823. $8 \times 6\frac{1}{2}$.

Devotion after C. Le Brun.
Durham Oxen after T. Weaver.
The Fortune Teller after W. Owen.
Going Milking after Wheatley.
Industrious Cottage Wife after Singleton, published 1803. $19\frac{1}{2} \times 24\frac{1}{2}$.
The Reading of a Will after W. H. Lizars. $21 \times 26\frac{3}{4}$.
The Savoyard after F. Singleton. 15×20.
A Shipwreck after J. M. W. Turner, published 1837. $20\frac{1}{2} \times 30$.
Waterloo series of seven, after Capt. Jones, published 1816. $9 \times 13\frac{1}{2}$.
The Yorkshire Rose (A Cow) after G. Horner. 18×24.

TURNER (JOSEPH MALLORD WILLIAM)
Born in London in 1775, died there in 1851. As a landscape painter, Turner needs no introduction. His pictures have been engraved by many famous craftsmen, the most notable of which is the 'Liber Studiorum' a series of 70 plates after Turner engraved by William Say, F. C. Lewis and others.
The Little Devils Bridge by C. Turner.
The Mildmay Seapiece by J. C. Easling.
Peat Bog Scotland.
Solway Moss by Thomas Lupton.
Solitude by W. Say
Ville de Thun Switzerland by T. Hodgetts.
Watercress Gatherers by T. Lupton.
Calm.
Isis by W. Say.
Woman at a Tank by W. Say.
Water Mill by Dumbarton.
Marine Dabblers by W. Say.
Windmill and Loch by W. Say.
Coast of Yorkshire by W. Say.
Raglan Castle.
Juvenile Tricks, by W. Say.
Little Devils Bridge by C. Turner.

VERTUE (GEORGE)
Born in London in 1684, died 1756. He was a line engraver who also practised mezzotint. He produced numerous plates, mainly portraits and antiquities.
Sir Thomas Gresham.
Sir Phillip Sidney, published 1745. 9×6.
Sir Edward Nicholas.
Sir John Locke.
Sir James Ware.
The Countess of Sunderland.

Sir Richard Blackmore after Vanderbank. $11\frac{1}{2} \times 9\frac{1}{2}$.
John Baptist Monnoyer after Kneller. $11\frac{1}{2} \times 9\frac{1}{2}$.
Sir John Coke (1724).

WILKIN (CHARLES)
Born in London in 1750 and died there in 1814. His engravings a combination of stipple and etching, consist mainly of portraits.
Children and Beggar Boy after Beechey.
Viscountess Andover after Hoppner. $8\frac{1}{4} \times 6\frac{3}{4}$.
The Countess of Euston after Hoppner. $8 \times 6\frac{3}{4}$.
Lady Charlotte Campbell after Hoppner. $8\frac{1}{4} \times 6\frac{7}{8}$.
The Duchess of Bedford after Hoppner.
Lady Gertrude Villiers after Hoppner.
The Lovely Brunette after W. Ward.

WOOLLETT (WILLIAM)
Born in Maidstone in 1735, died in London in 1785. He was one of the most eminent line engravers of his time.
Views of Switzerland after Pars.
View near Henstead in Suffolk.
The Spanish Pointer after G. Stubbs.
The Haymakers after Smith.
The Apple Gatherers after Smith, published 1783. 22×18.
Tobias and the Angel, published 1785. 12×18.
The Death of General Wolfe after West, published 1776. 17×24.
The Fishery after R. Wright.
Views at Pains Hill near Cobham.

YOUNG (JOHN)
Born in 1755 and died in London in 1825. He was a mezzotint engraver and his subjects were varied, but his portraits are considered to be his best plates.
The Distressed Girl after Paye.
Travellers after Morland, published 1802. $16\frac{3}{8} \times 21\frac{3}{8}$.
Rustic Ease after Morland. $17\frac{1}{2} \times 13\frac{1}{2}$.
The Flower Girl after Zoffany, published 1785. $13\frac{5}{8} \times 11$.
The Oyster Girl after Huck. 14×11.
Admiral Lord Nelson after J. Rising.
Eliza (Mrs Hoppner) after Hoppner.
George Canning after Hoppner, published 1808. $18 \times 13\frac{1}{2}$.
Colonel John Hope of Craighill after Hoppner. $12\frac{1}{4} \times 10\frac{1}{2}$.
Marquis Wellesley after Hoppner.
Richard Harvey after Hoppner.
The Peep Show after Hoppner, published 1787. 23×17.

The following is a list of European artists and engravers. It is by no means comprehensive, but it is hoped that those selected are a good cross section, and produced work that could be of interest to modern collectors.

Name	Nationality	Life Span	Styles
Aliamet, (Jean Jacques)	French	1728–1788	Line & Dry point.
Allais, (Jean Alexandre)	French	1792–1850	Mezzotint & Aquatint.
Altdorfer, (Albrecht)	German	c.1480–1538	Wood & Line Engraver.
Amstel, (Cornelis Ploos)	Swiss	1726–1798	Line Engraver.
Apostool, (Cornelis)	Dutch	1760–1844	Aquatint.
Assen, (Johann Walther)	Dutch	c.1480–c.1553	Wood Engraver.
Audran, (Benoit)	French	1661–1721	Line Engraver.
Audran, (Charles)	French	1594–1674	Line Engraver.
Audran, (Gerard)	French	1640–1703	Line Engraver & Etcher.
Baldini, (Baccio)	Italian	c.1436–c.1515	Line Engraver.
Balechou, (Jean Joseph)	French	1719–1764	Line Engraver.
Baron, (Bernard)	French	c.1700–1762	Line Engraver & Etcher.
Bartoli, (Pietro Santi)	Italian	c.1635–1700	Etcher.
Bartolozzi, (Francesco)	Italian	1725–1815	Stipple.
Beauvarlet, (Jacques F.)	French	1731–1798	Line Engraver.
Beccafumi, (Domenico)	Italian	1486–1551	Wood & Line Engraver.
Beham, (Hans Sebald)	German	1500–1550	Wood & Line Engraver also Etcher.
Benedetti, (Michele)	Italian	1745–1810	Stipple.
Berger, (Daniel)	German	1744–1824	Stipple and Etcher.
Berghem, (Nicholaas)	Dutch	1624–1683	Etcher.
Bettelini, (Pietro)	Italian	1763–	Line & Stipple.
Bischop, (Jan da)	Dutch	1686–	Etcher.
Bleeck, (Pieter van)	Dutch	1695–1764	Mezzotint.
Blooteling, (Abraham)	Dutch	1634–1685?	Etcher & Mezzotint.
Boissieu, (Jean Jacques)	French	1736–1810?	Etcher.
Boulanger, (Jean)	French	1607–1680	Line Engraver.
Buhet, (Felix)	French	1847–1898	Various.
Burgkmair, (Hans)	German	1473–1559	Wood Engraver.
Canot, (Pierre Charles)	French	1710–1777	Line Engraver.
Carracci, (Agostino)	Italian	1557–1602	Line Engraver.
Chevillet, (Juste)	German	1729–1790	Etcher.
Chodowiecki, (D. N.)	German	1726–1801	Etcher.
Claude Gellce	French	1600–1682	Etcher.
Cochin, (Charles Nicholas)	French	1688–1754	Line Engraver.
Colibert, (Nicholas)	French	1750–1806	Line Engraver & Stipple
Cort, (Cornelis)	Dutch	1536–1578	Line Engraver.
Cranach, (Lucas)	German	1472–1553	Wood Engraver.

De Bailliu, (Pieter)	Flemish	1614–1660?	Line Engraver.
De Bry, (Theodore)	German	1528–1598	Line Engraver.
De Laune, (Etienne)	French	1518–1595	Line Engraver.
Demarteau, (Gilles)	French	1722–1776	Stipple.
Drevet, (Pierre)	French	1663–1738	Line Engraver.
Du Jardin (Karel)	Dutch	1625–1678	Etcher.
Dürer (Albrecht)	German	1471–1528	Wood & Line Engraver & Etcher.
Faber, John) The Elder	Dutch	*c.*1660–1721	Mezzotint.
Faber, (John) The Son	Dutch	1684–1756	Mezzotint.
Forster, (Francois)	Swiss	1790–1872	Line Engraver.
Freudenberger (Sigmund)	Swiss	1745–1801	Line Engraver & Etcher.
Gaillard, (Robert)	French	*c.*1722–1785	Line Engraver.
Girard, (Alexis Francois)	French	1789–1870	Mezzotint & mixed.
Gole, (Jacobus)	Dutch	1660–*c.*1740	Mezzotint.LineEngraver.
Haid, (Johann Jakob)	German	1704–1767	Mezzotint.
Holbein, (Hans)	German	1497–1543	Wood Engraver.
Hollar, (Wenceslaus)	German	1607–1677	Etcher.
Houbraken, (Jacobus)	Dutch	1698–*c.*1780	Line Engraver.
Jacobé, (Johann)	German	1733–1797	Mezzotint.
Janinet, (Jean Francois)	French	1752–1813	Line Engraver.
Jazet, (Eugene)	French	1816–1856	Mezzotint & Aquatint.
Jegher, (Cristoffel)	German	*c.*1592–1665	Wood Engraver.
Lasne, (Michel)	French	1595–1667	Line Engraver.
Le Bas (Jacques Phillipe)	French	1707–1783	Etcher & Line Engraver.
Longhi, (Giuseppe)	Italian	1766–1831	Line Engraver.
Masson, (Antoine)	French	1636–1700	Line Engraver.
Matham, (Jacobus)	Dutch	1571–1631	Line Engraver.
Mazzuola, (Francesco)	Italian	1503–1540	Etcher.
Meryon, (Charles)	French	1821–1868	Etcher.
Morghan, (Rafaelle)	Italian	1758–1833	Line Engraver.
Nanteuil, (Robert)	French	*c.*1623–1678	Various.
Ostade (Adriaen Janusz Van)	Dutch	1610–1685	Etcher.
Pass (Crispin van de)	Dutch	*c.*1565–*c.*1643	Line Engraver.
Pass (Simon van de)	Dutch	*c.*1590–*c.*1640	Line Engraver.
Penez, (Georg)	German	1500–1550	Line Engraver.
Picot, (Victor Maria)	French	1744–1802	Line & Stipple Engraver & Etcher.
Poilly, (Francois de)	French	1623–1693	Line Engraver.
Porporati, (Carlo Antonio)	Italian	1740–1816	Stipple, Mezzotint.
Raimondi (Marc Antonio)	Italian	1480–1527?	Line Engraver.

Rajon, (Paul Adolphe)	French	1843–1888	Etcher.
Rembrandt (Rembrandt Harmenoz Van Rijn)	Dutch	1606–1669	Etcher.
Richter, (Adrian Ludwig)	German	1803–1884	Etcher.
Saenvedam, (Joannes)	Dutch	c.1565–	Line Engraver.
Santi, (Pietro)	Italian	1630–1700	Etcher.
Schiavonetti, (Luigi)	Italian	1765–1810	Stipple.
Schongauer, (Martin)	German	c.1440–c.1488	Line Engraver.
Simon, (Jean)	French	c.1675–1755	Mezzotint.
Solis, (Virgil)	German	1515–1562	Wood & Line Engraver.
Stadler, (Joseph C.)	German	fl.1780–1812	Aquatint.
Toschi, (Paolo)	Italian	1788–1854	Line Engraver.
Vaart, (jan van der)	Dutch	1647–1721	Mezzotint.
Vaillant, (Wallerant)	French	1623–1677	Mezzotint.
Vandyck, (Sir Anthony)	Flemish	1599–1641	Etcher.
Vidal, (Gerard)	French	1742–1804	Stipple, Line & Aquatint
Visscher, (Claes Janoz)	Dutch	1580–1609	Line and Etcher.
Vivares, (Francois)	French	1709–1780	Line Engraver.
Zorn, (Anders)	Swede	1860–1920	Etcher.

9. Maps.

Maps and prints are virtually the same, the processes used for both are identical. It is only their purpose that divides prints from maps in the eye of a collector.

A map is a graphic statement of direction and contour, it strives to give a three dimensional representation on two dimensional paper. Early cartographers endeavoured to make their work as accurate as possible, but they were limited to crude and inadequate equipment, and they had little background knowledge to fall back on, in fact, at this time it was not possible to establish longitude with any real accuracy, neither was there an established unit of measurement.

The earliest maps date from the fifteenth century and although primarily concerned with assisting the traveller and recording land parcels, it must be assumed that even in the fifteenth century they were as much appreciated as works of art, as they were for any scientific value.

Early cartographers, like the rest of the population had to earn a living either by direct selling, or by assistance from a patron, so market requirements must have had a certain influence on the presentation, together with the natural tendency of the period to combine the functional with the artistic.

For reasons that are obvious, cartographers did not avail themselves of all the printing techniques involving tonal graduations, but confined themselves to 'Relief' and 'Engraved' blocks. Lithography made its appearance during

he nineteenth century, but nineteenth century lithographic maps can hardly interest a serious collector of antique maps.

Printing from wood-blocks was one of the earliest forms of reproduction, and the majority of maps printed during the fifteenth century and early sixteenth century used this process. Most of the early maps were produced in book forms, and the blocks lent themselves admirably to the contemporary methods of printing.

Early type consisted of separate blocks of wood with the letters engraved in relief. These were assembled in the printers 'forme' or frame, and the block carving of the map could be included and printed simultaneously.

During this period, cartographers were certainly using copper plates, but with a few exceptions it can be assumed that no maps of any consequence were produced on copper during the fifteenth century. The copper plate superceded the wood block from about the mid-sixteenth century. The quality of an antique map depends upon the same factors as those for prints, early impression being obviously of a higher quality than late ones.

It is impossible to assess with any degree of accuracy the number of impressions that were taken from a wood block or plate, because much depended upon the quality of the original engraving, and the care in which the printer used them, but it has been estimated that about 3,000 copies were possible from a new plate, before it became necessary to re-work the plate or block. Wood blocks and copper plates had much about the same life. The wood block, although a softer material did not require so much pressure as the copper, to obtain the impression.

The decoration of early fifteenth century maps was more or less restricted to border decoration. The first half of the sixteenth century saw the ornamental cartouche, usually imitative of wood-carved scrolls, and the compass indicator dividers, coats-of-arms, ships, cherubs with wind issuing from their mouths, figures and a whole host of decorative devices.

The period from the mid-sixteenth century to eighteenth century is undoubtedly the one that will interest a collector most. It was the period during which decorative cartography and technical achievement was at its best.

10. Colouring for Maps.

The information given elsewhere in this book for the restoration of prints applies equally well for the restoration of maps and the methods of applying watercolour are also the same, but as maps are more conventionalised than prints it is possible to be more precise in the colouring used. Sixteenth century maps of Central Europe produced from woodblock had the colour applied in flat washes, often rather thickly, but in the Netherlands the art of illuminating had become an established craft before the middle of the century, and map colouring was included as part of the illuminators trade, and map engravers either employed these craftsmen in their own workshops or 'placed the work' with specialist colourists. From the sixteenth to the eighteenth century, maps were sold either plain or coloured. As the decoration on Dutch and Flemish maps became more ornate, so the colouring became more elaborate. Cartouches of tracery and strapwork were usually coloured in magenta or brown, and touches of gold, blue and other colours added for effect. Other embellishments such as figures, fish, monsters, fruit etc., were coloured in their natural colours—gold was represented by yellow, flesh tones by Cochinele; robes in a pale wash of green, shadows with a thicker wash; borders framing the map were either yellow, light-red or crimson. Boat hulls were in umber; symbols representing towns and villages were red, hills umber, sometimes green; trees a rather blue green, and the boundaries of the hundreds, and county boundaries were washes of almost any colour, the rule being that no two adjacent counties

172

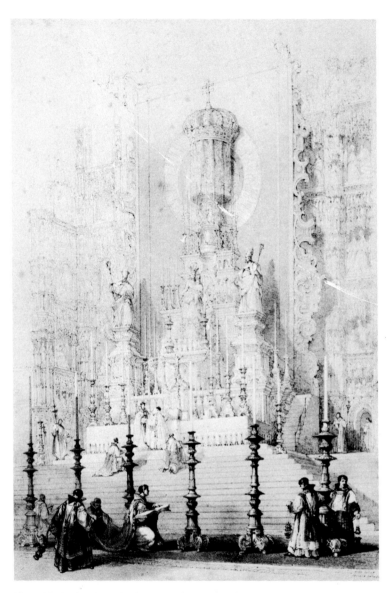

Plate 76. High Altar, Seville Cathedral. By and after T. Allom. ($10\frac{3}{4}$ × 15.)
Lithograph.

or boundaries should be painted the same colour. For rivers, a wash of indigo was used. Sometimes an engraver would assist the colourist when engraving coats-of-arms. For instance, a careful look at a John Speed map will reveal small alphabetical letters engraved on the various motifs of the coats-of-arms, and on others the method of shading will give an indication. On Speed's maps the initials represent the colours and tones used in heraldry and are referred to in heraldic terms as Tinctures:

O = Or, or gold use yellow (sometimes expressed as dots)

A = Argent or silver. Left uncoloured (left Plain)

G = Gules or red (Vertical lines)

A = Azure or blue (Horizontal lines)

V = Vert or green (diagonal lines, left to right)

P = Purple (diagonal lines, left to right)

S = Sable or black (Cross hatched, vertically and horizontally framing tiny squares)

T = Tenne or tawny, use orange (diagonal cross-hatch)

If the opportunity arises to obtain a few maps in original colours, get them, they will prove invaluable as a reference source, and will express themselves better than any words can possibly do.

Plate 77. A Camp Scene. By C. White after H. W. Bunbury. Published 1794. (15 × 10½.)
Lithograph.

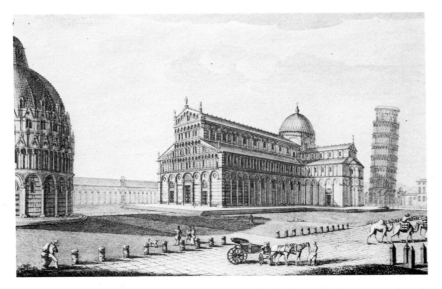

Plate 78. Veduta generale della Piazzadel Duomo di Pisa. By and after Ranieri Guassi.
(12¾ × 8.) Line engraving, partly etched.

175

11. Principle Map-Makers.

JOHN ADAIR
In 1703 he produced a set of 6 sea charts of the Scottish coasts.

JEAN BAPTISTE d'ANVILLE
Jean Baptiste Bourguignon d'Anville, to give him his full title, was born in 1697. This famous French map-maker produced his maps during the period when accuracy of·detail, and a more scientific approach was being given to the subject, but although the geographical information was reformed, the cartouche remained decorative. d'Anville's 'Nouvel Atlas de la Chine' (The Hague 1737) was prepared by him from surveys made by Jesuit missionaries who surveyed China between 1708–1716 for the Emperor.

He was also responsible for a number of other maps, and his maps have been used by other cartographers on which they based their designs.

GEORGE BICKHAM
Bickham was an engraver and author. He was born in 1684 and flourished at Covent Garden. His only work connected with maps was his strange birds-eye views of counties, first published c.1743.

WILLIAM BLAEU
This Dutch engraver was born in 1571 and died in 1638 at Amsterdam. He had two sons, Joan William (1596–1673) and Cornelius (–1642). This family was responsible for producing some of the finest maps of their period, the quality of their engraving, sense of design, and beautiful cartouches have rarely, if ever, been surpassed.

They produced a series of county maps after Speed, and although they used the same basic information, including the heraldry, they re-composed the presentation to give an entirely different map.

William Blaeu in about 1596, was in business as an instrument maker, and globe manufacturer. Undoubtedly Blaeu was a technician in every aspect of his career. Later when he became an engraver and printer, he invented an improved printing press. In 1633 his service to navigation was rewarded by his appointment to map-maker to the Republic.

The Blaeu family also produced the earliest maps of the Scottish counties and provinces, engraved from the surveys taken by Timothy Pont in the latter part of the sixteenth century.

RICHARD BLOME

The maps of Richard Blome are well below the standard of most antique maps in the quality of the engraving. Blome was not a skilled craftsman and his maps lack the careful discipline usually found in·such an exacting art. Nevertheless, they have some artistic merit and the fact that they have antiquity, makes them worthy of a place in the collector's folio.

He produced a set of county maps in 1673 decorated with cartouches and coats of arms, and he also issued a miniature series in 1671 and in 1681, these were reprinted in various forms until about 1735.

Blome published maps of various parts of the world late in the seventeenth century.

EMANUEL BOWEN

The output of Bowen was prodigious. He was an engraver and map seller with a place of business in Fleet Street. He flourished from about 1770 to 1767.

He produced a series of small county maps, for the 'General Magazine of Arts and Sciences' for W. Owen about 1758. These were boldly produced with a scroll design cartouche and the hundreds notated.

Bowen also produced a large series of county maps in conjunction with Thomas Kitchen. These were published in 1749 to 1755, and a series of medium sized maps in 1762, most of which were endorsed with information in the blank areas describing towns, products, climate etc. He also produced the beautiful 'Britannia Depicta' based on Ogilby's road maps, but with the addition of historical facts, coats of arms, heraldry etc. Emanuel Bowen and later his son, Thomas, until he died in the workhouse in 1790 issued and re-issued a great number of maps in addition to those already mentioned.

JOHN CARY

Although the appeal of antique maps comes mainly from the artistry of decoration, the plainer maps of the later periods are nevertheless interesting to serious collectors. John Cary's maps are utilitarian, they were beautifully engraved and accurately lettered.

Cary was born about 1754 and died in 1835, his engraving career having started by the 1770s. He produced a great number of maps including two sets of county maps published in 1789 and 1805 and quarto-size county maps from 1793. His premises were initially in the Strand, but later he removed to St. James Street.

CAPTAIN GRENVILLE COLLINS

Collins was born in 1693 and died in 1785. He surveyed the coastlines of the British Isles and produced charts that were both useful and decorative. The cartouches of Collins are usually the most dominant feature of his charts, well designed and intricate and when expertly coloured, are very beautiful indeed. The first publication was in 1693, but they were re-issued often during the eighteenth century.

MARCO VINCENZO CORONELLI

Coronelli was Cosmographer to the Republic of Venice, and was the most famous Italian cartographer of his period. He produced a series of large maps in 1690–1697 the majority of which were decorated, and numerous other maps.

He died in 1718 at the age of 68.

GUILLAUME DELISLE

A French engraver born in 1675 and died in 1726. Delisle's maps were of good quality and include maps of various parts of the world.

MICHAEL DRAYTON

Michael Drayton was not in a strict sense a cartographer, he was, in fact, a poet, but his 'Poly-Olbion' published in two parts in 1612 and 1622, did contain some maps of a kind. Very few places were named, but important towns were marked by crowned figures, hills and mountains were shown more or less conventionally, but they were often capped with a seated shepherd, rivers contain nude nymphs, and some counties were grouped. These maps were engraved by William Hole and have a decorative value.

JOHN ELLIS

John Ellis was not a cartographer in the true sense, but rather a skilled engraver who included map engravings among his general activities. He flourished between 1750–1796, and produced a set of county maps in 1766, using the quarto maps of Thomas Kitchen as a basis, but omitting the Kitchen cartouche and substituting a miniature scene.

CHRISTOPHER AND JAMES GREENWOOD

The Greenwoods produced a set of English county maps from their own surveys, these are all dated between 1817 and 1834.

WILLIAM HOLE

Little is known about the life of this cartographer except that he was working in London from about 1600 to 1646. He engraved the unusual maps to illustrate Michael Drayton's poem 'Poly-Olbion' issued in 1612 and 1622

and is also reputed to have been the first engraver to commit music to the copper plate. However, it is mainly for his work in connection with county maps that he is known, and he produced a number of these working in conjunction with William Kip.

As a basis for their map design they used Norden's and Saxton's surveys, and produced some fine, original work.

JAN JANSSON

Jansson was born at Arnhem in 1596 and died at Amsterdam in 1664. He produced fine quality maps of English and Welsh counties closely resembling the maps of Blaeu. These were published between 1638 and 1637, in various editions, and re-published later, c.1683 by Valk and Schenk.

When Jansson died, his business continued under the administration of his two sons-in-law under the name of Janssonius-Waesbergh, until 1694 when they sold the plates by auction.

THOMAS JEFFERYS

Thomas Jefferys flourished approximately during the same period as Kitchen, in fact, he engraved a set of small county maps with Kitchen which were first issued in 1749. He also produced maps of various parts of the world, including the West Indies and North America.

PIETER VAN DEN KEERE

This Dutch engraver worked between 1590 and 1620 approximately. He was also an artist of some merit, and a bookseller.

He spent much of his working time in England, and is thought to have worked with Jodocus Hondius.

Sometime around 1599, van den Keere produced a 'pocket edition' of an atlas, using Saxton's maps as his basis, and at that time the project seemed doomed to failure. However, by 1627 the plates had been acquired by Speed's publisher, John Sudbury and George Humble, and from then onwards, they became a very successful series.

One of van den Keere's most interesting engraved maps was produced in Germania Inferior (Amsterdam 1617) entitled 'The Seventeen Provinces of the United Netherlands. It is a very decorative map with figures and an outline boundary forming the outline of a lion.

JOHANNES VAN KEULEN

Van Keulen was born in 1654 and died in 1704. He produced many fine sea charts in his Zee-Atlas published in Amsterdam in 1681, the English edition being published one year later.

The coast lines were strongly engraved with a double line and the cartouches large and very ornate, and more often than not, contained figures.

WILLIAM KIP

This cartographer worked between 1598 and 1635 approximately and

although his work was excellent, it was not of the quality of Jansson, Speed or Blaeu.

Kip, working with William Hole, produced a fine set of maps of the English and Welsh counties. These were first issued in 1607 with Latin text on the back, they were re-issued in 1610 without text on the back, and again in 1637 with a plain back and a numeral engraved on the lower left hand corner of the majority of the counties.

THOMAS KITCHEN

Thomas Kitchen flourished between 1738 and 1776. He produced county maps and some from various parts of the world. He is probably best known for his quarto-sized county maps published in 1764.

The quality of Kitchen's engraving was excellent, but he was also author, publisher and purveyor of artists' materials which he sold from his shop in Holborn Hill.

GERARD MERCATOR

Born in Rupelmonde in 1512, Mercator was a mapmaker of equal ability to that of Ortelius. His maps were of exceedingly fine quality and he is reputed to have been the first mapmaker to name a collection of maps with the title 'Atlas'.

Until about 1552, Mercator manufactured scientific instruments, including large globes; his first map, engraved on a copper plate, was published in 1537. Nearly all of his maps were original productions, being both drawn and engraved by him.

Mercator produced an atlas which was published between the years 1585 and 1595, it was issued in three parts. He produced maps of single countries and others including groups of countries.

After his death, Mercator's sons, and grandsons continued to issue his maps, supplemented with works of their own until 1606, when Jodocus Hondius acquired the plates and re-issued them. Later John Jansson joined him and eventually took over the business.

HERMAN MOLL

A Dutchman who came to England in the 1680s, Moll was a bookseller and an engraver of maps. Initially he had premises in Blackfriars and later in the Strand. He produced a wide range of maps from miniature to very large, decorated with inset plans and pictures.

He produced medium sized county maps engraved in ·thick black lines which were a hall-mark of his particular style; interest was added by notating antiquities excavated in the county, such as coins etc., or views. His Wiltshire map (1724) about $7\frac{1}{2} \times 12\frac{1}{2}$ inches in size, has two small views of Stonehenge in the top margin, and various excavated items on the lower margin. In addition, to county maps, he also produced large ones of the World, India, North America, Scotland etc. Moll died in London in 1732.

ROBERT MORDEN

Robert Morden was a bookseller, publisher and mapmaker. His premises from 1688 to 1703 were in Cornhill.

His best known maps are those of English counties first published in 1695, and subsequently re-issued in 1722, 1753 and 1772. These maps were nicely engraved with a moderately decorated cartouche and endowed with numerous place names. The first issue 1695—was usually printed with a good impression on rather thin paper; the second—1722 had a water-mark of a horse encompassed in a circle, and the paper somewhat thicker, the third and fourth—1753 and 1772 were printed on good quality, smoother paper.

Morden also produced maps of parts of the world issued from 1688, many of which were quite small. He also produced a small set of county maps, issued initially in 1701. These are attractive little collectors items, but they are rarer than the larger county maps.

THOMAS MOULE

Thomas Moule's county maps, published in 1836 were highly decorated, but have a 'modern' sense of cartography. They are however, covered with inset views; foliage; shields etc., but it is unlikely that they will appeal to a serious collector. Moule was born in 1784 and died in 1851, and was a man of considerable talents, being noted a authority on heraldry and antiquities.

SEBASTIAN MUNSTER

Born at Hessen in 1489 and educated in Tübingen and Heidelburg. His earliest maps date from about 1530 and were produced from woodblocks. He produced both large and small maps including the World, and continental maps of Africa and the Americas. In 1528, Munster requested German geographers to survey their own provinces and to forward the maps to him. Of those he received many were printed together with acknowledgements in his Ptolemy produced in 1540 and his Cosmographia in 1545.

He also produced a number of town views usually birds-eye vistas, executed in great detail, each house, bridge etc., being accurately notated.

JOHN NORDEN

Born in 1548, probably somewhere in the county of Somerset, John Norden intended to produce county maps from surveys of his own, but after completing only a few, he had to discontinue through lack of funds. These surveys were intended to supply deficiencies which he observed in the maps of Saxton's and Camden's descriptions such as roads, hundred boundaries, historical sites, reference grids and·so on. However, the few surveys he did manage to complete resulted in maps of Middlesex date 1593, Hertfordshire date 1598; Hampshire date 1595; Surrey date 1594; Sussex date 1595. Original copies of these maps are now rare, in fact only one copy of the Sussex map is known to exist, and that is in the library of the Royal

Geographical Society. Norden's county handbooks, entitled 'Speculum Britanniae' by him, of which only two volumes were printed in his lifetime, were actually produced and published at his own expense.

The few known county maps of Norden were re-issued early in the eighteenth century.

JOHN OGILBY

Ogilby was born in 1600 at Edinburgh, and died in 1676. During his life-time, he was a man of many parts, but his name immediately brings to mind his most famous achievement—his strip road maps. These were a series of maps showing roads between large towns represented as a continual scroll, hills and ladmarks were notated to aid the traveller. These maps have a central cartouche along the top margin giving details of the route, and beautifully decorated. Each strip has a compass to indicate direction, and where a direction changes a second compass is added and a dividing lines added across the strip. These were the first maps to use the standard mile until this time the length of the mile varied in different parts of the country, hence, it is not unusual to find more than one scale on old maps.

Smaller copies of Ogilby's road maps were produced by Thomas Gardner and John Senex.

John Ogilby also produced some books, dealing with the Americas, Asia and Africa.

ABRAHAM ORTELIUS

Born in Antwerp in 1527, this brilliant and accomplished cartographer produced maps that were truly beautiful works of art, and his name is high on the list of famous mapmakers.

Ortelius was a man of considerable education and he entered the business world in partnership with his sister selling and colouring maps. In 1570 he published his atlas 'Theatrum orbis terrarum', a fine collection of exquisite maps which were subsequently re-issued until about 1612. The text on the back was printed in Dutch, French, German, Latin, Spanish and finally English in 1606. He also produced a series of fine quality miniature maps from 1576. He died at the age of 71.

SIR WILLIAM PETTY

Born in 1623 at Hampshire, Petty was a man of science. He was a mathematician, scientist and sufficiently skilled in medicine to become the Physician General to the Army then established in Ireland.

Whilst in Ireland, and encouraged by Cromwell's Government, he undertook a survey of the county. The quality of his work left much to be desired from an artistic standpoint, being somewhat crude and lacking the precision of line usually associated with antique maps. These maps were published in 1685, and these are now scarce. They were re-issued in 1690 and again approximately during the mid-nineteenth century. Various

issues of a miniature set was published between 1685 and 1728.

PIGOT & CO.

In 1829 this house published a set of county maps decorated with vignetted views, a similar set, but smaller, and with the views omitted was published in 1835.

REUBEN RAMBLE

In 1845, a little set of lithographic maps were issued for children. These are now scarce.

JOHN ROCQUE

John Rocque flourished between about 1734 and 1762 and although an Huguenot, he spent the best years of his life working in London He is probably recognised mainly for his survey of London, produced to a large scale and engraved by Pine and issued in 1746. He also produced a set of county maps, in which the county boundaries were shown by cross hatching.

NICHOLAS SANSON

A French mapmaker of some reputation, Sanson produced some very attractive maps with decorative cartouches.

He was born in Abbeville in 1600, and died in Paris during 1667.

CHRISTOPHER SAXTON

This English cartographer was born near Leeds, in Yorkshire, about 1542. He was educated at Cambridge and later came to London.

In 1575, the Privy Council issued an order that Saxton should be 'assisted in all places necessary for him to survey certain counties'. This meant that authority was vested in him to gain access to property, climb hills, towers etc. Thomas Seckford, an official of the Queen's court, obtained this authority for Saxton, and also supplied the necessary financial backing.

The results of Saxton's surveys were committed to the engravers between 1574 and 1579, and as the technique of engraving on copper was far more advanced in the Netherlands, some Flemish and Dutch craftsmen were employed on fourteen of the plates, but all of the thirty six plates show the Dutch influence in their style of lettering and decoration. Remegius Hogenburg and Leanord Terwoort were of the two Dutch engravers employed, and Augustine Ryther, although English, produced maps almost indistinguishable from those produced by the Dutch.

In 1577, Saxton received a ten year privilege to engrave, print, and sell maps, and it is likely that many maps produced during this period were obtainable in single sheets. In 1579 they were issued as an atlas with a frontispiece showing Queen Elizabeth as the patron of geography and astronomy. Saxton's maps were frequently reprinted to supply a popular market, and they continued in popularity until the arrival of Speed's county atlas took over the market, however, reworked and corrected plates of Saxton's were still being used to produce maps as late as 1795.

JOHN SELLER

This mapmaker produced numerous maps and sea charts covering the major parts of the world. His best known item is probably his 'English Pilot', but he also produced sea charts covering the coasts of most parts of the world. Many of his sea charts were printed from plates acquired from the Dutch.

In 1695 he issued a set of miniature county maps, which were reprinted in 1701. These continued to be issued with minor alterations into the early nineteenth century.

Apart from his cartographical activities, Seller was an instrument maker of mathematical instruments to Charles I and James II. He died approximately 1700.

Seller was one of the most prominent map sellers of the seventeenth century.

JOHN SENEX

John Senex produced a set of uninspired charts in 1728, sometimes with more than one map to a sheet. The engraving was executed by Senex and published in conjunction with Henry Wilson and John Harris. The maps of Senex were considerably more interesting. In 1719 he issued a handy size road book, with small strip maps after Ogilby, but without the decoration. He also engraved a set of large maps of various parts of the world.

He flourished from c.1700 to 1740 when he died, operating initially from premises in Cornhill and later at the Globe, Salisbury Court, Fleet Street.

CHARLES SMITH

In 1804 Smith produced a set of plain undecorated county maps.

JOHN SPEED

The name of John Speed is a byword among collectors of maps and even many non-collectors. His maps rank among the best ever executed. They are interesting, finely engraved, and beautifully decorated.

John Speed was born in Cheshire in 1552, and in his early days followed the trade of a tailor, which was the profession of his father. In 1580 he entered the Merchant Taylors Company and married two years later.

Speed was also a student of history and gained a reputation in this field. His 'Theatre of the Empire of Great Britaine' was designed by him as a geographical prologue and was the first printed atlas of the British Isles. Speed was not an originator, he used the earlier works of other cartographers as a reference; making full use of works of Saxton and Norden.

The back of Speed's maps carries a description and history of the county on one half, and a list of important towns and villages on the other.

Most of his plates were engraved by Jodocus Hondius in his workshop at Amsterdam and no doubt the skill of this engraver added much to the picturesque detail they contain. The early maps were published by John

Sudbury and George Humble in 1611–12 but they were issued and re-issued many times well into the eighteenth century.

NIKOLAUS VISSCHER

Claes (Nicolaes) Janoz Visscher was born in 1587 and died in 1637. He worked initially for Hondius but subsequently set up his own map printing business. In due course, the business passed to his son, and subsequently to his grandson. They all bore the same name, but the son sometimes used the Latin version of his name. 'N. J. Piscator'

The son produced large wall maps in the style of Blaeu, and published his first atlas in 1666.

EDWARD WELLS

Wells issued a set of maps about the turn of the seventeenth century (1700). They were decorative examples of cartography covering various parts of the world. They were not very valuable in terms of geography, but they were strongly engraved and carried a decorative cartouche and a dedication to the Duke of Gloucester, together with his coat-of-arms.

FREDERICK de WIT

The maps of de Wit were typical of the style of his period, they were competently executed and decorated with cartouches. His style was similar to Jansson and others and many of his maps were re-issues of Jansson. During the business life of the de Wits, (he had a son of the same name) they acquired the plates of the 'town-books' originally owned by Jansson, and the surviving plates of Joan Blaeu after his printing house was destroyed by fire in 1672.

de Wit died in 1706, and the total stock of his plates were acquired by Pieter Mortier.

The following is a short list of the Principal MapMakers in approximate chronological order.

	1489–1552	Sebastian Munster
	1512–1594	Gerard Mercator.
	1527–1598	Abraham Ortelius.
	1548–1626	John Norden.
	1552–1629	John Speed.
fl.	1569–1606	Christopher Saxton.
	1571–1638	William Blaeu.
	1571–*c*.1646	Pieter van den Keere.
	1587–1637	Nikolaus Visscher.
	1596–1664	Jan Jansson.
fl.	1598–1607	William Kip.
	1600–1667	Nicholas Sanson.
	1600–1676	John Ogilby.
fl.	1607–1646	William Hole.

fl. 1612–1622	Michael Drayton.
fl. 1648–1689	Frederick de Wit (The elder).
1650–1718	Marco Vincenzo Coronelli.
1703 died	Robert Morden.
1654–1704	Johannes van Keulen.
1705 died	Richard Blome.
fl. 1669–1691	John Seller.
1675–1726	Guillaume Delisle.
fl. 1685–1690	Sir William Petty.
1693–1785	Capt. Grenville Collins
1697–1782	Jean Baptiste Bourguignon d'Anville.
fl. 1703	John Adair.
1732 died	Herman Moll.
fl. 1700–1740	John Senex.
1704–1762	John Rocque.
*fl. c.*1700	Edwards Wells.
1718–1784	Thamas Kitchen.
fl. 1720–1767	Emanuel Bowen.
fl. 1743	George Bickham.
fl. 1750–1796	John Ellis.
1771 died	Thomas Jefferys.
*c.*1754–1835	John Cary.
1784–1851	Thomas Moule
fl. 1804	Charles Smith.
fl. 1817–1834	Christopher Greenwood.
fl. 1817–1834	James Greenwood.

GLOSSARY OF TERMS

After: This term is used to denote any print which is not the original work of the engraver, but copied from the original design of a painter or engraver whose name is usually stated; for example, a line engraving executed by W. Byrne using a W. Turner painting as a master from which to copy would be referred as 'By W. Byrne after W. Turner'.

Aquatint: A method of engraving using acid and a resin ground (See Styles).

Block: A block of wood on which designs were engraved, material usually boxwood.

Brief-maler: A name used to describe the playing card makers of Germany. They were considered to be the initial engravers of wood blocks.

Burin: A graver. The engraver's tool made from good quality hardened steel, one end ground at an angle to provide a fine cutting edge. The other end usually had a wooden handle that nestled into the palm of the hand.

Burnisher: Tool used by the engraver to soften a harsh line, in effect burnishing a line is to polish it by friction.

Burr: The rough edge thrown up along the edge of the engraved line by the cutting tool, particularly on soft metal like copper.

Cameo: The opposite of intaglio. The projection of the design or image above the common ground; a design cut in relief.

Chalcography: The art of engraving on metal plates.

Chiaroscure: The treatment of strongly contrasting light and shade in paintings: a method of producing engravings by the super-imposition of two or more blocks or plates to obtain the effect of light and shade independently.

Collectors Mark: A signature, mark, or device stamped on a print by the owner, to show ownership and to identify it as belonging to his collection.

Counter-proof: An impression taken from a proof on paper still wet with ink and pressed onto another sheet of paper, the design is then shown in reverse.

Cradle: This is another name for the rocker used to prepare the ground for mezzotints. It consists of a flat piece of good quality steel, hardened and prepared with small teeth, to which a handle is fitted. By rocking the teeth over a copper plate burrs are raised on the surface and so lays the grounds.

Cross-hatch: An engraving device to produce a particular effect, it consists of engraving one series of lines over lines already engraved at right angles.

Cut: A woodcut, or an impression taken from a woodblock.

Dry Point: A sharp needle type engraving tool used in copper plate engravings to obtain very fine lines, also used for making fine dots in stipple, and for fine shading.

Also used to produce lines with a burr which held the ink and so produced rich line. (See Styles).

Etching: A means of producing a plate by etching the lines with acid, and

masking with wax (See Styles).

Etching Ground: The coating of wax, or varnish applied to the plate to prevent the acid attacking where not required to do so.

Etching Needles: Tool used to scratch through the wax to expose the raw metal to the action of the acid.

Fecit: Literally, he made it, following the name of an engraver to denote authorship.

Exc: Excudit, literally he executed it, on an engraving usually refers to the publisher, often synonymous with the engraver.

Foxed: The brown stains, usually spotted, found on old prints mainly caused by damp, and perhaps traces of minerals in the paper.

Graver: Tool used for engraving the plate, see Burin.

Ground: The prepared surface of a block or plate prior to engraving, i.e. mezzotint surfacing, and the wax ground prior to etching.

Heliograph: Not a print, more a kind of photograph, obtained by means of the sun and a camera obscura.

India Paper: A tissue thin paper, usually tinted, possessing a soft silky texture and capable of absorbing ink to a much greater degree than normal somewhat thicker papers. Usually mounted on a stiffer paper for support.

Intaglio: The reverse of relief. A design cut below the surface like an engraved plate, a depression.

Laying Down: Prints are said to be the 'laid down' when they are pasted to a support of canvas, or cardboard. When a paper of similar texture is used to form a lining it is said to be 'backed'. The latter method is often employed to repair prints with large tears.

Line Engraving: A method of making a plate by engraving lines into the plate to hold ink prior to its transfer to paper. (See Styles).

Lithograph: A print produced from a stone on which the design has been drawn with a greasy crayon. (See Styles).

Mezzotint: A process of engraving using a completely burred plate as a basis, the lighter shades are produced by scraping away the burrs. (See Styles).

Needles: Pointed tool used in engraving.

Paper-mark: Same as watermark.

Parcels: Job lots of prints sold in bundles.

Pax: A small plate of gold, silver etc., carrying a picture of the Crucifixion

Pinx: Pinxit; precedes the name of the painter after whom the engraver produced it; usually engraved just below the picture on the bottom margin

Plate: The sheet of metal carrying the engraved design.

Plate Mark: The impression made in the paper by the outer edges of the plate when squeezed in the press.

Pontuseaux: The parallel lines caused by the wire mesh of the tray onto

which the paper was poured during the process of paper-making. These lines are in fact watermarks.

Proof: Initially this term was used to describe impressions taken to check the progress of the engraving, but now often used to describe prints prior to the lettered impression.

Proof (Artist's): A proof usually carrying the written signature of the artist on the lower margin.

Proof (Engraver's): A proof usually carrying the written signature of the engraver on the lower margin.

Proof before Letters: A print untitled. Prints that do not carry any inscription.

Proof with Open Letters: Print with inscription engraved in outline letters only. The main body of the letters having not been inked in.

Relief: Raised designs, (see Cameo).

Remarque Proof: A proof from a plate, usually etched, which carries a small engraving appropriate to the design on the lower margin and usually the name of the artist signed in pencil.

Re-Touching: The reworking of a worn plate by deepening the worn cuts and the retouching of feint areas, with the object of restoring the plate to its original condition.

Roughing: A wood engraving term used to describe the ground formed for the drawing. A mixture consisting of Bath brick and water was spread on the block, and when dry, smeared with the palm of the hand.

Rule: A tool used in the line engraving to produce a series of close parallel lines.

School: This term has no really precise meaning. In its broadest sense it means that a painting can be identified in respect to its country of origin. It is also used to describe the followers or pupils of a particular engraver.

Scraper: A tool used in producing mezzotint plates to scrape away areas of metal.

Sculp: Sculpsit. Literally he engraved it, on an engraving precedes the name of the engraver just the bottom edge of the picture when used.

Shake or Seer: A double impression caused by the paper moving whilst under the press.

Soft Ground Etching: A method of engraving using a wax ground on the copper plate. Paper is placed on the ground and the design drawn on paper. When the paper is lifted wax adhere to the drawn line, exposing the metal to be bitten by acid. (See Styles).

Solander Case: A box made of cardboard opening horizontally for holding prints.

State: A term used to describe the condition of a plate as it exists for a particular period in the life. (See Proofs and States).

Stopping Out: A process used to 'stop-out' or mask a particular part of

plate with wax, varnish or other suitable material so that it is protected from the action of acid for a period during the production of the plate.

Vamp: To renovate, to repair, sometimes with intent to fraud.

Watermark: A number of parallel lines and sometimes a device and name visible when the paper is held up to a strong light.

FURTHER READING

The Conservation of Antiquities and Works of Art
by H. J. Plenderleith. Published by the Oxford University Press, 1962.
Baxter Prints. A Concise guide to their Collection
by Ernest Etheridge. Published by Stanley Martin and Co. Ltd., 1929.
A Manual of Heraldry
by Sir Francis J. Grant. Published by John Grant. Edinburgh, 1952.
Decorative Printed Maps of the 15th to 18th Centuries
by R. A. Skelton. F.S.A. Spring Book, 1965.
Antique Maps
by P. J. Radford. Published by Radford, 1965.
Engravings and their Value
by J. Herbert Slater. Published 'The Bazaar, Exchange and Mart', 1921.
A Dictionary of Art and Artists
by Peter and Linda Murray. Published by Penguin Books, 1959.
Print Collectors Handbook
by Whitman and Salaman. Published by G. Bell and Sons Ltd., 1912.
The Story of British Sporting Prints
by Captain Frank Siltzer. Published by Hutchinson and Co.
Bryans Dictionary of Painters and Engravers
Published G. Bell and Sons Ltd.
Colour-Prints. Eighteenth Century Colour-Prints
by Mrs Julia Frankau. Published by Macmillan, 1907.

Index

A

Acid, Citric, 80
 Oxalic, 80
Ackermann, R. (publishers), 44
Adair, J., 176
Agar, J. S., 89
Alexander, W., 89
Alken, H., 90
Alken, S., 90
Allen, D., 90
Allom, T., 34
Ammonia, 79
Amstel, C., 42
Ansdell, R., 92
Ansell, C., 92
d'Anville, J. B., 176
Armstrong, C., 92
Artlett, R. A., 92
Atkinson, J. A., 92
Atkinson, T. L., 92
Aquatint, History of, 42
 Method, 16

B

Bacon, F., 93
Baily, J., 93
Baird, J., 93
Baker, B. R., 93
Bakhuysen, L., 24
Baldrey, J. K., 93
Bannerman, A., 93
Barker, T., 46
Barlow, F., 94
Barlow, T. O., 94
Barnard, W., 94

Barney, J. H., 94
Barney, W. W., 96
Baron, H., 46
Barry, J., 96
Bartlett, W. H., 34
Bartolozzi, 40, 52
Basire, J., 96
Baxter, G., 96
 licensees, 54
 prints, 56
Beard, T., 108
Beckett, I., 36, 108
Bell, E., 108
Bella, Stefano della, 24
Bellin, S., 110
Bennett, W. J., 44, 110
Bentley, C., 44, 110
Benzene, 81
Beugo, J., 110
Bewick, T., 20, 111
Bickham, G., 111, 176
Birch, W., 111
Birche, H., 111
Bird, C., 111
Black stains (on pigment), 81
Blackmore, J. or T., 112
Blaeu, W., 176
Blake, W., 112
Bleaching, 79
Bleeck, P. Van., 36
Blome, R., 117
Blon, Le., 50
Blond, Le., 54
Blooteling, A., 36
Bluck, J., 112
Bodger, J., 112
Bond, W., 112
Bol, 24

Bone, 114
Bowen, E., 117
Bowles, C., 114
Boydell, J., 34, 48, 115
Boys, J. S., 46
Bracquemond, F., 26
Brandard, R., 115
Brangwyn, F. W., 115
Bretherton, J., 116
Brewer, J. A., 116
Bridgewater, H. S., 116
Bright, H., 46
Brocas, H., 116
Brome, C., 118
Bromley, F., 118
Bromley, J., 118
Bromley, W., 118
Brooks, J., 118
Brookshaw, R., 120
Brown, A., 120
Brown, H. K., 120
Brown, J., 120
Brown, R., 121
Bruce, J., 121
Burford, T., 121
Burke, T., 121
Burne-Jones, E., 22
Burnet, J., 121
Butler, A., 122
Byrne, W., 122

C

Cadwall, J., 122
Callot, J., 24
Carey, W. P., 122
Carpi, Ugo da, 20
Cary, J., 177
Catton, C., 122
Cecil, T., 124
Chambers, T., 124

Cheesman, T., 40-124
Chillingham Wild Bull, 22
Chesham, F., 124
Chloramine, T., 80
Citric acid, 80
Cleaning, 73
Clark, J., 124
Clint, G., 126
Cockson, T., 126
Coffee, 85
 stain removal, 82
Collins, Capt. Grenville, 178
Collyer, J., 126
Colour prints, History of, 50
 method, 18
Colouring for maps, 172
 prints, 85
Cook, T., 126
Cooke, E. W., 127
Cooke, W. B., 127
Cooper, T. S., 46
Coronelli, M. V., 178
Corot, 26
Cotman, J. S., 26-46
Cousen, J., 127
Cousins, S., 127
Cox, D., 46
Cranach, L., 20
Crane, W., 22
Currier & Ives, 48

D

Dalziel, E., 22
Dalziel, T., 22
Daniell, J., 128
Davey, W., T., 128
Dean, J., 128
Decamps, A. G., 46
Delacroix, E., 26, 46
Delâtre, A., 26

Delisle, G., 178
Dictionary of Engravers, 89
Dickinson, W., 128
Dicksee, H., 129
Dixon, J., 129
Dodd, R., 129
Drayton, Michael, 178
Dry point, method, 14
Dubourg, M., 44
Duncan, E., 130
Dunkarton, R., 131
Dürer, A., 20, 30
Dutton, T. G., 48, 131

E

Earlom, R., 38, 132
Eginton, F., 132
Ellis, J., 178
Ellis, W., 132
Engleheart, F., 133
Engravers, dictionary of, 89
Etching, History of, 22
 Method, 12
Ether, 81
Everdingen, 24
Everett, J., 22

F

Faber, J., 36
Fawland, T., 133
Faithorne, W., 133
Fielding, N. S., 133
Fakes & reproductions, 6
Fat stain, removal, 81
Ferdinand, 24
Fielding, N. S. 133
Finden, W. & E., 134
Finlayson, J., 38, 134

Fisher, E., 134
Fitter, J., 134
Floding, P. G., 42
Flour paste, 84
Fly stain removal, 81
Formalin, 84
Foster, Birkett, 22
Frye, T., 136

G

Geddes, A., 26
Gelatine, 85
Geminus, T., 32
Gericault, T., 46
Giles, J. W., 136
Glossary, 187
Godby, J., 136
Goodall, E., 136
Goya, F., 26
Green, V., 38, 136
Green, W. T., 22
Greenwood, C. & J., 178
Grozer, J., 137

H

Haden, Sir F. S., 137
Haecken, A. Van, 36
Haghe, L., 48
Hanley, G., 44
Harding, J. D., 46
Harral, H., 22
Harris, J., 138
Havell, D. & R., 34, 44, 138
Heath, J., 138
Heraldic Tinctures, 174
Herkomer, H., 22
Hester, E. G., 140
Hill, J., 44, 140

Hodges, C. H., 140
Hogarth, W., 140
Holbein, H., 20
Hole, W., 128
Holler, W., 20, 24
Hooper, W. H., 22
Houghton, A. B., 22
Houston, R., 140
Howitt, S., 141
Huet, P., 26
Hughes, A., 22
Hullmandel, C., 46
Hunt, C., 141
Huysum, Jan van, 38
Hydrogen peroxide, 81

I

Ink stain removal, 80

J

Jacquemart, 26
Jansson, Jan, 179
Jardin, Du, 24
Jeakes, J. 142
Jefferys, T., 179
Jones, J., 142
Jukes, F., 42, 142

K

Keene, C., 22
Keere, D. van den, 179
Keulen, J. van, 179
Kip, W., 179
Kitchen, T., 180
Knight, C., 142

L

Lalanne, 26
Laurie, R., 52, 145
Lawless, M. J., 22
Lewis, C. G., 145
Lewis, F. C., 44, 145
Leyton, F., 22
Licensees, Baxter, 56
Lievens, Jan, 24
Line engraving, History of, 30
 Method, 12
 and wash mount, 67
Lithograph, History of, 44
 Method, 16
Linton, W. J., 22
Lucas, D., 145
Lupton, T. G., 146
Lutzeburger, Hans, 20

M

MacArdell, J., 36, 146
Mackrell, J., 146
Malton, J., 44
Malton, T., 44, 146
Maps, 170
Maps, colouring, 172
Marcuard, R. S., 40, 146
Mason, J., 147
Meadows, R. M., 147
Mercator, G., 180
Meryon, C., 26
Methylated spirits, 79
Meyer, H., 147
Mezzotint, History of, 34
 Method, 14
Millet, 26
Millais, 22
Moll, H., 180
Morden, R., 181

Mounts, 66
 Line & Wash, 67
 Overlay, 66
 Solid, 66
 Window, 66
Mounting, 66
Moule, T., 181
Munster, S., 181
Murphy, J., 147

N

Nash, J., 46
Newhouse, C. B., 148
Norden, J., 181
North, J. W., 22
Nutler, W., 148

O

Ogbourne, J., 40, 148
Ogilby, J., 182
Oil stains, removal, 81
Orme, D., 148
Ortelius, A., 182
Ostade, 24
Overlay mount, 66
Oxalic acid, 80

P

Palmer, W. J., 22
Paper, 58
 mark, 58
Parazyme, 78
Parr, R., 151
Paste, 84
Payne, J., 151
Pelham, P., 36

Pether, W., 38, 151
Petrol, 81
Petty Sir W., 182
Picken, T., 48
Pigot & Co., 183
Pinwell, G., 22
Place, F., 36, 151
Pollard, J., 151
Pollard, R., 152
Pot. perborate, 82
 permanganate, 81
Prince, J. B. le., 42
Principal map makers, 176
Prior, T. A., 152
Proofs and states, 61
 remarque, 61
Prout, S., 46, 152
Pyridine, 81

Q

"Quadrupeds, The", 22

R

Raffet, A., 46
Ramble, R., 183
Raimbach, A., 30, 152
Reduction of whiteness, 85
Reeve, R. G., 44, 152
Reeve, T., 155
Remarque proof, 61
Rembrandt, 22
Removal of backing, canvas, 78
 card, 76
 paper, 78
 varnish, 78
Reprints, 71
Reproductions & Fakes, 69
Restoration, 73

bleaching, 79
cleaning, 73
colouring, 85
ink stain removal, 80
paste, 84
reduction of white & red
 pigment, 85
sizing, 84
removal of backing canvas, 78
card, 76
paper, 78
varnish, 78
fly stains, 81
oil, fat, tar, 81
tea & coffee stains, 82
tears repair, 82
Reynolds, S. W., 38, 155
Roberts, D., 46
Rogers, W., 32
Rosenberg, C., 155
Rowlandson, T., 44, 156
Ryall, H. T., 156
Ryland, W. W., 38, 52, 159

S

Sandby, P., 42, 159
Sandys, F., 22
Sanson, N., 183
Say, W., 159
Saxton, C., 183
Scott, J., 160
Segler, 24
Seller, J., 184
Senefelder, A., 44
Senex, J., 184
Shannon, C. H., 46
Sharp, W., 160
Shepherd, T., 34, 161
Sherwin, W., 36
Sherwin, J. K., 161

Siegen, von L., 34
Simman, W. H., 161
Simon, J., 36
Sizing, 84
Small, W., 22
Smith, C., 184
Smith, J. P., 36, 161
Sod. hypochlorite, 79
formaldehyde sulphoxylate, 80
thiosulphate, 79
Soft ground etching, 18
Solid mounts, 66
Solomon, J., 48
Somer, Paul van, 36
Speed, J., 184
Stadler, J. C., 44
States & proofs, 61
Stipple engraving, History of, 38
Method, 16
Stubbs G. & G. T., 162
Styles & methods, 10
aquatints, 16
colour prints, 18
dry point, 14
etching, 12
line engraving, 12
mezzotint, 14
stipple, 16
soft ground, 18
wood block, 12
Suggestions to beginners, 3
Sutherland, T., 163

T

Tar stain removal, 81
Tea & coffee stain removal, 82
Tears repair, 82
Tenniel, J., 22
Teyler, J., 50
Thomas, W., 22

Tomkins, P. W., 40, 163
Tomlinson, J., 164
Turner, C., 164, 38
Turner, J. M. W., 165, 26
Turpentine, 78

V

Vaart, van der, 36
Vaillant, V., 34
Valck, G., 36
Varnish, 78
Vernet, H., 46
Vertue, G., 165
Visscher, N., 185
Vliet, van, 24

W

Ward, J. 46,
Wax stain removal, 81

Wechtlin, 20
Wells, E., 185
Westall, W., 34
Whistler, 26
White, G., 36
Whymper, J. W , 22
Wilkie, D., 30
Wilkin, C., 166
Window mounts, 66
Witt, F. de, 185
Wood block, History of, 20
 Method, 12
Woollett, W., 166

Y

Young, J., 166

Z

Zeeman, R., 24